Sports Illustrated Sports Illustrated Sports Illustra
Sports Illustrated Spor or
Sports Illustrated Sports Illustra or
Sports Illustrated Sports Illustrated Spo
Sports Illustrated Sports Illustrated Sports Illustra
Sports Illustrated Sports Illustrated Spor
Sports Illustrated Sports Illustrated Sports Illustra
Sports Illustrated Sports Illustrated Spor
Sports Illustrated Sports Illustrated Sports Illustra
Sports Illustrated Sports Illustrated Spor
Sports Illustrated Sports Illustrated Sports Illustra
Sports Illustrated Sports Illustrated Spor
Sports Illustrated Sports Illustrated Sports Illustra
Sports Illustrated Sports Illustrated Spor
Sports Illustrated Sports Illustrated Sports Illustra
Sports Illustrated Sports Illustrated Spor
Sports Illustrated Sports Illustrated Sports Illustra
Sports Illustrated Sports Illustrated Spor
Sports Illustrated Sports Illustrated Sports Illustra
Sports Illustrated Sports Illustrated Spor

Sports Illustrated

The New York

Mets

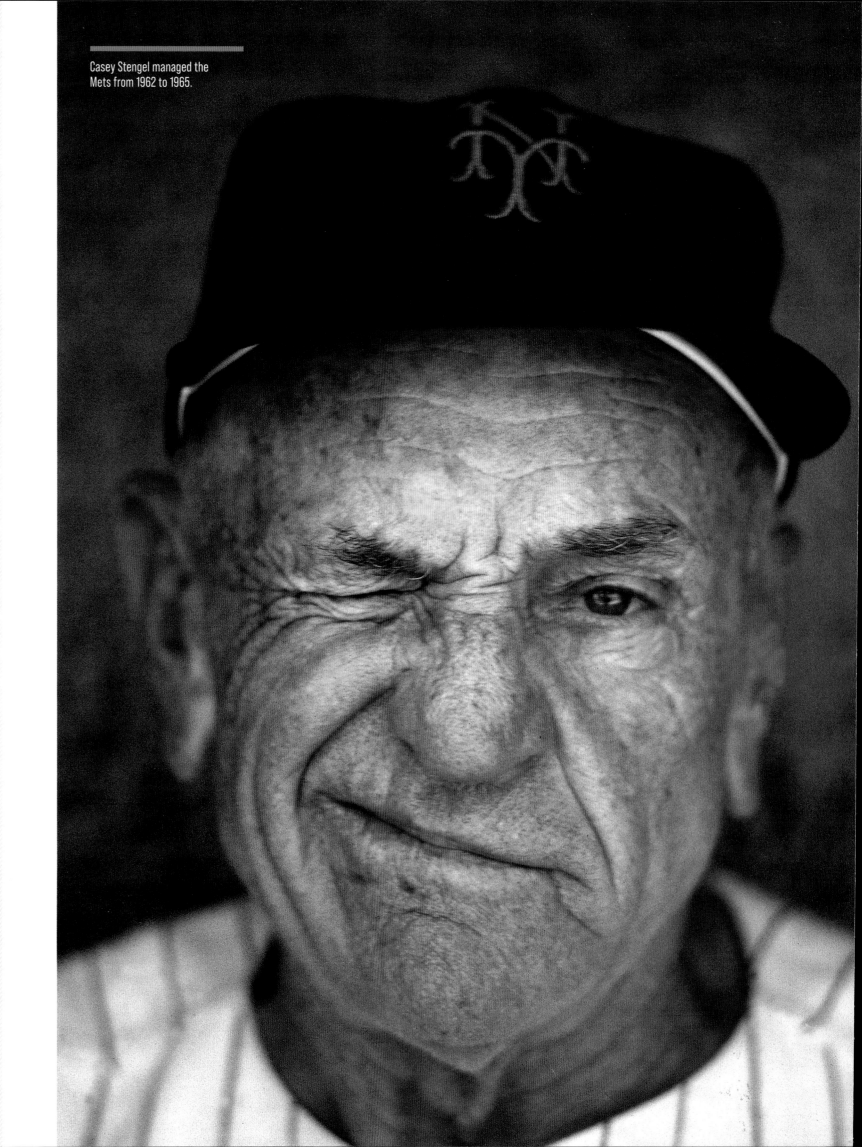

Casey Stengel managed the
Mets from 1962 to 1965.

CONTENTS

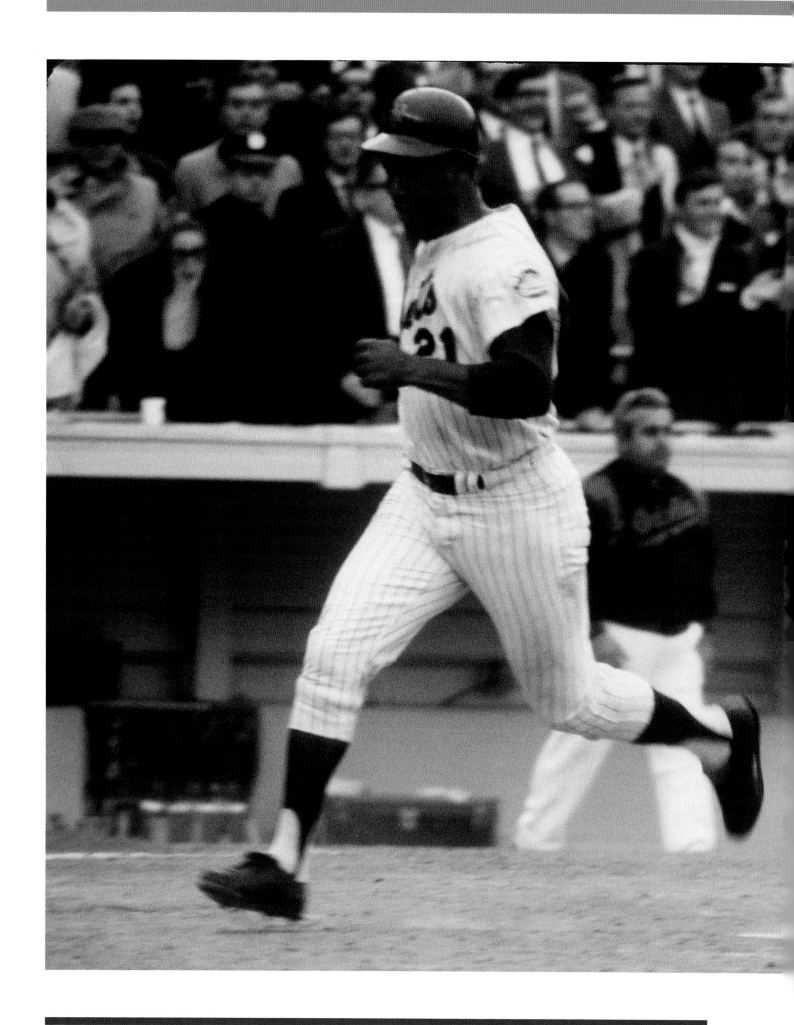

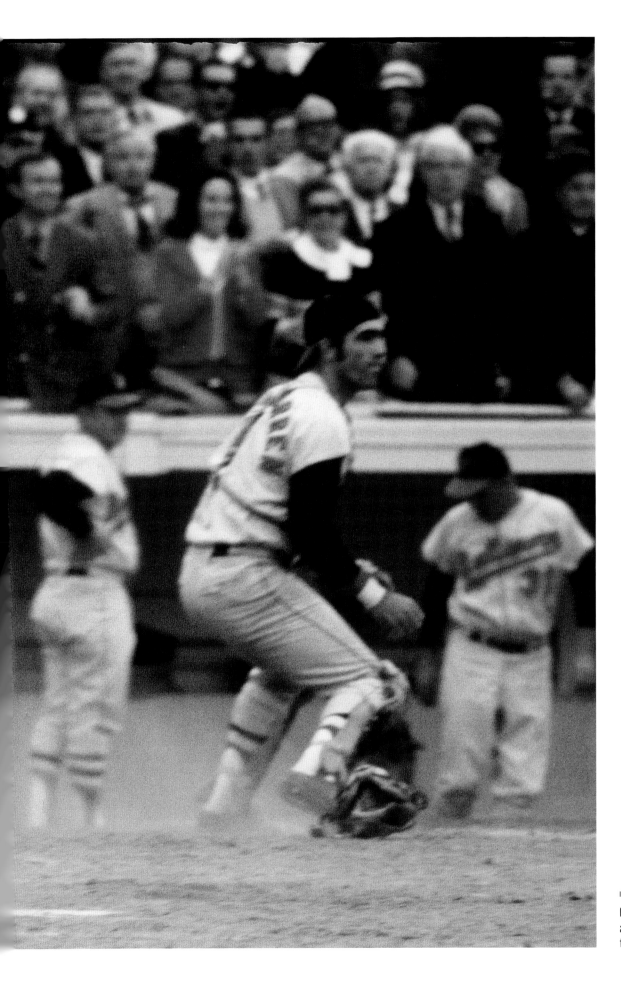

Cleon Jones scores
against the Orioles during
the 1969 World Series.

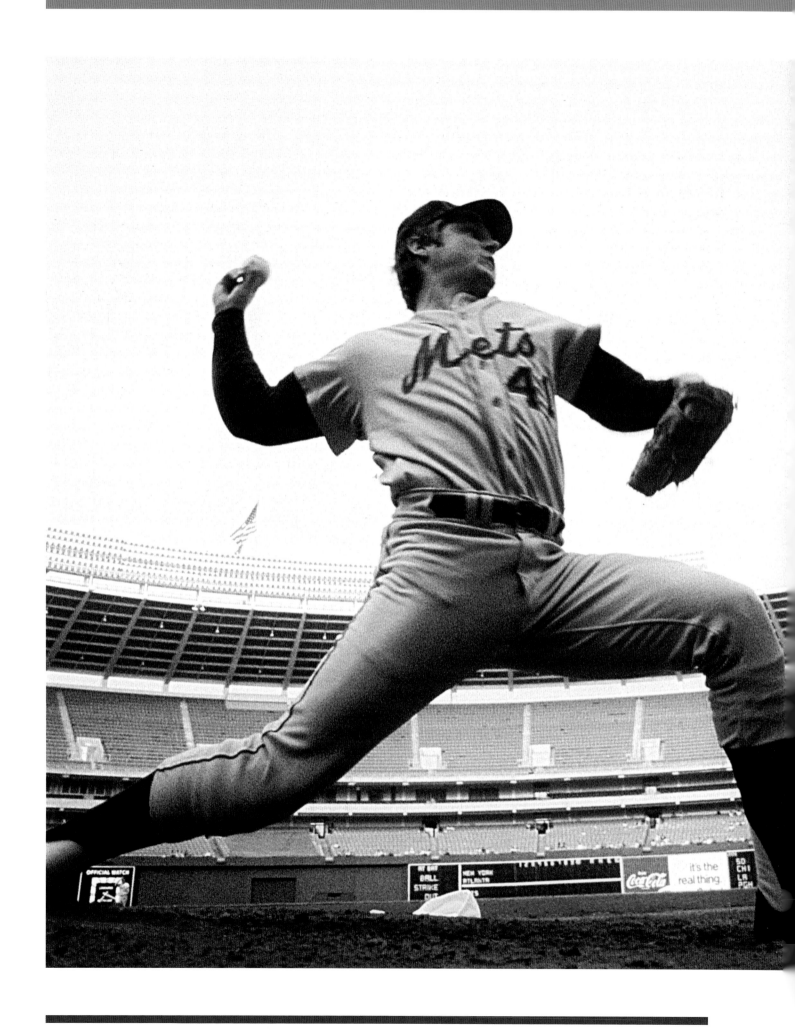

Tom Seaver warms
before a game against
Atlanta in 1975.

Bob Ojeda, Sid Fernandez,
Ron Darling and Dwight
Gooden formed the
nucleus of the 1986 world
champions' starting rotation.

INTRODUCTION

by JOHN FRANCO

Christmas came early for me in 1989. On December 6, I got a call that really changed my life. The Reds had traded me to the Mets, and the kid from Brooklyn was back home in Queens.

I had been a Mets fan my entire life. I was nine in 1969 when the Miracle Mets shocked the baseball world and won the World Series. I loved Tom Seaver, Cleon Jones, Jerry Koosman and Tug McGraw. I would go to Banner Day, Photo Day and every other day.

My first number with the Mets was 31, but then I took 45 to honor Tug. He was my idol. I loved his enthusiasm and the way he approached the game. He was a great pitcher and had fun too. I read everything I could about him in the papers and magazines. He was a lefty, like me, and I loved the way he competed. One of the big thrills in my life came in 1996 when the club had a day for my 300th career save. They gave me a motorcycle and Tug came riding out of the bullpen to give it to me.

I am truly honored to be writing the introduction to this book celebrating 60 years of Mets baseball. I personally know so many of the guys on these pages. Many of them were at Citi Field in August 2022 when we had our first Old Timers' Day in 28 years.

I enjoyed talking to the 1962 Mets like Frank Thomas, Jay Hook and Craig Anderson, and the 1969 guys like Ed Kranepool, Cleon Jones, Art Shamsky and Ron Swoboda. What a happy day that was. It was like decades of Mets baseball came together. I'm a true baseball historian and it was great to learn about what when on before me.

I had no choice but to be a Mets fan. My dad was an old Brooklyn Dodgers fan, and my older brother Jimmy was for the Mets. I always loved the passion of the Mets fans. Sure, we haven't won as many titles as the team across town, but the support is always there. They never give up.

It's kind of like my career. A lot of people probably never thought I would accomplish what I did. I pitched in over 1,000 big league games, had 424 saves, 90 wins and was picked to four All-Star teams in 22 years.

There were a lot of things I was proud of during my days at Shea. One little known fact is that during

John Franco spent 14 of his 21 years in the big leagues as a Met.

my time in Flushing, I played Santa Claus at the Holiday Party for 15 straight years. Baseball was important but I never ignored the kids.

I will never forget about the thrill of the Subway Series in 2000. It was my first World Series appearance. In the Division Series against the Giants, I was able to strike out Barry Bonds in a key spot to get the save, and then I got our only win in Game 3 against the Yankees.

It was so great playing in front of my friends and family. You would go out to get a paper in the morning and there would be Mets fans and Yankee fans arguing with each other. It's just a shame that we fell a little short. I think we lost four games by a total of five runs.

The year 2001 was a year I never will forget for so many reasons.

On May 1, Bobby Valentine called me into his office and said my teammates had voted me to be their captain. Going forward I now would have a big C on my shirt. It was quite an honor being only the third captain in team history. Look who I was succeeding: Keith Hernandez and Gary Carter.

I took the job seriously. I tried to be there for the guys and help Bobby and the coaches out in any way I could.

Then came the attacks on September 11. We were in Pittsburgh and I remember watching the towers fall on TV. All hell was about to break loose.

Our hotel was next to a federal building, and we had to move to the suburbs because no one knew what to expect.

We bused home to Shea and began helping as best we could. The parking lot was turned into a recovery area, and we packed stuff to send down to Ground Zero.

I was so proud of what our team did. We went to firehouses, police stations, hospitals. I know we helped NYC heal and helped first responders smile again.

On September 21, 2021, at Citi we celebrated the 20th anniversary of our first game back after the attacks, and we all relieved the memory of Mike's home run. We had close to 20 guys back from the 2001 team. What we did after 9-11 was personal, because I lost friends as did so many others. That will be a bond that will keep us together forever.

In 2012, I had the honor of being inducted into the Mets Hall of Fame. Who would have thought that somebody like me, who was drafted in the fifth round by the Dodgers in 1981, would wind up in the Mets Hall of Fame? Every now and then when I walk into the Hall of Fame at Citi and see my plaque there, it still gives me a special thrill.

I still root for the Mets like crazy. I represent the club at various events and dinners. My dad was a NYC sanitation worker who taught me how important it was to give back.

Sure, the way we finished in 2022 was a disappointment, but there is no doubt in my mind we are headed in the right direction. There is no reason in the world why we can't get in the playoffs on a regular basis and sometime soon win another World Series.

I had a great time in Cincinnati and made some life-long friends. But everything changed when I came back home and put on a Mets uniform.

I hope everyone has a great time reading this book. I know a lot of fond memories will pop off the pages for me, and I hope they do for you too.

Let's Go Mets. •

Franco celebrates his induction into the Mets Hall of Fame at Citi Field in 2012.

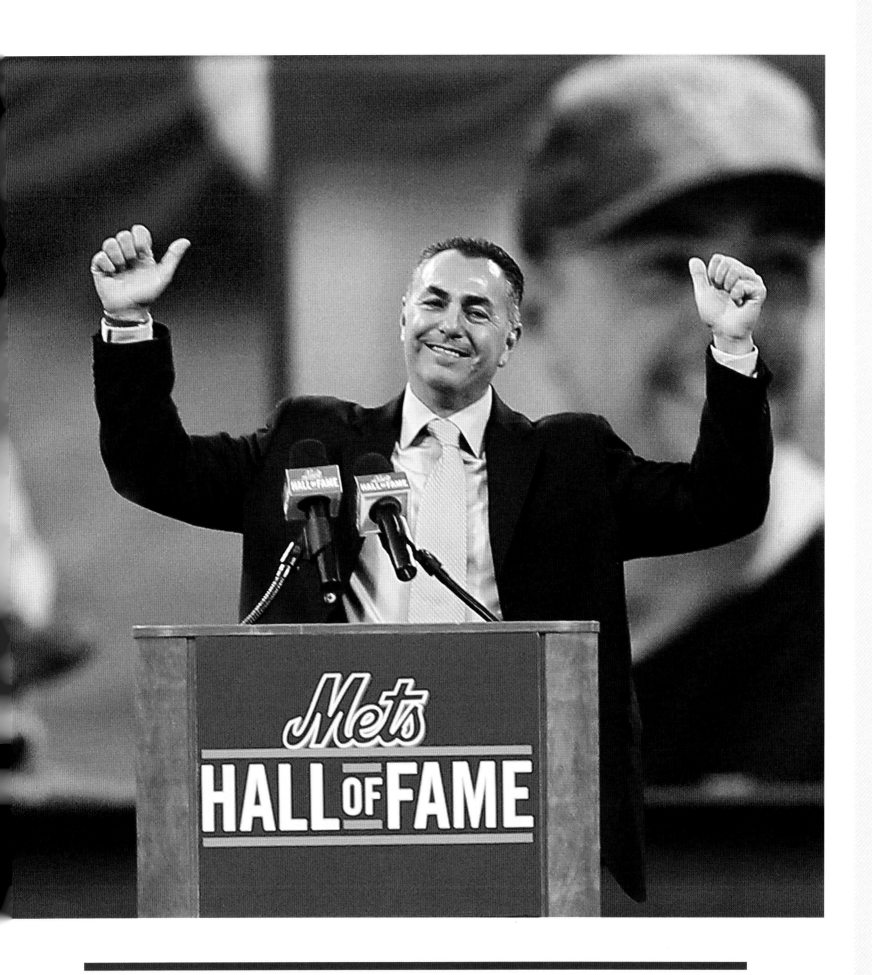

THE CHARACTERS

A collection of unforgettable personalities helped turn the Mets into one of baseball's most beloved franchises. These are the members of the team's Hall of Fame

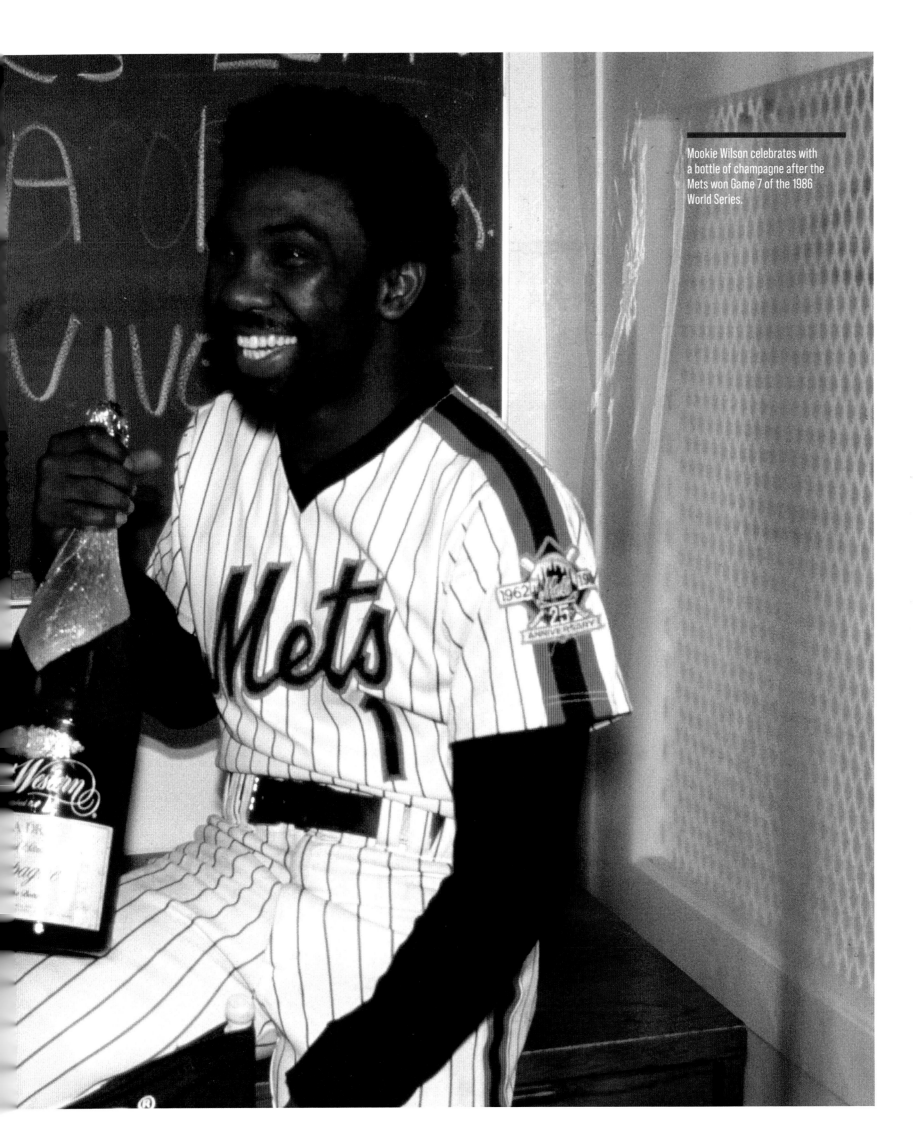

Mookie Wilson celebrates with a bottle of champagne after the Mets won Game 7 of the 1986 World Series.

JOAN WHITNEY PAYSON

» **Owner 1960–1975**

» **President 1968–1975**

Though she was the third woman to own a Major League Baseball club, when Joan Whitney Payson assumed majority control of the expansion New York Mets in 1960, she was the first woman to have bought, rather than inherited, a team. Payson served as club president from 1968 to 1975, with the Mets winning their first World Series in 1969. A true fan of the game, Payson had a distinctive method of keeping score at games which she taught to her chauffeur so that he could fill out her scorecards and mail them to her when she could not attend in person. The New York City native, who died in 1975, was inducted posthumously into the New York Mets Hall of Fame in 1981.

Payson was a minority owner of the New York Giants before that team moved to California.

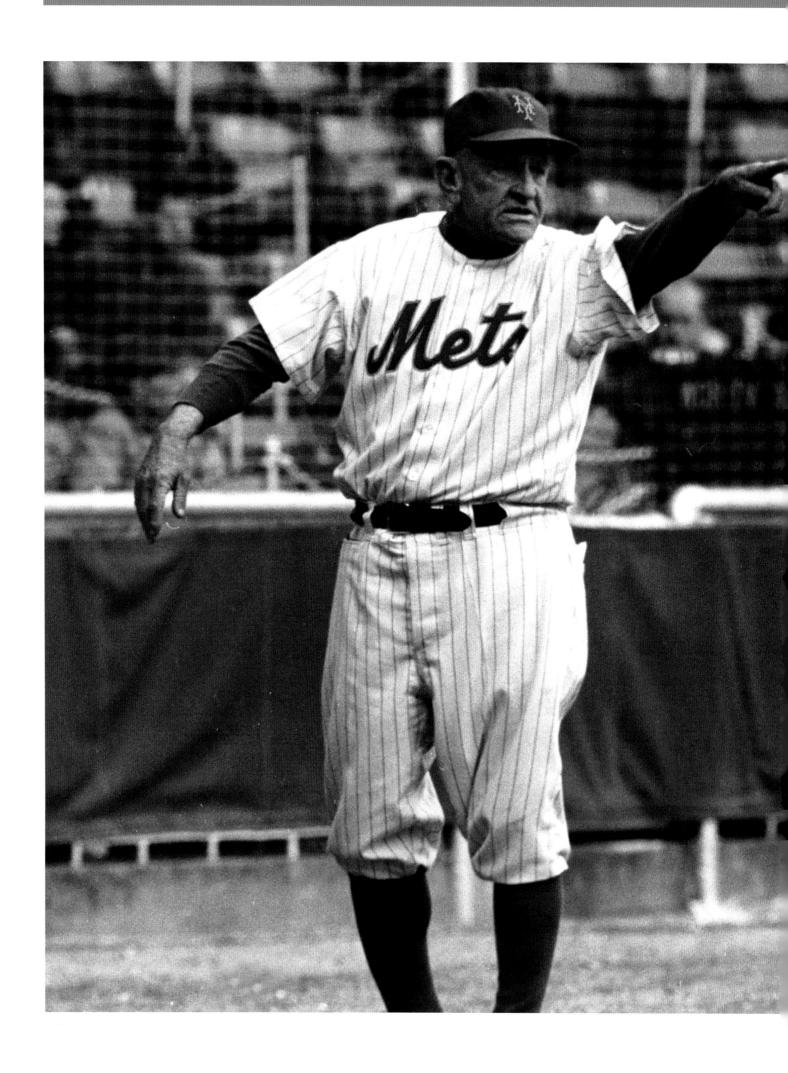

CASEY STENGEL

» **Manager 1962–1965**
» **Vice President 1965–1975**

One of baseball's most colorful characters, Casey Stengel was already beloved in New York City when he agreed to manage the expansion Mets in 1961, having led the Yankees to seven World Series titles in 12 seasons. Though he would never reach the pinnacle with the Mets, who lost 404 games during his three-and-a-half-year tenure to become "Lovable Losers," it's also true that without the quippy Stengel, the Mets never would have earned their "Amazin'" nickname. Despite the poor product on the field, the early Mets earned substantial fan support thanks to Stengel's tireless promotion. In return, the team honored Stengel with a World Series ring from the Mets' improbable win over the Baltimore Orioles in 1969. Stengel was inducted into the New York Mets Hall of Fame in 1981, 15 years after his entry into the Baseball Hall of Fame.

Stengel's 1,905 wins as a manager rank 13th in baseball history.

GIL HODGES

» **First Baseman 1962–1963**

» **Manager 1968–1971**

After making his mark with the Brooklyn (and then Los Angeles) Dodgers as one of the game's preeminent first basemen, helping his team to two World Series titles, Gil Hodges finished his playing career with the New York Mets in 1962-63. The Mets hadn't finished above .500 in years, but when Hodges took over as manager the following season, he set about changing that. In 1969, the "Lovable Losers" became the "Miracle Mets," defeating the heavily favored Baltimore Orioles in the World Series. Hodges tragically died of a heart attack at only 47 in 1972. He was inducted into the New York Mets Hall of Fame in 1982 and the Baseball Hall of Fame in 2022.

Hodges was an eight-time All-Star during his playing career.

GEORGE WEISS

» **President 1961–1966**
» **National Baseball Hall of Fame 1971**

When the expansion New York Mets were formed, George Weiss (far left) became the club's first president, bringing with him decades of experience building the New York Yankees farm system into a juggernaut. The Mets' player-development system took some years to bear fruit, but by the time Weiss's tenure ended in 1966, future New York Mets Hall of Famer players Cleon Jones, Ed Kranepool, Tug McGraw and Bud Harrelson had emerged as bright spots. In 1962, Casey Stengel, who had managed the Yankees under Weiss to 10 pennants and seven world championships, joined his old boss with the new club across town. Weiss was inducted into the New York Mets Hall of Fame in 1982, 11 years after he was selected to the Baseball Hall of Fame.

Weiss was responsible for acquiring several players on the 1969 championship team.

JOHNNY MURPHY

» **Chief Scout 1961–1963**

» **Vice President/GM 1964–1970**

Johnny Murphy (middle, between MLB commissioner Bowie Kuhn and pitcher Tom Seaver) wore many hats for the Mets, including as chief scout and vice president. But it was his appointment to general manager in 1968 that shifted the fortunes of the franchise forever. Murphy skillfully oversaw a trade with the Senators to bring manager Gil Hodges to New York, sending pitcher Bill Denehey and $100,000 back to Washington. Murphy worked closely with director of player development Whitey Herzog to build the Mets' pitching staff, and that homegrown talent—Tom Seaver, Jerry Koosman, Gary Gentry, Nolan Ryan, Jim McAndrew and Tug McGraw—was instrumental in the Mets becoming the first expansion team to win the World Series in 1969. He was inducted into the New York Mets Hall of Fame in 1983.

Murphy passed away just three months after the 1969 World Series.

WILLIAM SHEA

» Proponent

» New York Mets Hall of Fame 1983

Without William Shea's efforts to bring National League baseball back to New York City after the New York Giants and Brooklyn Dodgers departed in 1958, the Mets as we know them today may never have existed. Shea (throwing ball), a name partner at law firm Shea & Gould, founded the Continental League, which would have been a third major (and rival) league, forcing MLB's hand when it came to expansion and opening the door for the Mets. For his efforts, the stadium that housed the club for 44 years was named in his honor. Shea's name was retired on the outfield wall of Shea Stadium, and now at Citi Field, alongside the club's other players' and managers' retired numbers.

Shea was instrumental in bringing the Mets and Colt .45s to the National League in 1962.

RALPH KINER

» **Broadcaster 1962–2013**

» **National Baseball Hall of Fame 1975**

After an accomplished but injury-shortened playing career that saw him lead the National League in home runs between 1946 and 1952, Ralph Kiner moved into the broadcast booth to become an original voice of the Mets in 1962 alongside Bob Murphy and Lindsey Nelson. Murphy would remain in that post until 2013, then the oldest active announcer in the major leagues prior to his death the following year. The Emmy Award winner was known fondly for his malapropisms, which included calling broadcasting partner Tim McCarver "Tim MacArthur" and even once referring to himself as "Ralph Korner." Kiner's signature home run call during his 50-plus years in the booth was, "It is gone, goodbye!" He was inducted into the Baseball Hall of Fame in 1975.

As a player, Kiner led the National League in home runs seven times.

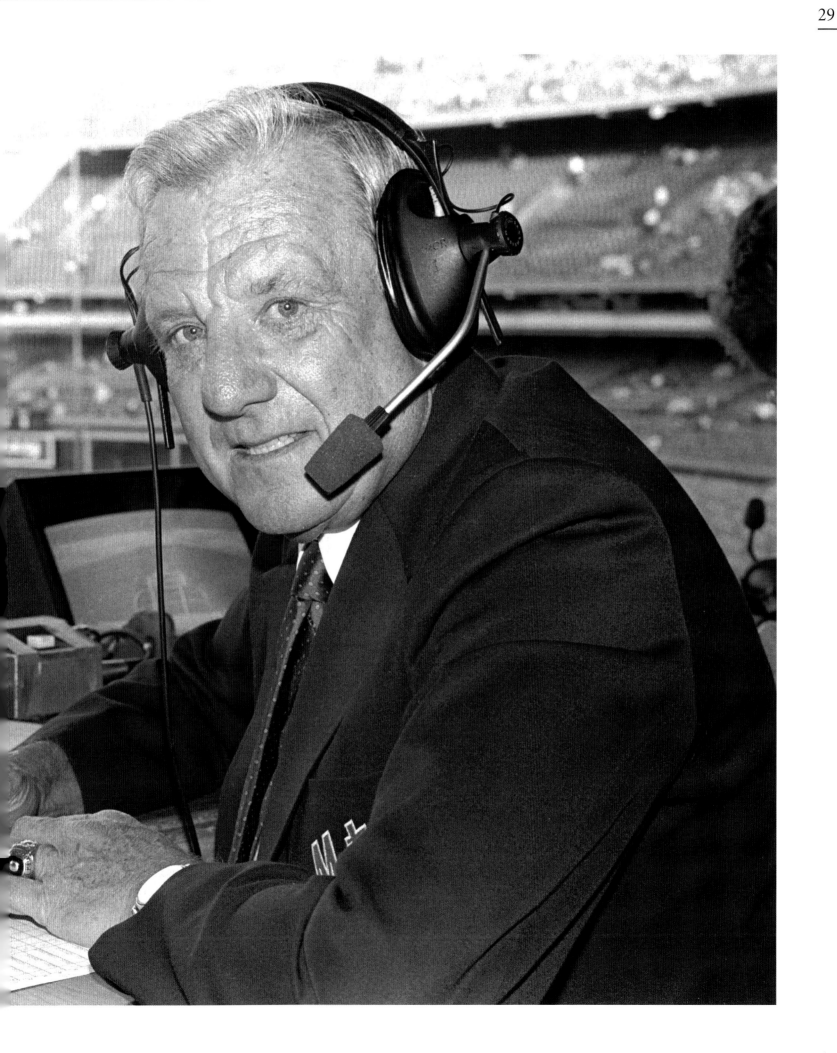

BOB MURPHY

» Broadcaster 1962–2003

» New York Mets Hall of Fame 1984

After stops with the Boston Red Sox and Baltimore Orioles, Bob Murphy joined Ralph Kiner and Lindsey Nelson as the expansion New York Mets' first broadcast team in 1962. The audition tape that landed Murphy the job was his call of Roger Maris's record-tying 60th home run in the 1961 season. Known for his optimistic outlook, Murphy opened games with his signature phrase, "The sun is shining, the sky is blue, it's a beautiful day for baseball." The recipient of the Ford C. Frick Award in 1994, he remained on the mic for the Mets in both television and radio until his retirement in 2003.

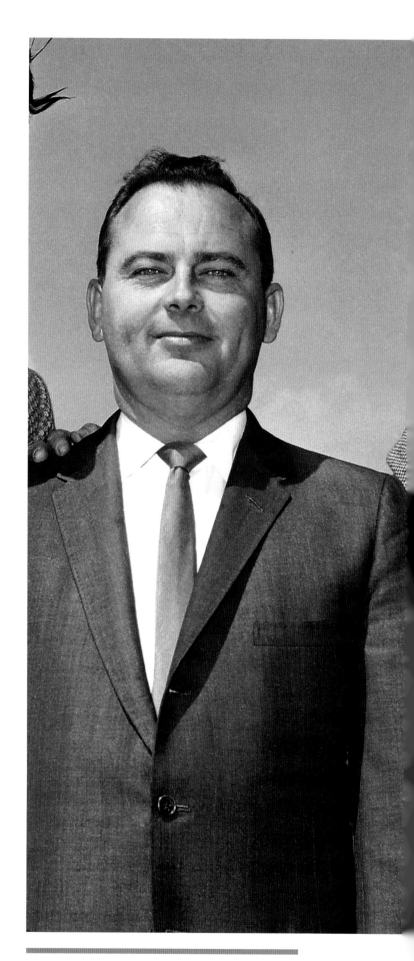

Murphy was also the voice of Oklahoma Sooners football in the 1950s.

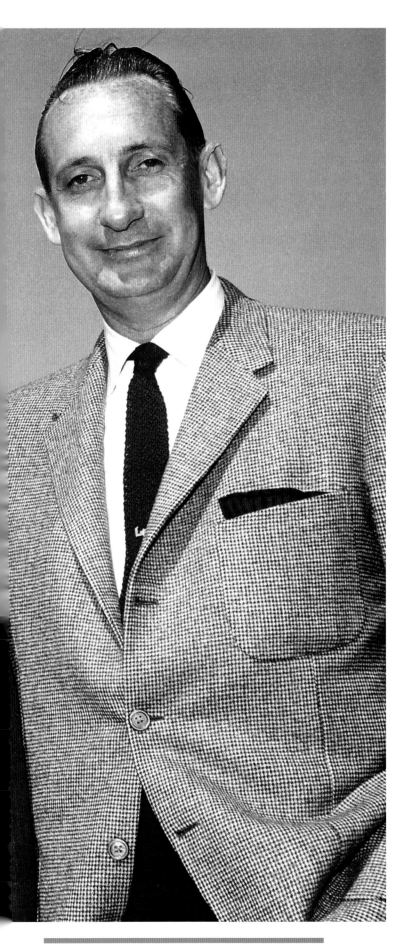

LINDSEY NELSON

» **Broadcaster 1962–1978**

» **New York Mets Hall of Fame 1984**

Prior to joining Ralph Kiner and Bob Murphy in the Mets' broadcast booth in 1962, Lindsey Nelson had cut his teeth broadcasting college football, NBA and college basketball, professional golf and tennis. His rich Tennessee drawl was perfect for radio, but he entertained viewers on camera by cultivating a collection of 335 colorful plaid sport coats. In the Baseball Hall of Fame and Museum, Lindsey Nelson and Murphy are honored with a display for receiving the prestigious Ford C. Frick Award, with Nelson receiving that honor in 1988. His trademark opening phrase, "Hello everybody, I'm Lindsey Nelson," was also the title of his autobiography. He was awarded an Emmy Award for Lifetime Achievement in 1991.

Nelson, Kiner and Murphy shared TV and radio duties using a rotational system from 1962 to 1979.

BUD HARRELSON

» **Shortstop 1965–1977**

» **Manager 1990–1991**

Bud Harrelson both played for and managed
the Mets. Harrelson anchored their infield for
13 seasons, including their 1969 and 1973 playoff
runs. Though known more for his glove than his
bat, the shortstop hit the go-ahead triple in the
fourth inning of Game 1 of the 1969 NLCS against
the Atlanta Braves and an RBI double in Game 2.
Owning a lifetime .969 fielding percentage,
Harrelson won a Gold Glove in 1971 and earned an
All-Star berth the previous year. He was also a
coach on the 1986 World Series team. Harrelson
was inducted into the Mets Hall of Fame during
that memorable year, and eventually replaced
Davey Johnson, following the manager's dismissal
42 games into the 1990 season. He led the Mets
to their seventh consecutive winning season and
lasted one more season as manager.

Harrelson's 1,322 games played in a Mets uniform are the
fourth most in team history.

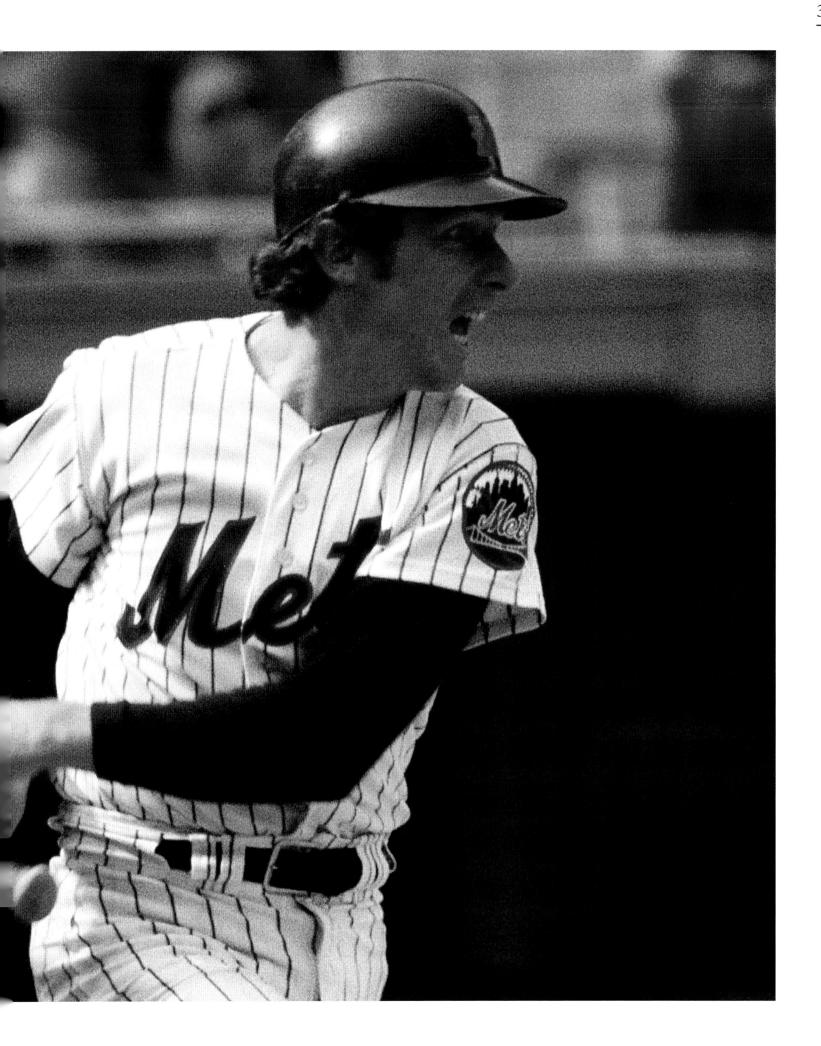

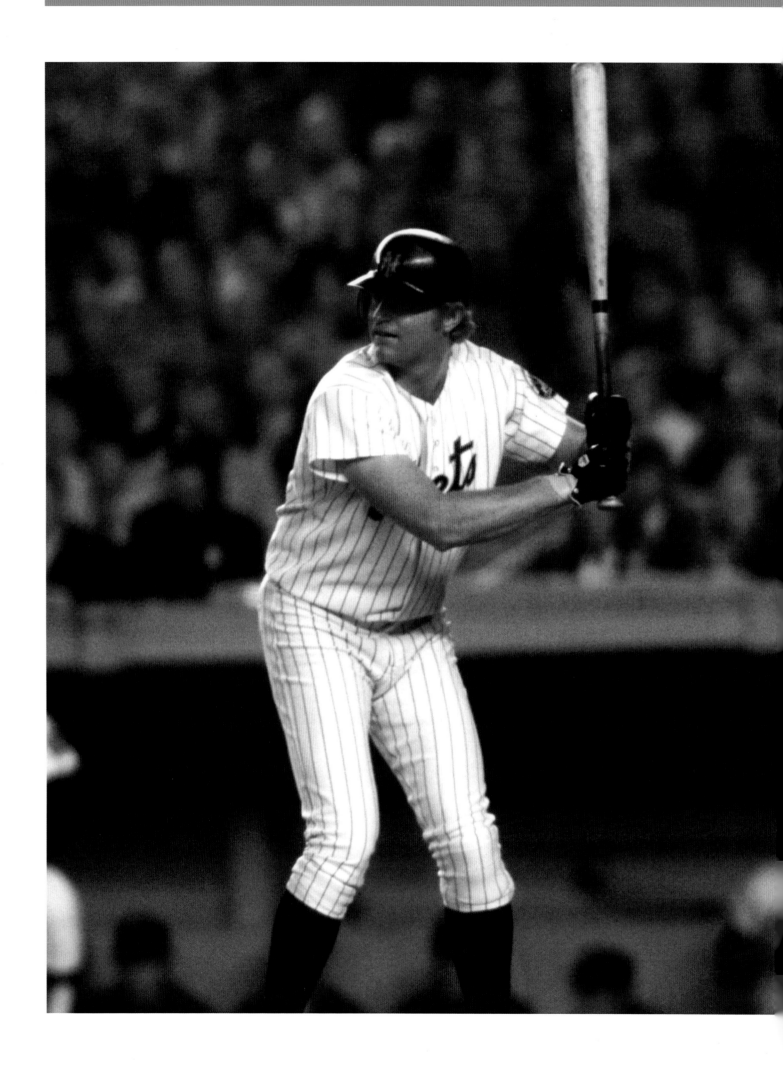

RUSTY STAUB

» Outfielder/First Baseman 1972–1975, 1981–1985

» New York Mets Hall of Fame 1986

Rusty Staub was known as both a tough out and a tough player. In one example of his ability to play through pain, he robbed Cincinnati's Dan Driessen of an extra-base hit in the 1973 NLCS while making the play in right field, crashing into the outfield fence and separating his shoulder. He missed the rest of the NLCS but returned in the World Series to bat .423 with six RBIs against the Oakland A's. The Mets acquired him from the Montreal Expos in 1972 in a blockbuster trade involving three players, including future All-Star Ken Singleton. He was part of another big trade when the Mets sent him to the Detroit Tigers for Mickey Lolich and Billy Baldwin in 1975—but not before he became the first Mets player to surpass 100 RBIs in a season.

Staub is the only player in baseball history to collect 500 hits on four different teams.

TOM SEAVER

» Pitcher 1967–1977, 1983

» National Baseball Hall of Fame 1992

When Tom Seaver became eligible for induction into the Baseball Hall of Fame in 1982, he received the highest percentage of votes ever recorded at that time. A 12-time All-Star, Seaver won the Rookie of the Year and three NL Cy Young Awards as a Met and is the team's all-time leader in wins. Between 1970 and 1976, Seaver led the NL in strikeouts five times and also finished second in 1972 and third in 1974. Seaver also won three ERA titles while with the Mets. Due to a contract dispute, he was infamously traded to the Cincinnati Reds in 1977 in what Mets fans dubbed "the Midnight Massacre." On December 16, 1982, the Reds traded him back to the Mets, for whom he tied Walter Johnson's MLB record of 14 Opening Day starts. The first Mets player to receive the honor, his No. 41 was retired in 1988.

Seaver's 198 victories remain the most in Mets history.

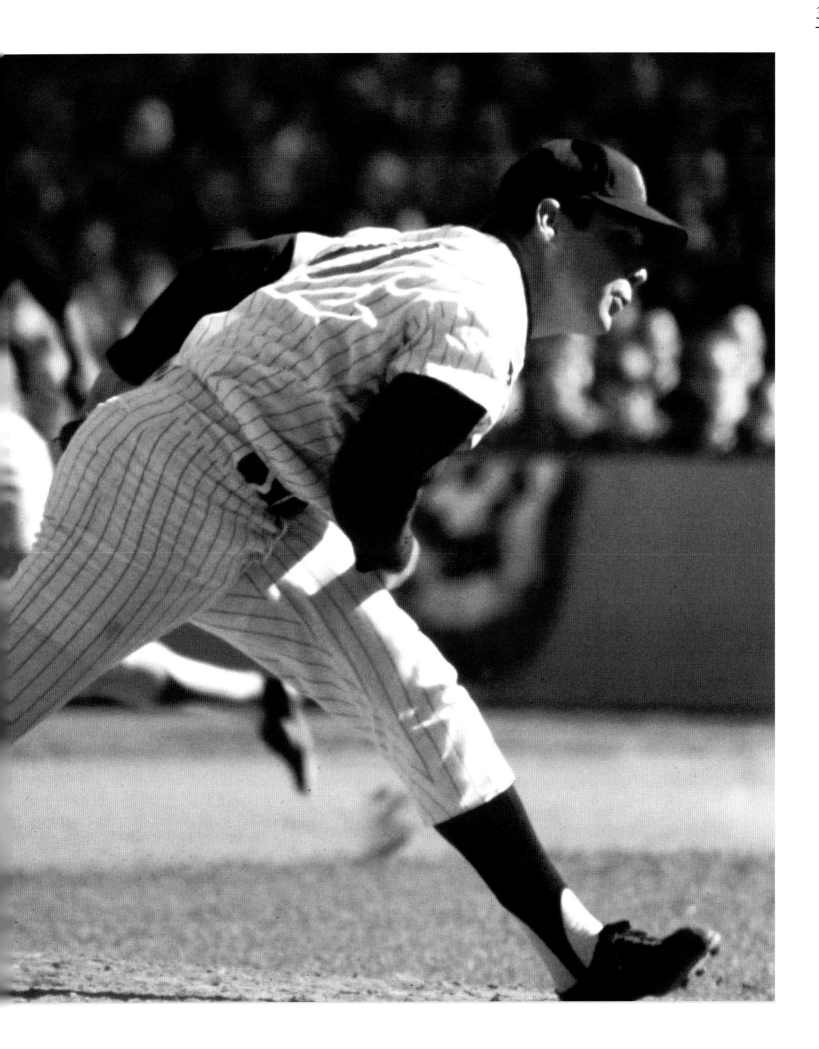

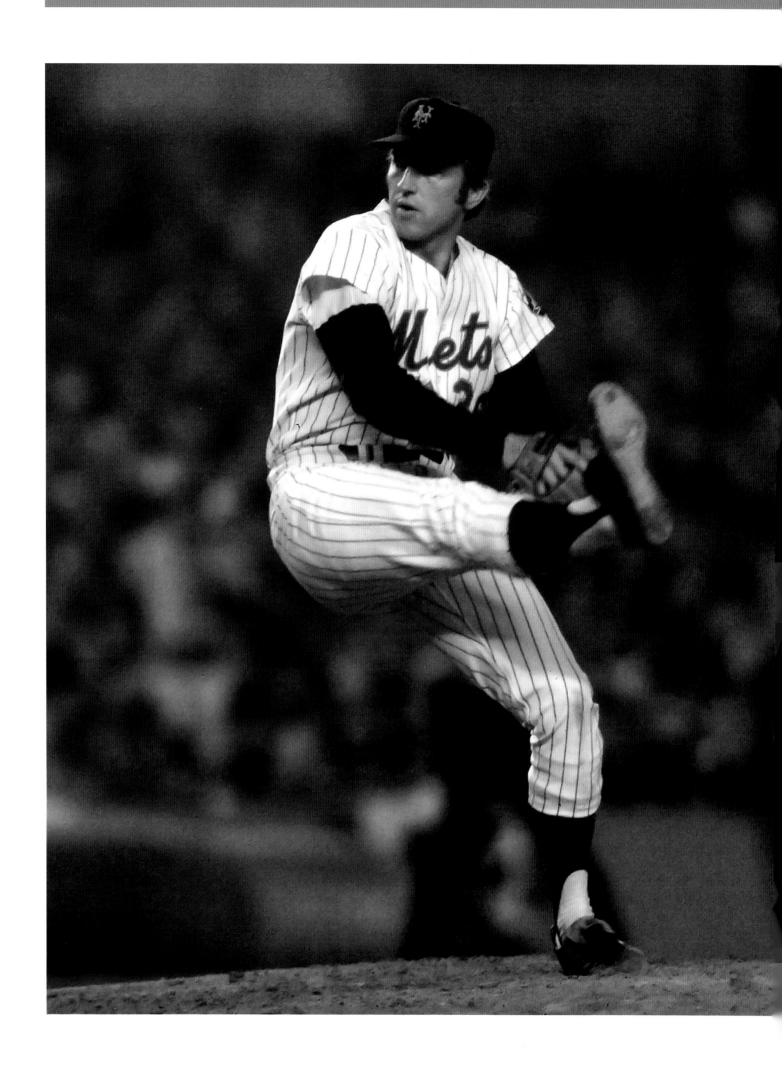

JERRY KOOSMAN

» **Pitcher 1967–1978**

» **New York Mets Hall of Fame 1989**

The splendid career of Jerry Koosman had a serendipitous start. He was discovered by the son of a Shea Stadium usher, who had caught Koosman when he pitched for the Army at Fort Bliss. Koosman broke into the Mets' rotation in 1968, compiling a 19–12 record, seven shutouts, 178 strikeouts and a 2.08 ERA. But his important stretch occurred during the ensuing season when he starred during the 1969 World Series against the Baltimore Orioles. He started the Game 2 victory to even the series, and his Game 5 performance won the game and the series for the Mets. The 5–3 victory concluded with him retiring the final three Orioles batters and earning his second win of the series. The two-time All-Star had his No. 36 retired by the Mets in 2021, making him the third Mets player (after Tom Seaver and Mike Piazza) to receive that honor.

Only Tom Seaver started more games on the mound for the Mets than Koosman.

ED KRANEPOOL

» First Baseman 1962–1979

» New York Mets Hall of Fame 1990

A young phenom, Ed Kranepool debuted for the Mets as a 17-year-old in September of 1962, making him the league's youngest player. The first baseman was an All-Star in 1965, and later batted .300 in 1974 and 1975 while sharing first-base duties with John Milner and Dave Kingman. A fan favorite, Kranepool became the last of the 1969 Miracle Mets after the team traded Jerry Koosman at the end of the 1978 season. Kranepool spent his entire 18-year career with the Mets, and retired after the 1979 season as the Mets' all-time leader in 10 major statistical categories including games played, at-bats, plate appearances, hits, total bases, doubles and triples.

No one has played more games as a Met than Kranepool, who appeared in 1,853.

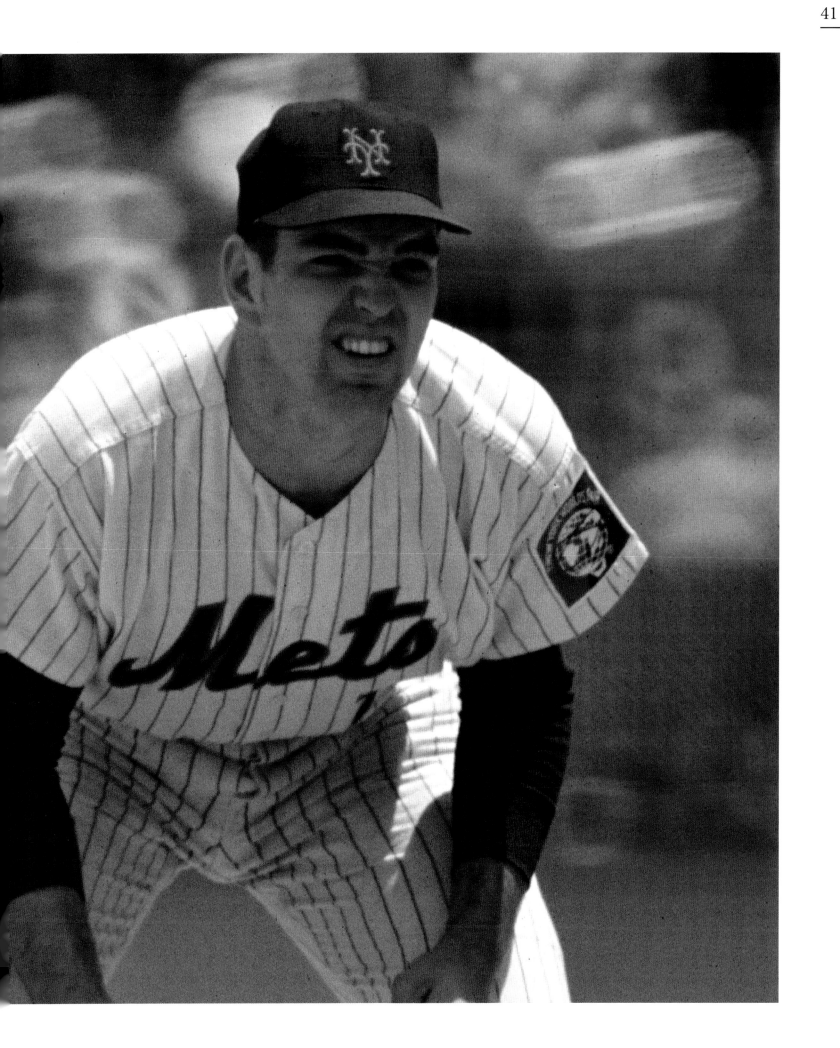

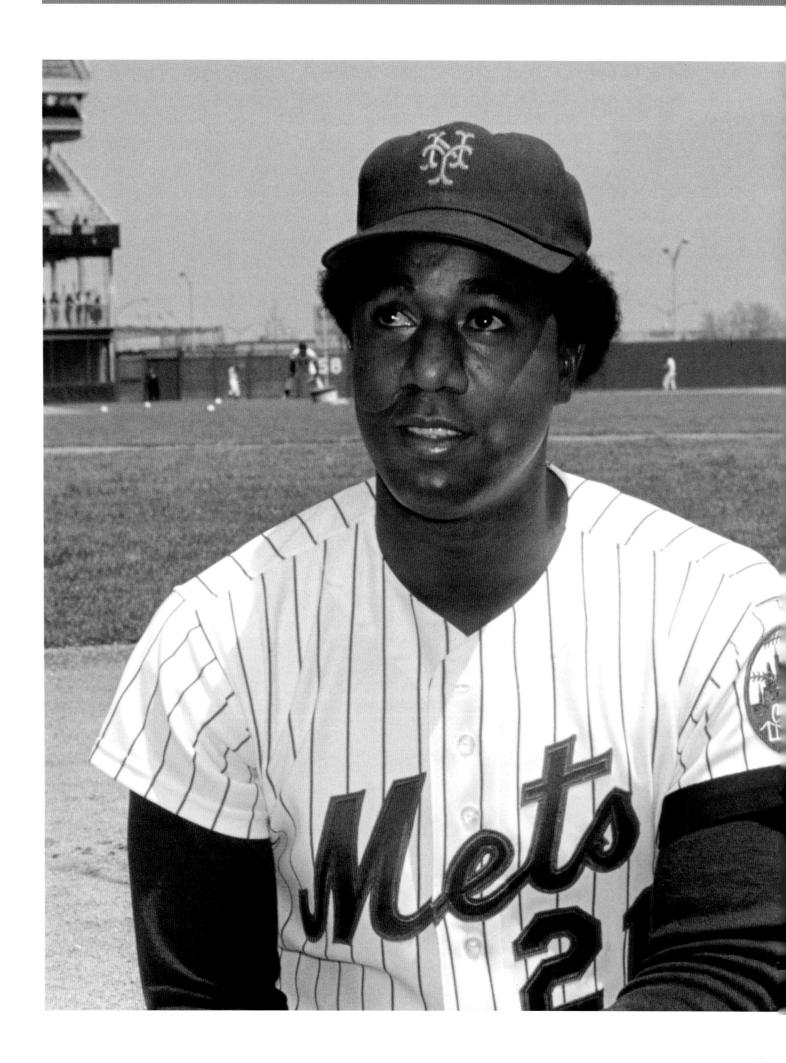

CLEON JONES

» **Outfielder 1963, 1965–1975**

» **New York Mets Hall of Fame 1991**

Cleon Jones memorably caught the final out of the Miracle Mets' World Series victory in 1969, but his career was much more than one moment. Jones hit .340 during that championship season and received an All-Star berth. Jones played 12 years for the Mets and finished in the top 10 in batting average three times. When Jones retired in 1976, he was the Mets' all-time leader in many offensive categories and still ranks among the top 10 in a dozen categories, including games played, runs scored and base hits. Jones has spent his post-baseball career refurbishing homes, combatting blight and providing youth programs in his home state of Alabama.

Jones finished third in batting in the NL in 1969, behind only Pete Rose and Roberto Clemente.

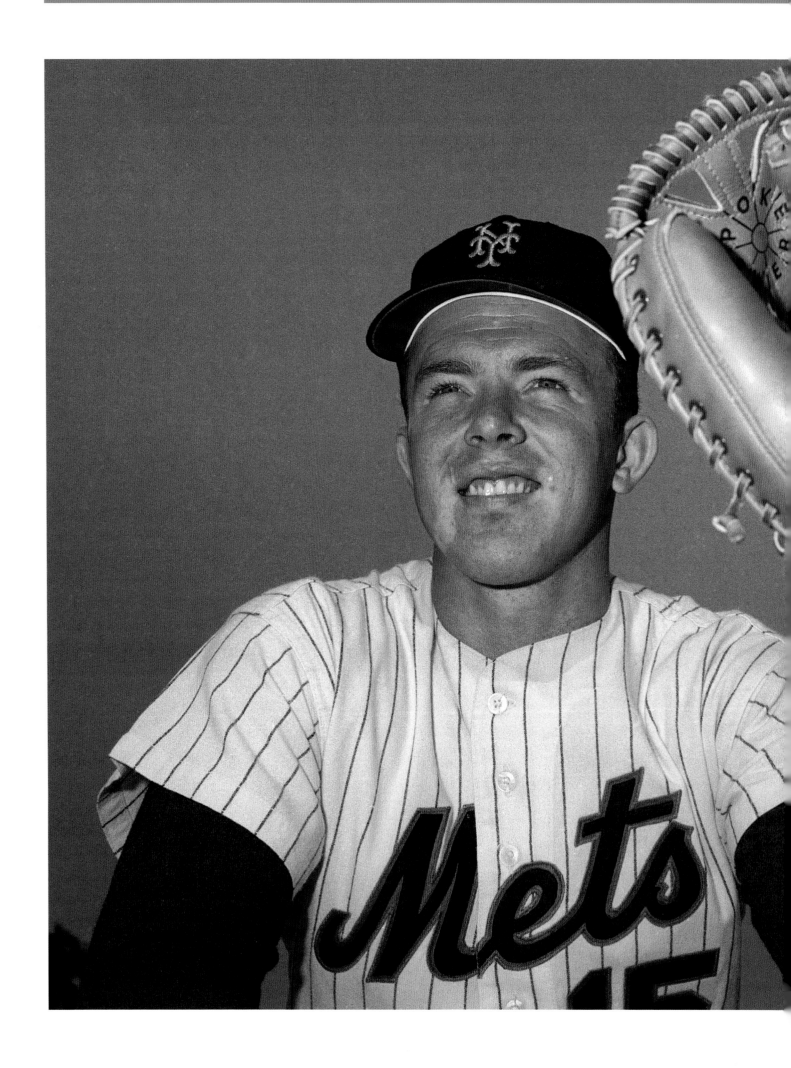

JERRY GROTE

» Catcher 1966–1977

» New York Mets Hall of Fame 1992

One of the best defensive catchers of his era, Jerry Grote caught every inning of the Mets' World Series appearances in 1969 and 1973. In 1968 he earned the first of his two All-Star appearances while hitting .282. The next season he was an integral part of the Mets' championship team, posting a .991 fielding percentage and guiding a young Mets pitching staff, which went on to lead the NL in wins, shutouts and was second in ERA. Though known for his defense, Grote doubled to start the 10th inning in Game 4 of the 1969 World Series, and the pinch runner who replaced him came around to score the winning run.

Of the two World Series teams he was a part of, Grote said, "[The 1969 season] was no miracle. Now, '73 was a miracle."

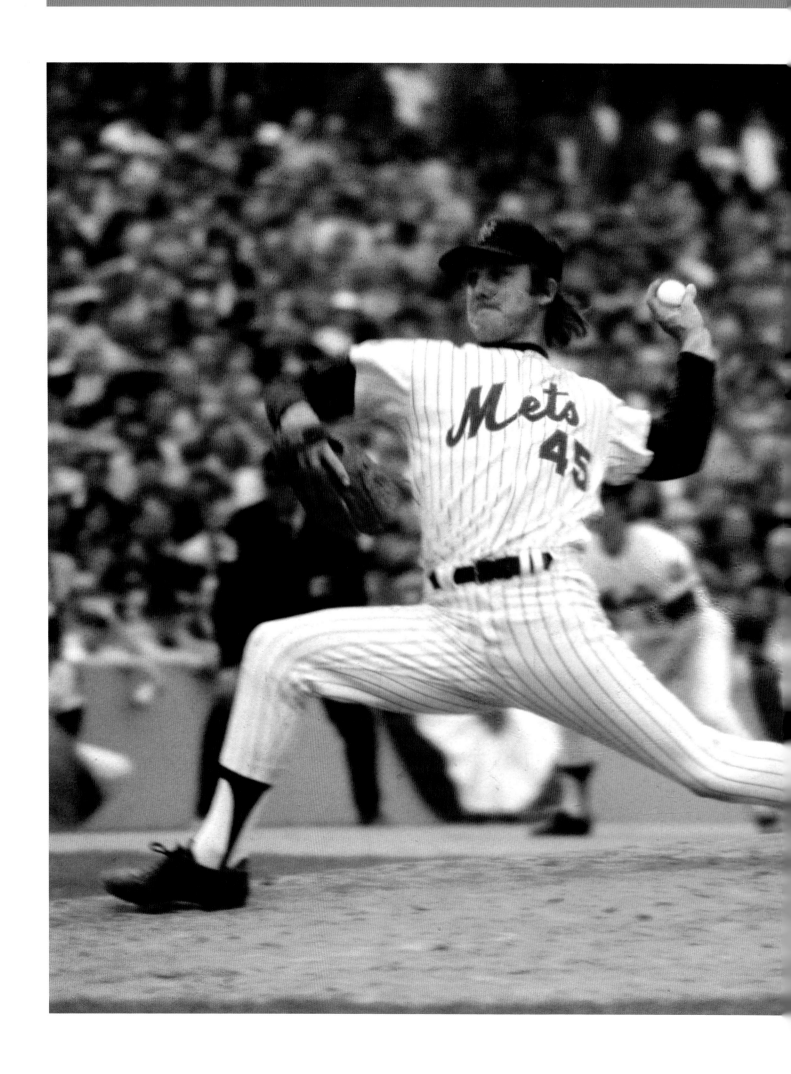

TUG McGRAW

» Pitcher 1965–1967, 1969–1974
» New York Mets Hall of Fame 1993

Tug McGraw's career started slowly as he alternated between pitching as a starter and out of the bullpen. He appeared sparingly during the 1969 postseason but really came on as a pitcher in 1971 and 1972, finishing both seasons with a 1.70 ERA. The next year, while Mets chairman M. Donald Grant was trying to encourage the team at a July 9 team meeting, McGraw shouted, "Ya gotta believe!" That became the rallying cry for the Mets' charge back to the World Series. McGraw continued his stellar pitching into the postseason, throwing five innings over two games in the NLCS without giving up a run. He then appeared in five of the seven games of the World Series against the Oakland A's. McGraw was the last active major leaguer to have played under famed manager Casey Stengel.

McGraw was born Frank Edwin McGraw Jr. in California in 1944.

MOOKIE WILSON

» Outfielder 1980–1989

» Coach 1997–2002, 2011

A speedy switch hitter, Mookie Wilson played 10 years with the Mets, and in 1984 he became the team's all-time stolen base leader, though José Reyes has since surpassed him. Despite suffering an eye injury, he posted a .979 fielding percentage in 1986, and he batted .289 with nine home runs and 45 RBIs. But he will always be remembered as the player who hit the ground ball that rolled through the legs of Boston's Bill Buckner in the bottom of the 10th inning in Game 6 of the 1986 World Series. With the Mets trailing 5–4, Wilson battled through a 10-pitch at-bat against Boston's Bob Stanley. First, Wilson avoided being hit by a wild pitch that scored Kevin Mitchell to tie it. Three pitches later, he hit a slow roller to Buckner at first base. Buckner saw the ball pass through his legs, allowing Ray Knight to score the winning run. The Mets won the World Series two days later in Game 7.

Wilson is second on the Mets' all-time leaderboard in both stolen bases and triples.

KEITH HERNANDEZ

» First Baseman 1983–1989

» Broadcaster 2006–present

After multiple disagreements with St. Louis Cardinals management and admitted issues with drug use, Keith Hernandez was traded to the Mets in June of 1983 for pitchers Neil Allen and Rick Ownbey. It ended up being one of the best trades in Mets history. The first baseman on the 1986 World Series champions, Hernandez made three All-Star teams with New York, and his batting average surpassed .300 four times. One of the best defensive first basemen of all time, Hernandez won five of his 11 Gold Gloves while with the Mets. Known for his work-hard, play-hard style, Hernandez was a media darling. After his playing career ended in 1989, Hernandez remained in the spotlight. He had a memorable guest appearance on *Seinfeld* and is currently a Mets color commentator for SportsNet New York alongside his former teammate, Ron Darling.

In 1987, manager Davey Johnson named Hernandez the first captain in Mets history.

GARY CARTER

» Catcher 1985–1989

» National Baseball Hall of Fame 2001

One of only four players to be named captain of the Mets, Gary Carter was an instrumental part of the 1986 World Series winners. Known as "the Kid" for his seemingly boundless energy and enthusiasm, Carter won three Gold Glove Awards with the Montreal Expos before being traded to the Mets after the 1984 season. In his first season in New York, he finished sixth in NL MVP voting; the next season, he drove in nine runs and helped lead the team to its victory over the Boston Red Sox in the World Series. In 2001, Carter was inducted into the Mets Hall of Fame; two years later, he was enshrined in Cooperstown.

Carter passed away in 2012; SI's Tom Verducci wrote, "This world, not just this little game, is less sunny without him."

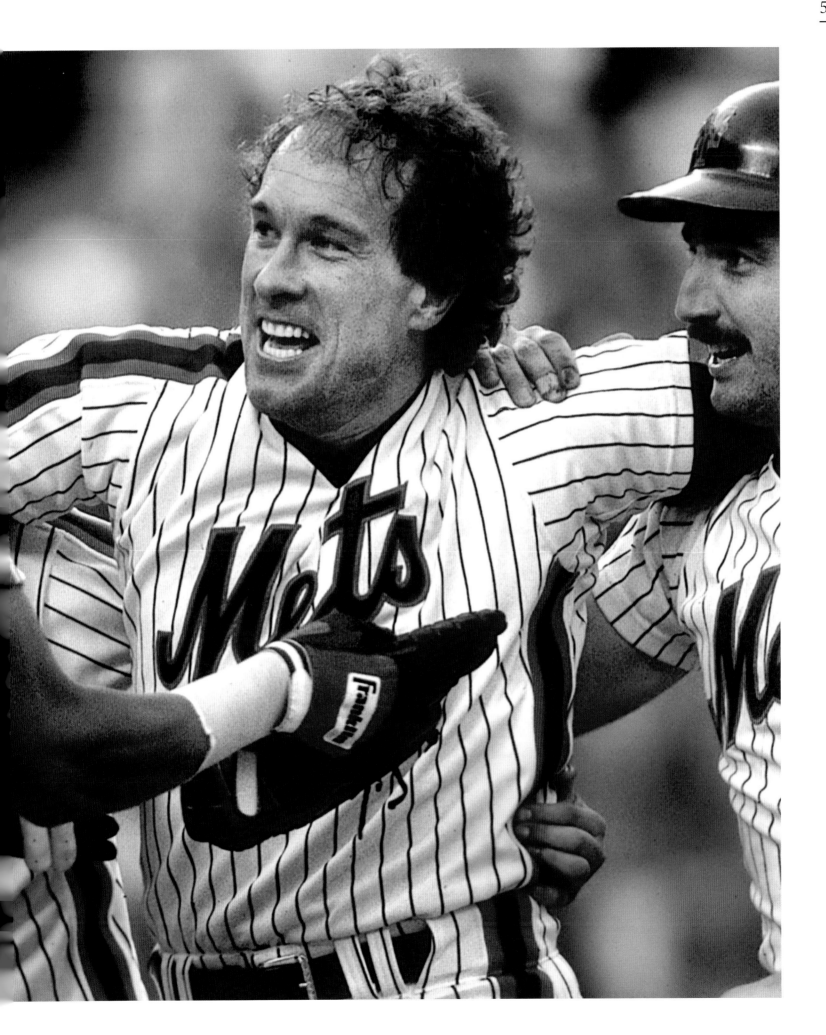

TOMMIE AGEE

» Outfielder 1968–1972

» New York Mets Hall of Fame 2002

Tommie Agee played five seasons for the Mets, highlighted by his 26-home-run performance in 1969. But he'll always be remembered for his incredible plays in Game 3 of that year's World Series against Baltimore. In the bottom of the first inning, Agee homered off future Hall of Fame pitcher Jim Palmer to give the Mets the lead. Up 3–0 in the fourth, Agee chased down a ball in left-center off the bat of catcher Elrod Hendricks and made a backhanded catch to end an Orioles threat. In the seventh, Baltimore's Paul Blair came to the plate with the bases loaded against New York's Nolan Ryan. This time, Agee raced all the way into right-center to make a diving, sprawling catch to keep the Mets in front. New York went on to win that game, as well as Games 4 and 5, to claim the franchise's first championship. The American League Rookie of the Year in 1966 as a member of the Chicago White Sox, Agee passed away in 2001 at the age of 58. He was posthumously inducted into the Mets Hall of Fame in 2002.

Agee hit .357 with two home runs in the 1969 NLCS against the Braves.

FRANK CASHEN

» GM/COO, 1980–1991

» New York Mets Hall of Fame 2010

After building the Baltimore Orioles into a two-time World Series champion in the late 1960s and early '70s, Frank Cashen joined the Mets in 1980 looking to do the same in New York. Cashen was at the helm when the team selected the talented but raw Darryl Strawberry first overall in the 1980 MLB draft and young pitcher Dwight Gooden fifth overall in 1982. Hiring manager Davey Johnson in 1984 completed the nucleus of the group that would go on to win the 1986 title. Though the Mets never reached the pinnacle again during his tenure, which ended in 1991, Cashen's seven-year run remains the most successful in franchise history, with the club averaging more than 95 wins per season. He was inducted into the team's Hall of Fame in 2010, along with fellow 1986 World Series linchpins Johnson, Gooden and Strawberry.

Before his career in baseball, Cashen was a sportswriter for nearly two decades with the *Baltimore News-American*.

DWIGHT GOODEN

» **Pitcher 1984–1994**

» **New York Mets Hall of Fame 2010**

All Dwight Gooden did in his rookie season in 1984 was earn an All-Star nod, capture the NL Rookie of the Year award and lead the league in strikeouts—demonstrating why the Mets had promoted him from High A to the major leagues just one year after drafting him fifth overall in 1982. "Doc" followed up with an ascendant 1985 season that saw him become the youngest player ever to win the Cy Young Award, and earned a Triple Crown by leading the league in wins, strikeouts and ERA. In 1986, Gooden was the team's ace as they charged to 108 wins during the regular season and a World Series championship that fall. His struggles with addiction cut his spectacular career down in its prime, and he departed the Mets after the strike-shortened 1994 season.

Gooden is second in Mets history in both career strikeouts and victories, behind Tom Seaver.

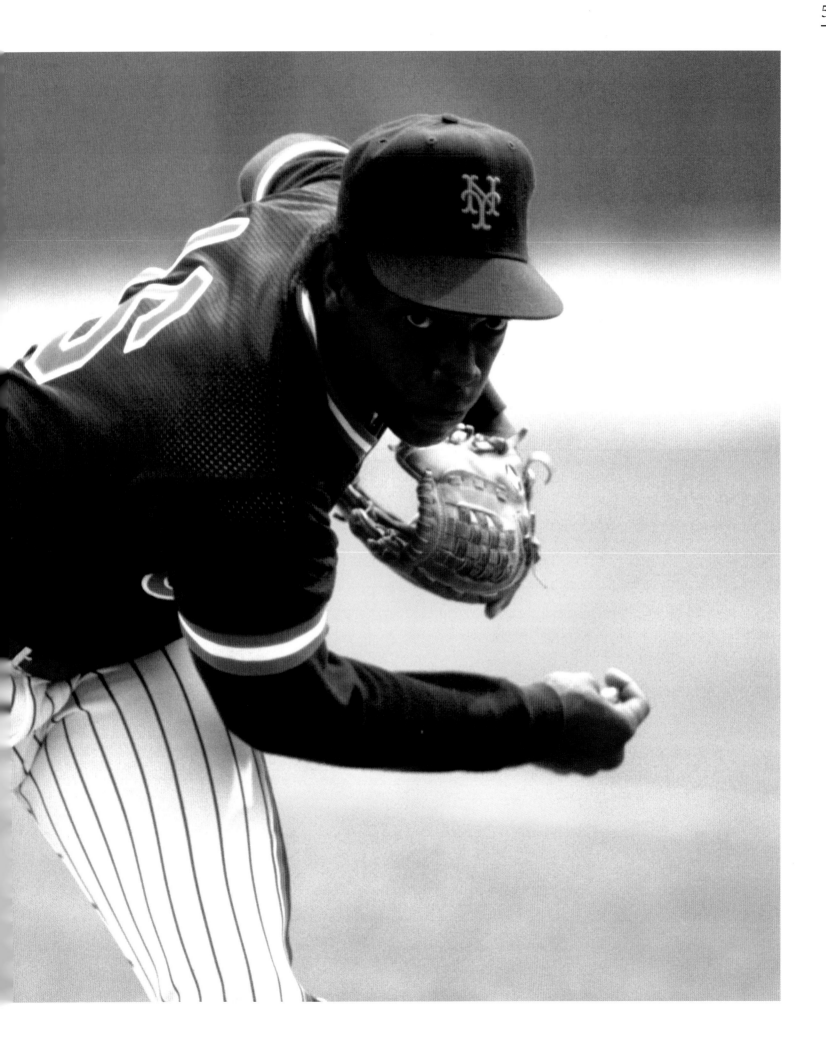

DAVEY JOHNSON

» Manager 1984–1990
» New York Mets Hall of Fame 2010

Only two men can say they managed the New York Mets to a World Series title—Gil Hodges and Davey Johnson. The career second baseman, three-time All-Star and two-time Gold Glove Award winner celebrated two World Series titles with the Baltimore Orioles before joining the Mets in 1984, his first stint as an MLB skipper. Johnson's Mets began their climb from a sub-.500 team to winning 90 games in Johnson's first season, 98 in his second and an MLB-best 108 in 1986. The last time the Mets had won 100 games, in 1969, they'd won the World Series; the same would hold true for Johnson's 1986 team, which defeated the Boston Red Sox in seven games. Johnson was fired in 1990 but remains the club's winningest manager of all time (595–417).

Johnson was named AL Manager of the Year in Baltimore in 1997 and the NL Manager of the Year in Washington, D.C., in 2012.

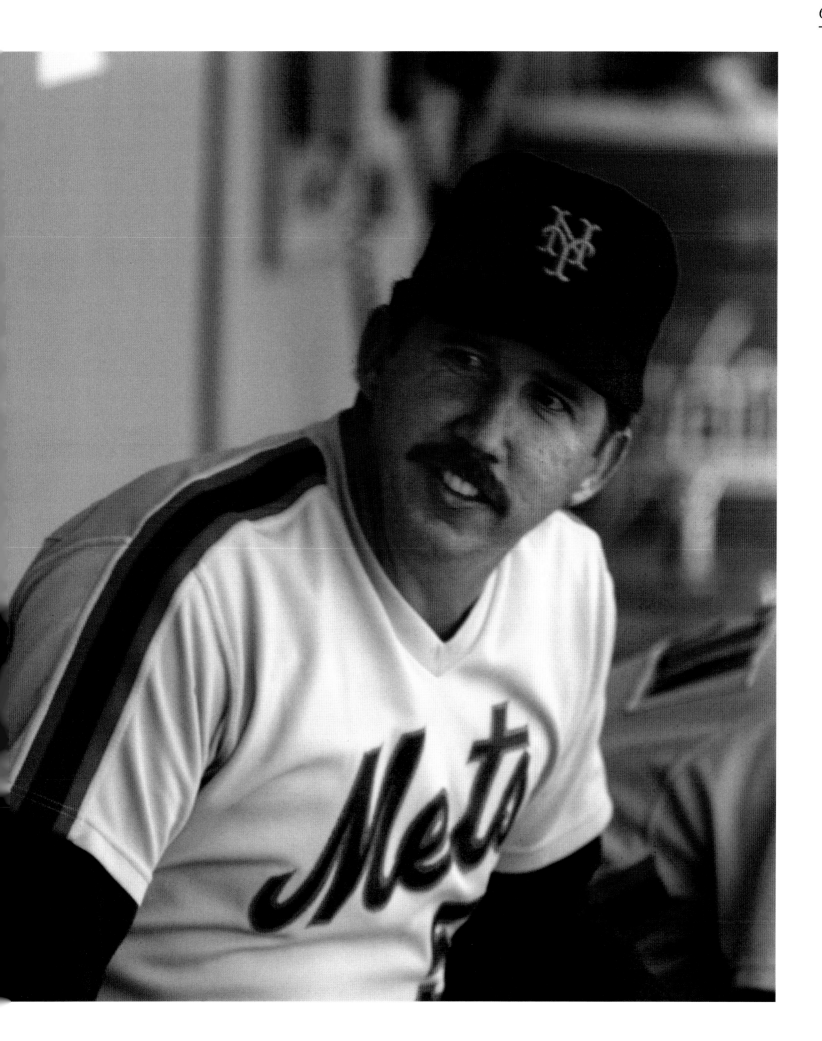

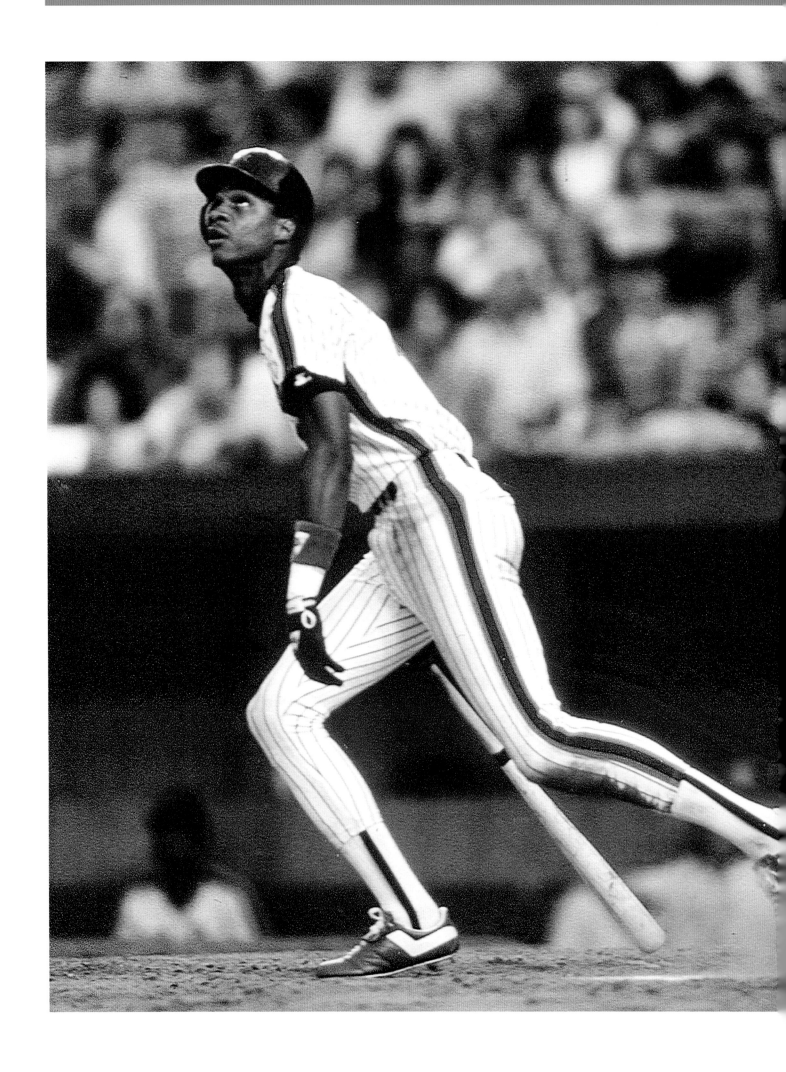

DARRYL STRAWBERRY

» Outfielder 1983–1990

» New York Mets Hall of Fame 2010

Darryl Strawberry was the NL Rookie of the Year in 1983, thanks to his 108 hits, 26 home runs, 74 RBIs and 19 stolen bases. The imposing slugger was a fan favorite and a major contributor to their 1986 World Series title, with 27 home runs and 93 RBIs that season. In 1987, Strawberry joined the exclusive 30-30 club with 39 home runs and 36 stolen bases, and then led the NL in home runs in 1988. Strawberry struggled with substance abuse during his years with the Mets and beyond, and he battled colon cancer twice. He returned to the Mets as an instructor in 2005 and 2008 and was inducted into the team's Hall of Fame in 2010.

Strawberry retired with 335 career home runs, 252 of them with the Mets.

JOHN FRANCO

» Pitcher 1990–2004

» New York Mets Hall of Fame 2012

John Franco played 21 seasons in the major leagues, 14 of them for the Mets. The left-handed reliever was traded to the Mets in 1989 and set about making his mark immediately, earning Rolaids Relief Man of the Year honors and leading the league in saves in 1990. New York honored him by holding a "John Franco Day" celebration to mark his 300th save, in 1996. Franco eventually became a team captain and remained with the Mets until 2004. He ranks fifth on baseball's all-time career saves list, with 424.

A Brooklyn native, Franco is the only pitcher to be named captain of the Mets.

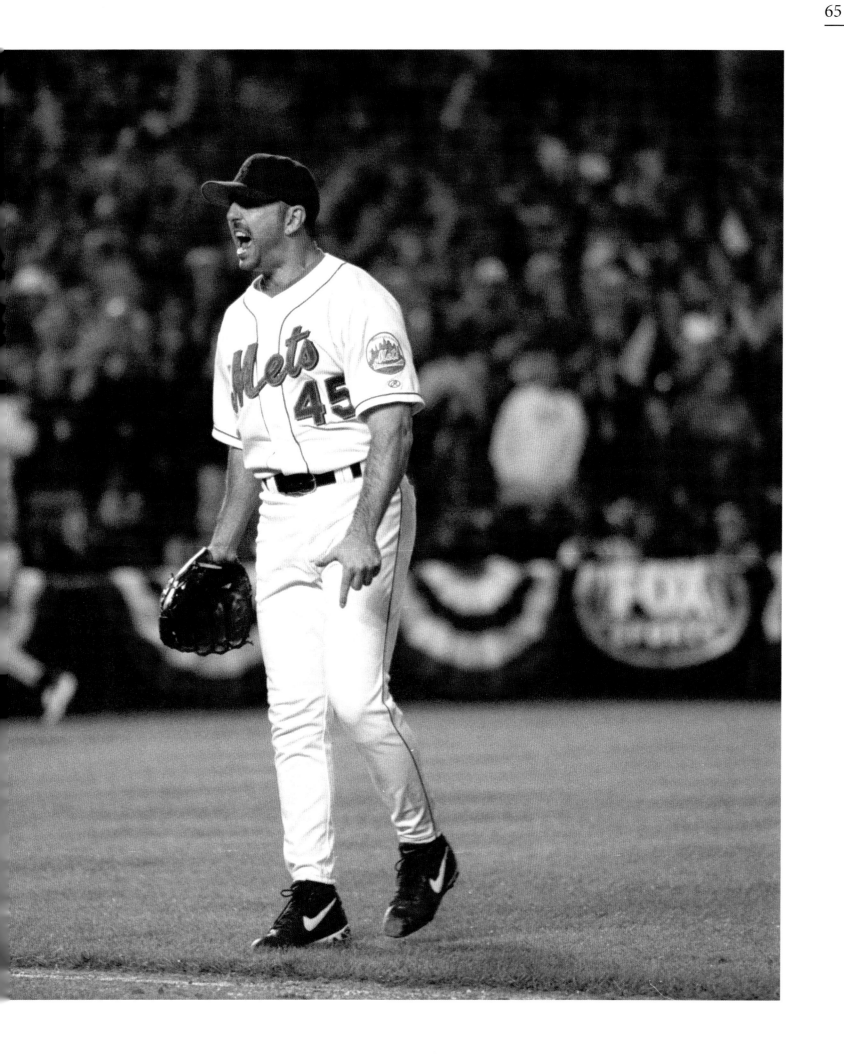

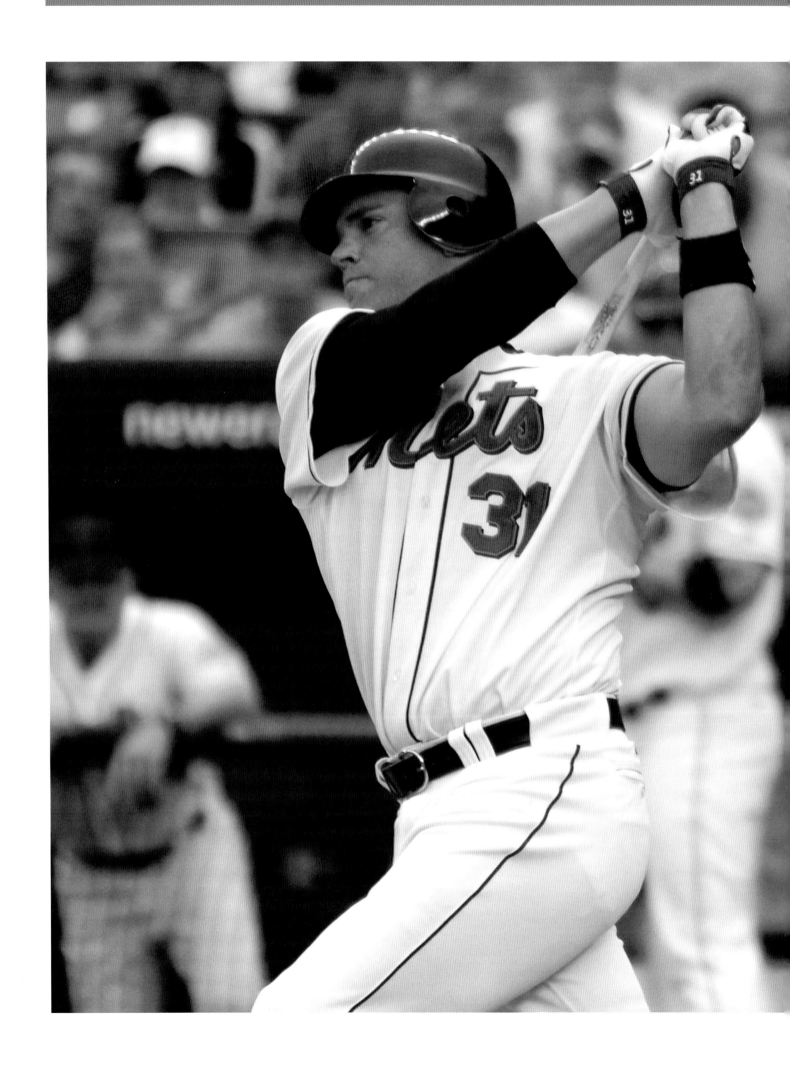

MIKE PIAZZA

» Catcher 1998–2005

» National Baseball Hall of Fame 2016

Mike Piazza endures as one of Major League Baseball's greatest underdog stories. Selected by the Los Angeles Dodgers in the 62nd round of the 1988 MLB draft, Piazza started his minor league career at first base but converted to catcher at manager Tommy Lasorda's urging. The NL Rookie of the Year in 1993 was traded to the Mets in 1998 and made an immediate impact, helping the team reach the 2000 World Series. One of the few club standouts to be enshrined in the Baseball Hall of Fame as a Met, Piazza earned five of his 10 career Silver Slugger awards in New York. Regarded as one of the best offensive catchers the game has ever seen, Piazza had his No. 31 retired by the Mets in 2016.

After the Mets played their last game at Shea Stadium in 2008, Piazza caught the ceremonial final pitch from Hall of Famer Tom Seaver.

EDGARDO ALFONZO

» Infielder 1995–2002

» New York Mets Hall of Fame 2021

After making his major league debut in 1995, Edgardo Alfonzo spent most of his first few seasons with the Mets patrolling the third base line. "Fonzie" emerged as a cornerstone of the club, coming in second in the NL Gold Glove voting in both 1997 and 1998. Alfonzo was initially unhappy about moving to second base after the team signed third baseman Robin Ventura in 1998, but his production quickly skyrocketed. In 1999, he set career highs in home runs (27) and RBIs (108), batting .304 and slugging .502 to win the NL's Silver Slugger award for second basemen. Injuries affected Alfonzo's game during his final years in New York, though his 29.7 career WAR as a Met ranks seventh in franchise history.

Alfonzo wore #13 in honor of another Venezuelan-born shortstop, Dave Concepción.

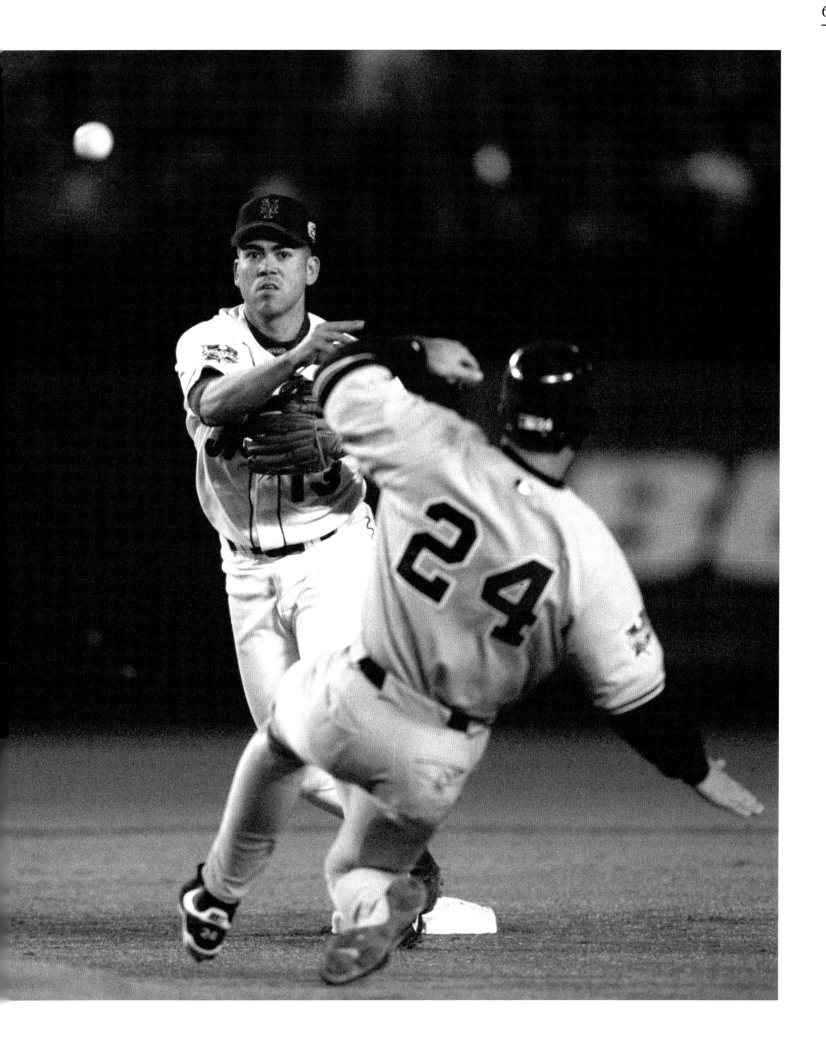

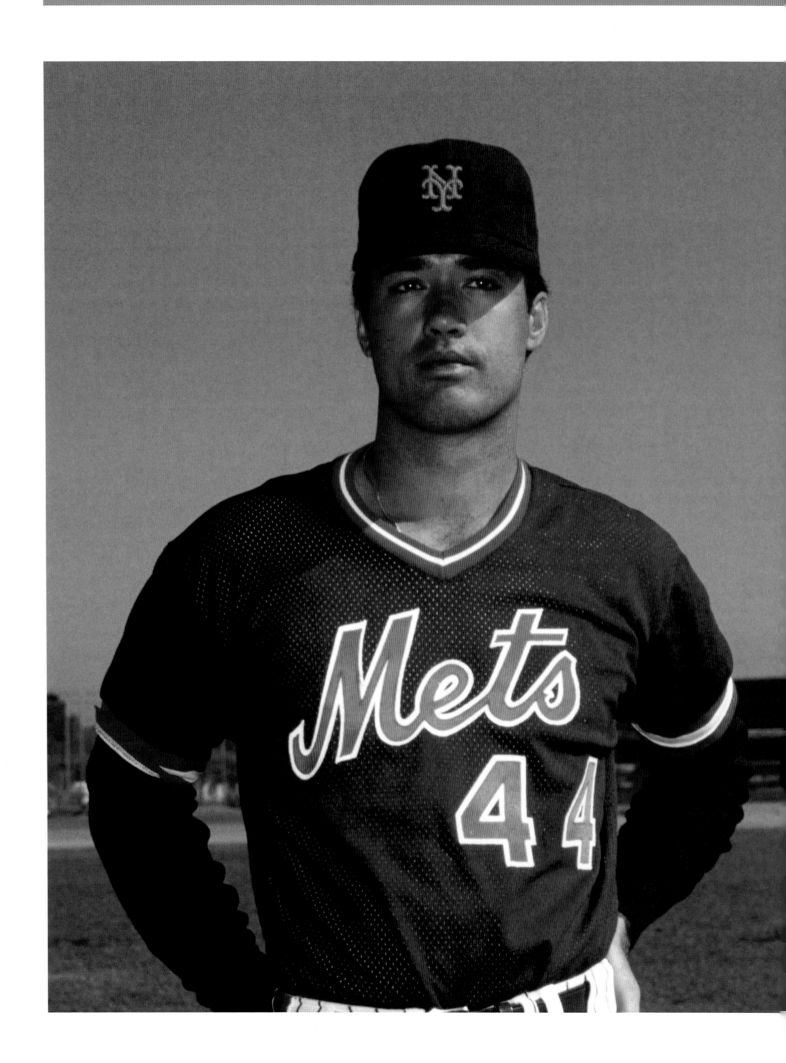

RON DARLING

» Pitcher 1983–1991

» Broadcaster 2006–present

Ron Darling has been writing the most recent chapter in his career as the Emmy Award–winning Mets color commentator on SNY broadcasts alongside fellow 1986 World Series champion Keith Hernandez, and on national broadcasts for TBS. But Mets fans have bookmarked the chapter he wrote as a member of the team's pitching staff from 1983 to 1991, a tenure that saw him earn a spot in the All-Star Game, win the 1989 Gold Glove Award and, of course, help lead the team to its unforgettable World Series title in 1986. That season, Darling posted a career-best 2.81 ERA—which improved to 1.53 in the final series against the Boston Red Sox—and finished fifth in the Cy Young Award voting. Darling still ranks fourth in Mets team history in wins, with 99. In 2021, he was inducted into the Mets Hall of Fame.

Darling played football at Yale University before leaving the team to focus on baseball.

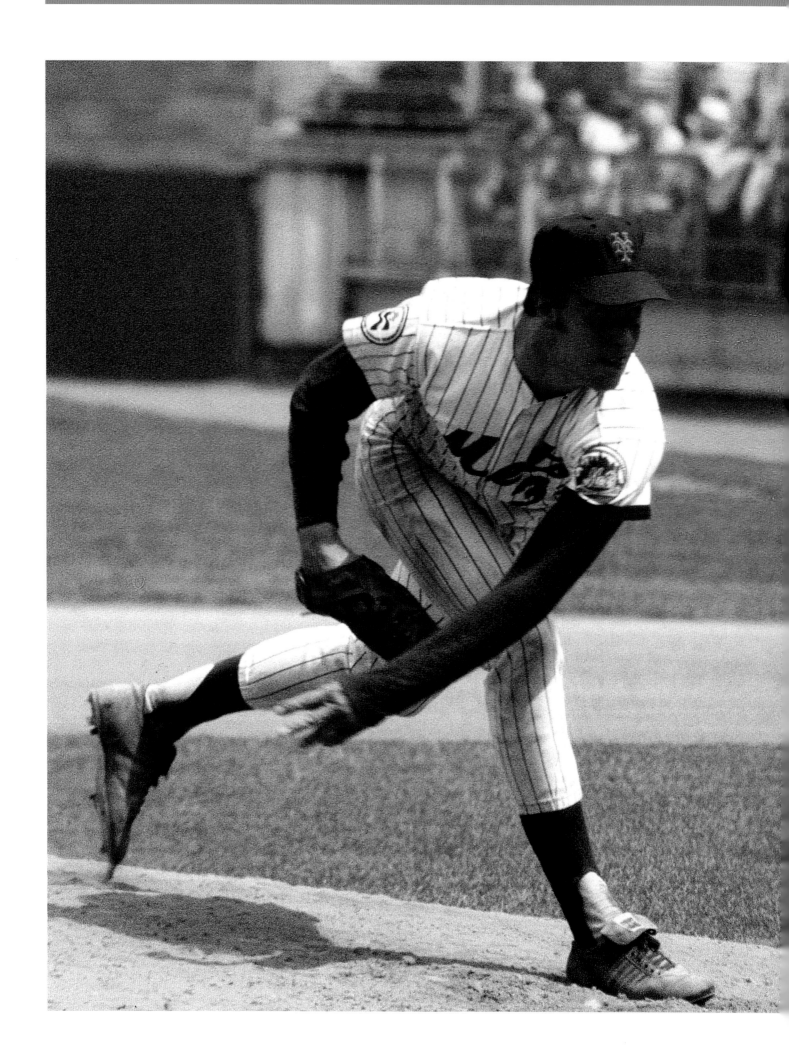

JON MATLACK

» Pitcher 1971–1977
» New York Mets Hall of Fame 2021

Drafted by the Mets in 1967, Jon Matlack ranks among the top 10 in franchise history in wins, ERA, complete games, strikeouts, shutouts and innings pitched. He was the NL Rookie of the Year in 1972, and in 1973, alongside Tom Seaver and Jerry Koosman, helped the Mets clinch the pennant and another trip to the World Series. Matlack earned three All-Star Game selections between 1974 and 1976.

Matlack led the NL in shutouts in both 1974 and 1975.

THE STORIES

The Mets' history is a rich one, filled with great characters and memorable games. SPORTS ILLUSTRATED has written about it extensively over the years

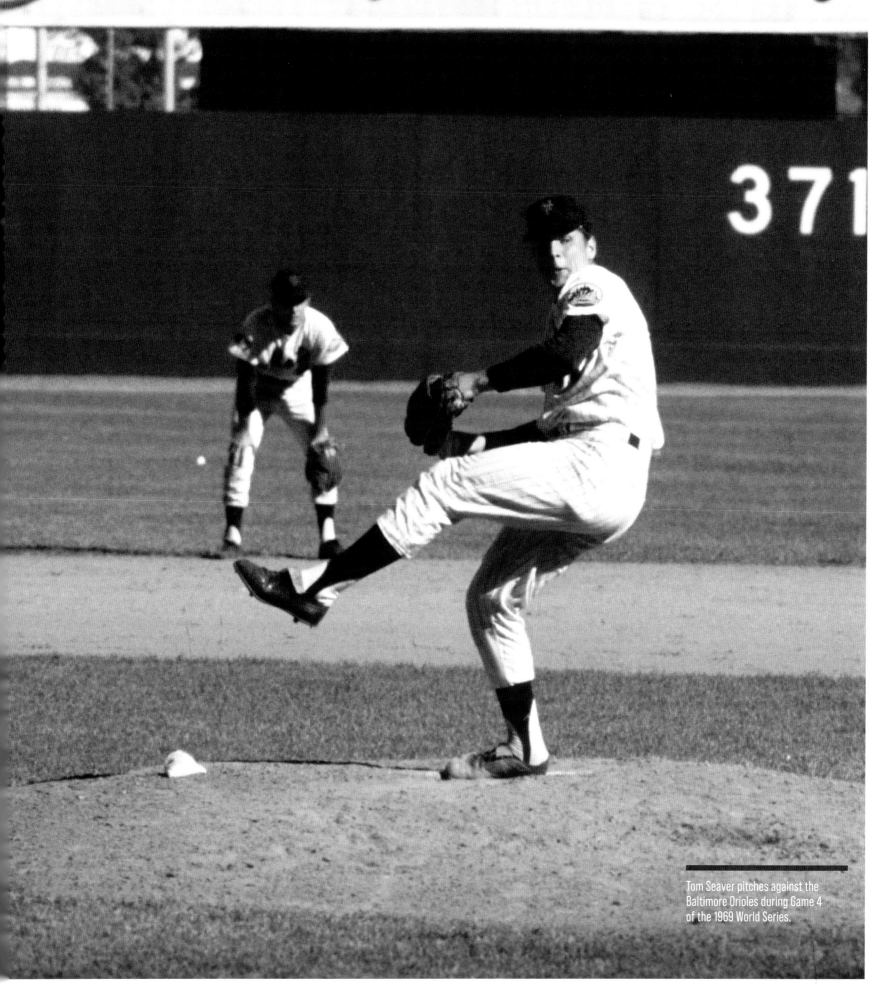

Tom Seaver pitches against the Baltimore Orioles during Game 4 of the 1969 World Series.

Excerpted from SPORTS ILLUSTRATED, May 25, 1992

BAD BEYOND BELIEF

In 1962, the newborn New York Mets made baseball history of the most dubious kind

by STEVE RUSHIN

Q: *What is there to say about a man who couldn't make the worst baseball team of this century?*
A: *That he didn't want to play badly enough.*

Evans Killeen was cut from the 1962 New York Mets. The pitcher sliced open his thumb while shaving on the morning of a scheduled spring training start. The Mets cut the righthander when he couldn't satisfactorily explain why, exactly, he was shaving his thumb.

Steve Dillon did not make the 1962 Mets. But manager Casey Stengel saw something in the lefthander that nobody else did, and he promoted him the following season. "Dillon probably shouldn't have been up there," recalls Craig Anderson, who pitched for the Mets from 1962 to 1964. "But Stengel was real big on him. Dillon was Stengel's middle name, you know."

Craig Anderson, of course, did make the 1962 Mets. Pitching in relief, Anderson won both halves of a doubleheader against the Milwaukee Braves on May 12 of that season to run his record to 3–1. Anderson *never won another game in his career*, which ended with *19 consecutive losses* spread over parts of

three seasons. Pardon my italics, but such factoids as these fairly demand the *Ripley's Believe It or Not* treatment.

Three decades have done nothing to diminish how bad the Mets were in 1962, the franchise's first season. Those Mets were bad like God is good: Their badness will endure forever. "I get three to five letters every day," says Marvin Eugene Throneberry, the Mets first baseman whose monogram and misadventures afield made him a mascot for the '62 season. "I throw 'em all in a box. When it rains, I answer 'em. No, I never thought it would carry on this long."

To understand why a 58-year-old salesman for the Active Bolt & Screw Company is up to his knees

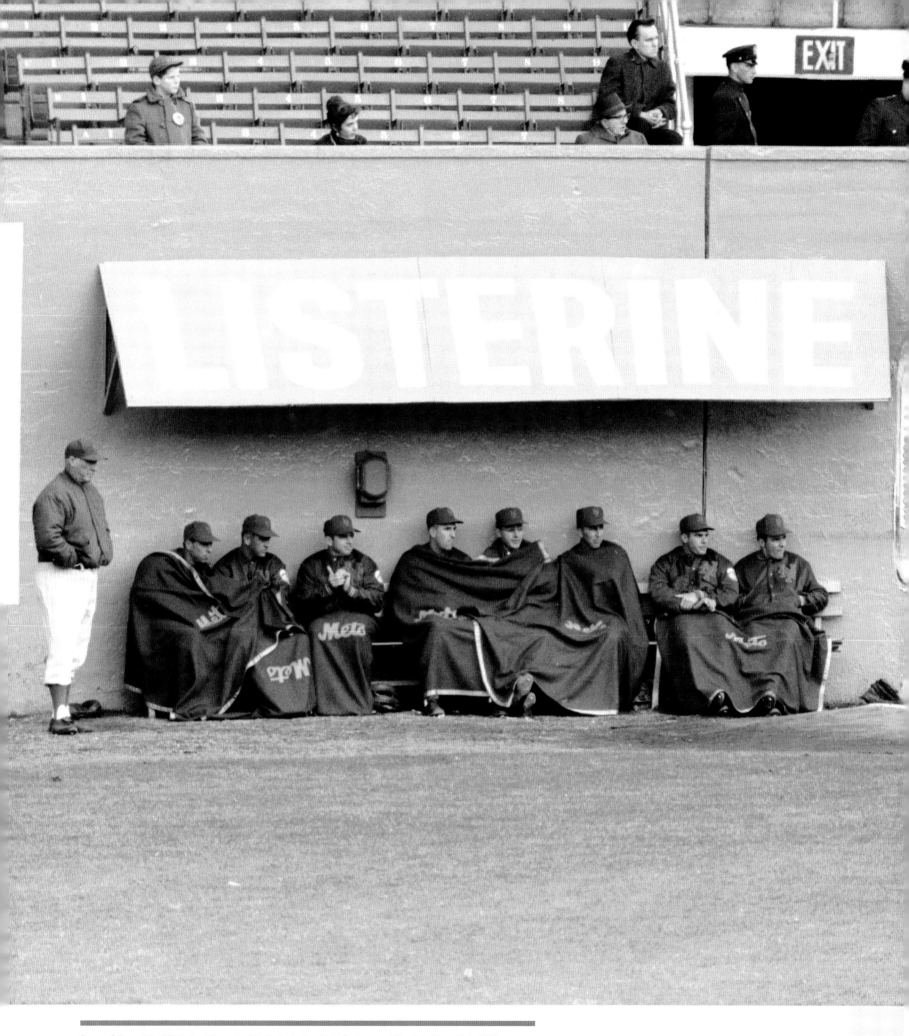

Some of the original Mets huddle under blankets during their first year at the Polo Grounds in 1962.

in S.A.S.E.'s at his home in Collierville, Tenn., one must understand those expansion Mets embodied by Marvelous Marv. And frankly, that summer of '62 is as difficult to fathom as a Stengel soliloquy. So if this backward glance at that season jumps ahead of itself occasionally or doubles back in spots or tends to ramble here and there, well, it could be no other way.

Stengel-like, the story often makes no sense whatsoever. Nine games into the 1962 season, for instance, the Mets were *nine-and-a-half* games out of first. Is that possible? In 15 tries, the Mets never once won on a Thursday. Bad? The team was mathematically eliminated from the pennant race on Aug. 7.

This is true—cross my heart, hope to die, stick a needle in my eye: The '62 Mets continued to lose ground in the National League standings *after* the season had ended. Is *that* possible? As we shall discover, it was possible for the Mets, whose record of 40–120 left them 60½ games behind the first-place San Francisco Giants.

Thus, being cut from the '62 Mets was to low self-esteem what the Buick Roadmaster was to low gas mileage. A snub from that club was like having a Hare Krishna on your threshold say that no, really, he couldn't possibly come in for coffee.

Or was it? In hindsight, who would you rather be, the standby passenger who was bumped from the Hindenburg or one of the chaps who went down with the zeppelin? "Oh, I'm glad that season was a part of my career," says the genial Anderson, now an associate athletic director and assistant baseball coach at Lehigh University. "I got to play with Gil Hodges. I got to meet Stan Musial. I got to play for Casey Stengel. I still get letters. How many people can say they were in a ticker-tape parade through New York City?"

Oh, the humanity. The Mets' home opener that April was scheduled for—and these stories have been fact-checked for accuracy; we do not make them up—Friday the 13th, at the Polo Grounds, the Mets' unlucky horseshoe in Harlem. On April 12 the Mets were given a ticker-tape parade up lower Broadway, culminating with ceremonies at City Hall. Among the dignitaries on the rostrum was William Shea. A local attorney and civic leader, Shea was the man most responsible for bringing National League baseball back to New York following the westward flight of the Dodgers and Giants four years earlier.

"At City Hall, Bill Shea—who was lionized in New York—made a speech in which he apologized for the players," recalls Richie Ashburn, the centerfielder who would be dubiously distinguished at season's end, named as the Most Valuable Player on the worst team of this century. "It still sticks in my craw. Before we had played a single home game, Shea told the fans, 'Be patient with us until we can bring some real ballplayers in here.' And the players—we were standing right there! I mean, he was probably right, but he didn't have to say it."

Ticker tape. Nineteen sixty-two was the dusk of that innocent postwar age when America's leading industrial product was … the hyphen. Remember? The U.S. was a veritable Hyphen-Nation of Ban-Lon and Sen-Sen and La-Z-Boys and Speedy Alka-Seltzer and un-American activities and movies like *Ben-Hur.*

And so the expansion Mets would stay at the Hi-Way House in Houston when they played the league's other expansion team, the Colt .45s. Little news nuggets about the team were tacked onto the end of longer stories in New York City newspapers, beneath bizarre column subheads like "Met-Ro-Nomes," "Met-a-Morphoses," "Met-Cellaneous," metc.

And from the very start, the New York pitching staff would induce runs like Met-a-Mucil. Opening Day starter Roger Craig and more than a dozen other Mets were stranded in an elevator for 30 minutes at the Chase Hotel in St. Louis, where the Mets were to begin the season against the Cardinals. Going down? Indeed. Rained out on Tuesday, the New York Mets debuted on Wednesday, April 11: Craig lasted three innings and balked in one run. His teammates committed three errors. The Cards won 11–4.

It was the first of Craig's 24 losses in 1962. Now the manager of the Giants, Craig recalls with humility pitching against the pennant-winning Giants of Willie Mays and Willie McCovey 30 seasons ago. "We would have pitchers' meetings before every series, and we would go over the scouting report," Craig

remembers. "One time when the Giants came to town, Stengel asked me, 'Mr. Craig, where would you like us to defense McCovey: upper deck or lower deck?'"

They say the best things in life are free, but the worst things, it turns out, also come pretty cheap. Mets owner Joan Payson had spent a trifling $50,000 as a fee for the franchise, a mere $1.8 million in payments to other clubs for players in the expansion draft, and all of $600,000 in salaries to field her team. Of course, general manager George Weiss was tighter than a Speedo two sizes too small. In making a salary offer that spring, he is said to have egregiously lowballed traveling secretary Lou Niss, then conspiratorially whispered these words of encouragement: "You know, traveling secretaries are usually voted a full World Series share."

So Mets management got what it didn't pay for. On Opening Night, Hobie Landrith was Craig's batterymate, and what an apt term *that* was. Gil Hodges, the erstwhile Brooklyn Dodger star who had just turned 38, was at first base. Charlie Neal was the second baseman. Felix Mantilla was at short. Don Zimmer played third base. The leftfielder was Frank Thomas. Ashburn, 35, was the centerfielder. And the rightfielder was … the rightfielder was …

Understand that Stengel had trouble with names the way Ronald Reagan has trouble with dates. When Stengel was hired at the age of 72 to be the Mets' first manager, he told the press that he was delighted to be taking over "the Knickerbockers" and playing in "the Polar Grounds."

And while Stengel had two pitchers named Bob Miller on his team—they were roommates on the road, in fact—he called one of them Nelson. Still, it is startling to see Stengel on a flickering black-and-white television screen during that first week of the '62 season trying to name his starting lineup for broadcaster Lindsey Nelson. Stengel makes it all the way to his rightfielder before treading air.

"He's a splendid man and he knows how to do it," says Casey on camera. "He's been around and he swings the bat there in rightfield and he knows what to do. He's got a big family and he wants to provide for them, and he's a fine outstanding player, the fella

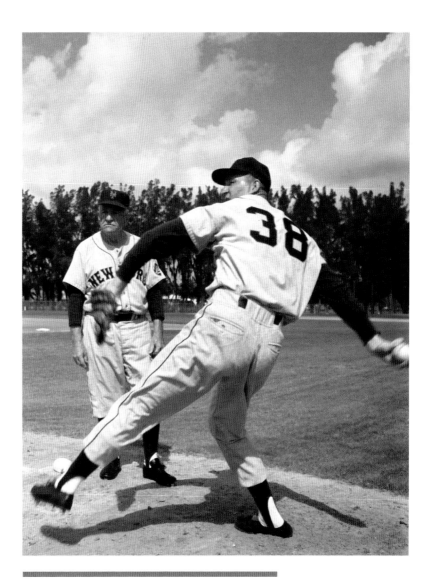

Manager Casey Stengel watches pitcher Roger Craig at spring training.

in rightfield. You can be sure he'll be ready when the bell rings—and that's his name, *Bell*."

Having returned from the Wednesday game in St. Louis to be disparaged at their own parade on Thursday, Gus Bell and the rest of the Mets then lost their first home game, amid snow flurries at the Polar Grounds on Friday the 13th. Still, advance sales were as brisk as the weather at the Mets' Manhattan ticket office, located seven blocks from the Metropolitan Opera in the Hotel Martinique. Legend has it that an opera buff mistook the Mets'

ticket window for the Met's ticket window one spring day, requested "two for *Traviata*" and was asked by an eager-to-please Mets employee: "First base or third base side?"

Apocryphal, you say? Hey, don't rain on our parade. Bill Shea did that once already.

———————————

Remember Miss Rheingold? Remember King Korn trading stamps? Remember when Ford Frick was baseball commissioner? Remember when people had names like Ford Frick? Remember cruising with the top down in your Ford Frick?

If so, you may also remember that the Mets began the '62 season 0–9. And because the Pirates got out of the gate 10–0, New York was indeed 9½ games back after playing only nine. In fact, the Mets beat those Bucs on April 23 for their first win, 9–1 on Ladies Night at Forbes Field. The following day Frick fined Stengel $500 for appearing in uniform with the voluptuous Miss Rheingold in a Rheingold Extra Dry Lager ad. Why ask why?

Two days later the Cleveland Indians announced that they had traded catcher Harry Chiti to the Mets for a player to be named later. The deal would not be completed until June 15, when Chiti was returned to the Tribe as the player named in compensation for himself. That's when the New York media—tough crowd, the New York media—suggested that the Mets had been fleeced in the Chiti-for-Chiti swap. And thus began a Mets tradition that continues to this day, in which fans in the street endlessly second-guess the team's front office. *Yo, I can't believe Weiss couldn't get more for Harry Chiti than, you know ... Harry Chiti.*

Chiti, by the way, was one of seven catchers who would do time with the Mets in 1962. Hobie Landrith, another, had been the Mets' very first selection in the expansion draft. "You gotta start with a catcher or you'll have all passed balls," explained Stengel, who then, just a few weeks into the season, had Landrith traded to Baltimore for Throneberry.

Stengel tried Clarence (Choo-Choo) Coleman behind the plate, and the former Phillie showed early promise. "He was one of the best low-ball catchers I've ever seen," says Craig. "But if it was high stuff,

you could forget it. Choo-Choo would also give you the sign and then look down to see what it was."

Coleman was also fidgety in the crouch, so animated that when journeyman pitcher Chuck Churn was once asked to name the toughest man he ever pitched to, he answered, "Coleman." Coleman was equally elusive in interviews. Mets broadcaster Ralph Kiner recalls, in his seminal prose opus *Kiner's Korner*, asking Coleman on the air how he got his nickname. Coleman responded that he didn't know. Flustered, Kiner then recovered by blurting, "Well, what's your wife's name, and what's she like?"

"Her name's Mrs. Coleman," replied Coleman. "And she likes me."

What does David Letterman say? *Do we have time for one more?* Here goes. On May 12, Stengel inscrutably sent the lefthanded Landrith to pinch-hit against Hall of Fame lefty Warren Spahn of the Braves. As soon as Hobie reached the batter's box, Stengel called time, hobbled out there himself, whispered in Landrith's ear and then returned to the dugout with a smirk on his mug. Hobie hit Spahn's first pitch for a game-winning home run. What had Stengel told him? "I told him," Stengel said afterward, "to hit a home run."

What does David Letterman say? *These are actual letters from actual viewers.* Well, these are actual stories from actual players. "Some of the stuff is myth," says Hot Rod Kanehl, the utility infielder who spent the eight seasons before 1962 kicking around the minor leagues. "Some of it sounds better than it actually was." But Kanehl not only fails to refute a single story, he also enthusiastically antes up with others and then embroiders those with delightful detail.

So on July 6, Hot Rod didn't just hit the Mets' first grand slam, he won 50,000 King Korn trading stamps for doing so. "King Korn had a store in Chicago, and I traded the stamps in there," says Kanehl, who now manages a Garcia's Mexican Restaurant in Rancho Mirage, Calif. "I got a living-room suite, a Deepfreeze, an end table—a lot of junk." *Go deep, win a Deepfreeze.* Mets home games were like *Wheel of Misfortune* that summer of '62.

The decrepit Polo Grounds, erstwhile home of the Giants, had undergone $350,000 in renovations

for that season, which is to say the place was painted white. The Polo Grounds were, in fact, more like a state-fair grounds, full of ridiculous sideshows and carnival-midway games that diverted attention from the Mets games themselves.

"They had circles on the walls down the foul lines at the Polo Grounds," recalls Ashburn, who is now a broadcaster for the Phillies. "If you hit a ball in a circle during a game, you got so many points. Ball boys were stationed down the lines, and they decided whether a ball landed in the circle or not."

The player with the most points at season's end would win a boat. Keep in mind that Ashburn would eventually be named the team's MVP, and for that he would win a 24-foot Owens powerboat that slept four. "Well, I hit one ball that I *know* was in the circle, but the ball boy didn't see it," Ashburn says. "And there was no appeals process. That ball would have given me enough points to win the boat. So I should have won *two* boats that season. But what the hell, I didn't even know what to do with one. I lived in Nebraska."

Remember, this nautical intrigue occurred *during the games.* Frank Thomas, in fact, tried to jerk so many balls boatward down the 279-foot leftfield line that Stengel is said to have chastised him at one point, saying, "If you want to be a sailor, join the Navy!"

In any event, Ashburn would dock his boat in Ocean City, N.J. "It sank," he says. "But it didn't just *sink.* The sucker took five or six days to go down. So they dragged it up, and I sold it. Oh, and the guy I sold it to—his check bounced."

No it didn't. "Yes," says Ashburn. "That really happened."

The Mets' official mascot was Homer the Beagle, and he lived at the Waldorf-Astoria on Park Avenue. Oh, what a wonderful time that was to be young and single and a beagle living in Gotham! And if you happened to be a big league mascot on top of that, well, then the world was indeed your Gaines-Burger.

Homer was trained by Rudd Weatherwax, the man who taught Lassie everything she knew. Alas, the Weatherwaxian magic didn't always work on Homer, and the beagle never quite got the hang of circling the

bases at the Polo Grounds. But then again, neither did Throneberry.

Matriculating in the Yankees' farm system of the 1950s, Marv Throneberry was thought to be the next Mickey Mantle, not the first Mickey Klutts. But by 1962 he found happiness in simply having one of the 500 big league jobs that then existed. As for his often erratic play? "A lot of it," Throneberry says now, "is nothin' but fiction."

Let us pull a nonfiction classic from the shelf: Throneberry lashed a triple off Chicago Cub starter Glen Hobbie in the first inning of a game at the Polo Grounds on June 17. But Chicago first baseman Ernie Banks motioned for the ball, stepped on first, and Throneberry was called out on appeal. Says Ashburn: "We could all see from the dugout that Marv really didn't even come close to touching first base."

All except Stengel, who shot from the dugout as if catapulted. Second base umpire Dusty Boggess intercepted the skipper and informed him that Throneberry hadn't touched *second* base, either. "Well, I know he touched third," went Stengel's timeless punch line, "because he's standing on it."

"I can kid about it now," says Throneberry, relaxing after dark at his fishing house near Collierville. "When people ask me about it, I ask them, 'Have you ever seen an umpire who could see?'"

He is good-natured enough to have done 13 self-deprecating beer commercials for Miller Lite. His name resurfaced nationally in 1983 when the incriminating bat George Brett used in the Pine-Tar Incident was discovered to be a Marv Throneberry model. When a young New York writer named Jimmy Breslin wrote a book about the 1962 season called *Can't Anybody Here Play This Game?*, Throneberry was, naturally, the comic lead. "Jimmy Breslin went on the TV once and said that I made him famous," says Throneberry. "I think it was on Johnny Carson. He admitted it."

Having said all that, Throneberry is still fiercely proud of his seven seasons in the major leagues. "I still don't know why they asked me to do this commercial" was one of his signature lines in the Miller Lite ads. And in wrapping up your conversation with him

about the '62 Mets, you get the feeling that he still doesn't know why you asked him to be in this story.

"People always ask me to tell them some of the funny stuff that happened that year," says Throneberry, "Really, I don't remember that much funny stuff happening."

Some people, of course, wouldn't know funny if it sprayed seltzer in their face. Marv Throneberry is not one of those people. He simply needs to have his memory refreshed.

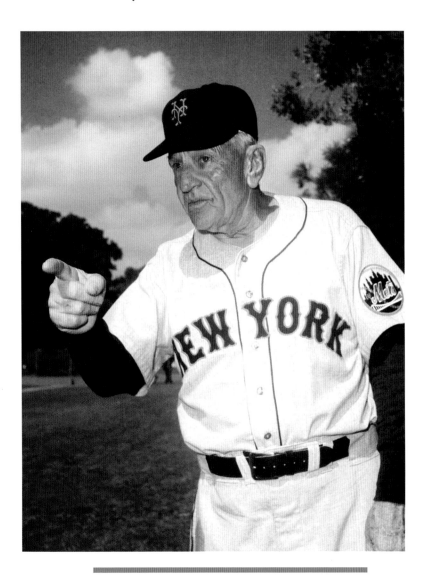

Stengel was hired by former Yankees boss George Weiss; the duo won seven World Series while in the Bronx.

You want funny? The New York Mets celebrated Old-Timers' Day before their game against the Dodgers on July 14, even though the franchise was four months old. Who were they supposed to bring back—Harry Chiti?

You want funny? After 5½ innings of the main event that day, the Mets trailed the Dodgers 17–0. "We were bad," says Galen Cisco, and he didn't even join the Mets until September. "If you could just win one game out of a series with the Dodgers or the Giants, you were good for the week. We weren't expected to win. We had a horse—— team. There were a lot of clubs we just couldn't beat. We were as bad as our record."

And so they were. Two weeks before their Old-Timers' Day loss to the Dodgers, the Mets were no-hit by Sandy Koufax in Los Angeles. Koufax struck out the first three Mets he faced that afternoon on *nine* pitches on his way to the first of his four no-nos.

The Mets didn't go bad, like lunchmeat. They were bad from the beginning. Wire-to-wire bad. But on the glorious first Saturday of August, they did sweep a doubleheader from the Reds at the Polo Grounds. This rendered Cincinnati manager Fred Hutchinson so distraught that he remained alone in the visitors' dugout for a full half hour after the second game had ended. "If you were playing the Mets you had to win four," explains Don Zimmer, who was traded from New York to Cincinnati in May. "Winning three of four wasn't good enough."

It was in another series against Cincinnati that summer that Ashburn pursued a fly ball to shallow left centerfield. Now, the Mets' Venezuelan shortstop, Elio Chacon, recklessly laid claim to every ball hit in the air. So before this game, Ashburn had asked bilingual teammate Joe Christopher how to say "I got it" in Spanish. "*Yo la tengo*," he was told.

So here comes the fly ball, and sure enough, here comes Chacon to invade Ashburn's airspace. "I see him whipping out from shortstop like a little kid on a scooter," says Ashburn. "So I yell, '*¡Yo la tengo! ¡Yo la tengo!*' And Elio puts on the brakes." It was at that precise moment that leftfielder Frank Thomas, a

native of Pittsburgh, ran headlong into Ashburn and knocked the ball loose.

There is no *i* in team, but there is an *e* or, in the case of the Mets, 210 of them. That's how many errors they committed in 1962. Their team ERA was 5.04. Their team batting average was .240. They crafted separate losing streaks of 11, 13 and 17 games and generally gave the Cleveland Spiders, who finished 20–134 in 1899, a run for their money.

But the most remarkable statistic from that season is the 922,530 unshakable fans the Mets drew to the Polo Grounds even while, minutes away, the Yankees were fielding what would be their ninth world-champion team in 14 years and drawing 1,493,574. So before their final home game, against the ninth-place Cubs on September 23, the Mets thanked their public. Each player was given a lettered placard to hold, and when the team assembled on the field, they spelled out WE LOVE YOU METS FANS TOO. Stengel then moved to the end of the line as an exclamation point.

"We had a big meeting in the clubhouse before the game about whether we should do this," says Craig Anderson. "Most of the guys were saying it was bush-league and we weren't going to do it. We were major leaguers. We weren't doing this. Then Stengel came in and made a 15-minute speech that began, 'You guys don't have to do this.' Fifteen minutes later we *ran* out there with our placards. I don't know what the hell Casey said, but we did it."

Because the Mets were to move into their new Queens ballpark, named for the parade-pooping Shea, at the start of the 1963 season, this was to be the last ball game at the historic park beneath Coogan's Bluff. So at the end of the Mets' 2–1 win over the Cubs, the Polo Grounds' public-address system played "Till We Meet Again."

Stengel, 73, was awarded home plate. As he made the long walk with the dish to the clubhouse, 600 feet away behind the centerfield fence, "Auld Lang Syne" wafted down from the speakers. The 10,304 spectators stood and wept openly. "And we all stood outside the clubhouse," recalls Hot Rod Kanehl, "and *we* cried."

Of course, "we did the same thing at the end of the next season," Kanehl notes. The Mets returned to the Polo Grounds in '63, you see: Shea Stadium would not be ready until 1964.

As befits a truly atrocious ensemble, the Mets closed on the road, far away from New York City. They lost their 117th game, in Milwaukee, to tie the 1916 Philadelphia Athletics as the most prolific losers of the 20th century. They lost their 118th game the next day and their 119th two days later, before 595 fans at Wrigley Field.

Well, all good things must come to an end, and the bad things have to stop eventually too, and so the Mets' season finally concluded on a frigid September 30 in Chicago. New York trailed the Cubs 5–1 going into the eighth inning, but Sammy Drake led off with a single, and Ashburn advanced him to second base with a single of his own. With the tying run on deck, catcher Joe Pignatano strode to the plate and promptly hit a blooper toward rightfield.

Trouble is, Cub second baseman Kenny Hubbs caught the lazy liner, threw to Ernie Banks at first to double off Ashburn and then watched as Banks threw to shortstop Andre Rodgers to catch Drake off second base. Triple play. It was Pignatano's final at bat in the big leagues.

It was also the final play of Ashburn's 15-year career. He hit .306 in 1962, made the All-Star team, was offered a $10,000 raise to return in '63, but walked away from it all. "I often wondered why a guy who hit .306 would retire," says Zimmer, who was Ashburn's roommate while with the Mets. "Three years later I asked him, 'How could you hit .306 and retire?' He said, 'I could see us losing 100 games again. I couldn't lose again.'"

"This was a group effort," Stengel told the team assembled in the visitors' clubhouse that afternoon in Chicago as they surveyed the foul waste left in their wake. "No one player could've done all this." And yet hadn't the season been fun? The question was put to Stengel by Louis Effrat of *The New York Times*. Responded Stengel: "I would have to say no to that one."

The Dodgers and the Giants—the two teams whose departures from New York necessitated the

Mets and this first unfathomable season— finished September in a tie for first place. L.A. and San Francisco would meet in a three-game playoff, the results of which would count toward the regular-season standings. Thus the Mets did indeed drop half a game in the race after their season had ended.

Richie Ashburn, Most Valuable Player on the worst team of this century, has returned to Chicago to broadcast a Phillie game. He was one of the Whiz Kids, Philadelphia's National League champs in 1950. His lifetime batting average was .308. He is not in the Hall of Fame, but Red Smith once wrote that he should be, and that, says Ashburn, is good enough for him.

And yet as he tugs on a pipe in his room at the Hyatt Regency, what is it that he finds himself talking about? The triple play that ended it all in the ballpark 10 minutes north of here. "That last season was a year I didn't want to go through twice," he says. "But I am glad I went through it once. I made great friends—I still talk to Marv a couple of times a year. I got to spend a year with Casey. You know, I get more mail for that one season than I get for all of my years before that."

Those Mets truly were bad like God is good. Their badness will endure forever. Three miles from Ashburn's downtown Chicago hotel, at a club called Lounge Ax, a professional rock 'n' roll band has been booked for the weekend. The band's lead singer was raised in Brooklyn in the 1960s. The band's name is Yo La Tengo. •

The Mets played at the Polo Grounds for two seasons before moving to Shea Stadium.

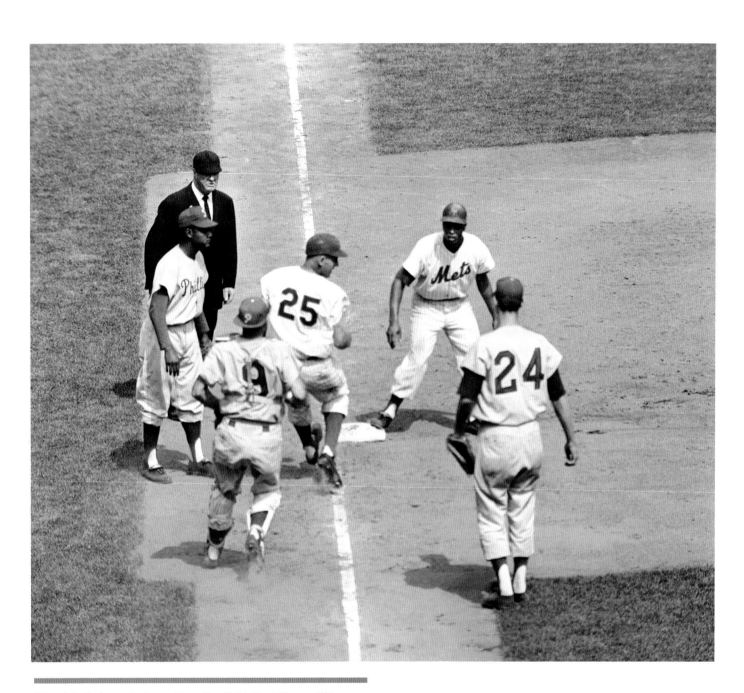

(Above) Confusion on the basepaths as New York's Frank Thomas (25) runs back to third base but finds teammate Charlie Neal already on the bag. (Opposite) First baseman Marv Throneberry can't catch an errant throw by third baseman Frank Thomas, allowing Cardinals pitcher Bob Gibson to safely reach base. The Mets finished the 1962 season 40–120; no team has posted a worse record since.

Excerpted from SPORTS ILLUSTRATED, October 27, 1969

NEVER PUMPKINS AGAIN

A seven-year joke—and a fraying one at that—the Mets brought joy
to New York with a succession of World Series victories that would be
hard to match for dramatic impact or for sheer improbability

by WILLIAM LEGGETT

It was nearing midnight in the Diamond Club four stories above what remained of the playing field at Shea Stadium, and the New York Mets, the most improbable champions in 100 years of professional baseball, gathered in a circle around the bandstand. Swaying back and forth with their arms wrapped around each other, they sang "Heart" from the musical, *Damn Yankees*. ("When your luck is battin' zero/Get your chin up off the floor;/Mister you can be a hero/ You can open any door, there's nothin' to it but to do it./You gotta have heart/Miles 'n miles 'n miles of heart....") Next they sang "God Bless America." And then, as the clock struck midnight, they all turned back into pumpkins.

No, they didn't, not really, for somewhere in the delirious weeks leading up to their victory over Baltimore, the Mets had been touched with permanent magic. Of course, no world championship will ever be the same again, either, as Cecilia Swoboda pointed out to her husband the next morning in their home on Long Island. Ron Swoboda was talking— and talking and talking—about what had been one of the biggest upsets in World Series history when

Cecilia smiled. "Ron," she said, "you can only win it for the first time once."

About the same time Al Weis, a man who hits a home run about as often as Gil Hodges smiles during a World Series game, thought again about the homer that had tied Baltimore in the seventh inning of the fifth and final game. During eight years in the major leagues, both with the Chicago White Sox and New York, Weis had gone to bat more than 600 times before home crowds without hitting a homer.

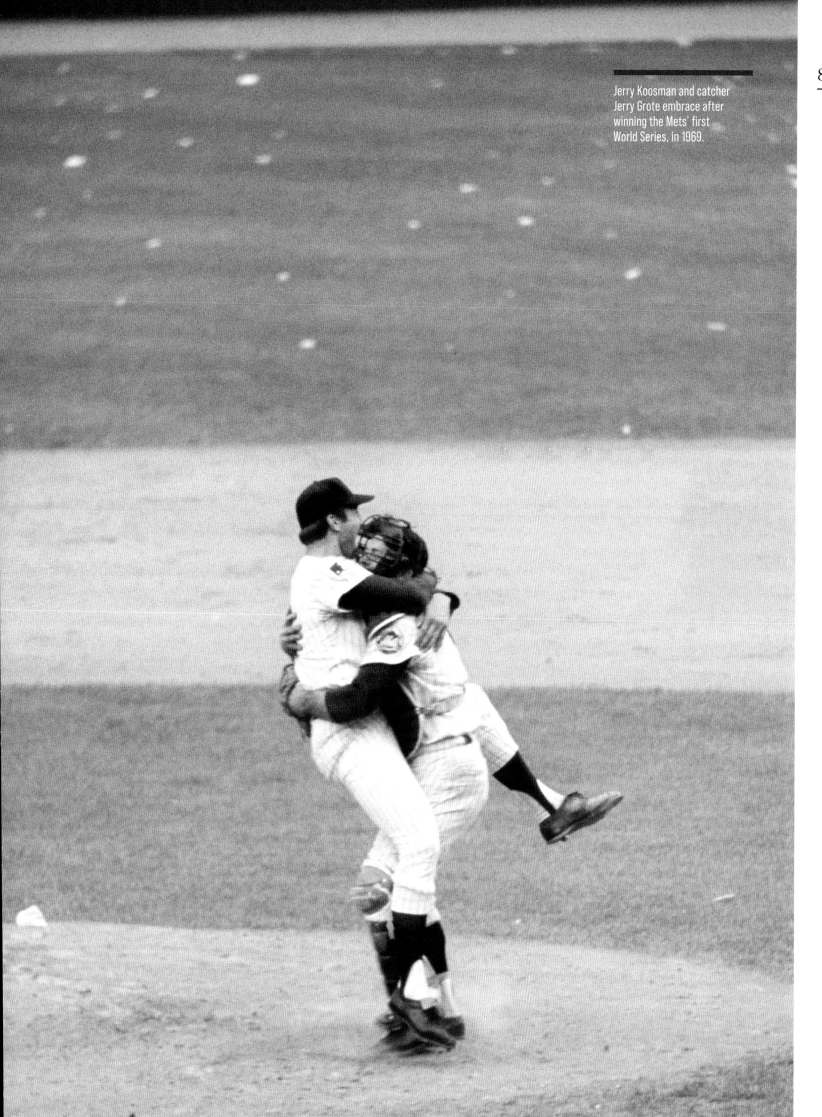

Jerry Koosman and catcher
Jerry Grote embrace after
winning the Mets' first
World Series, in 1969.

But he got hold of a fastball from the Orioles' Dave McNally and began to run as fast as he could. "When I got near second base," he said, "I started hearing the crowd roar and thought something must have happened. I guess I don't know how to react to a home run. I only know how to react to singles and doubles."

Also that day, as he cleared out his locker in Shea, Ken Boswell looked at the stack of mail before him. The hard-hitting second baseman had batted .422 through the Mets' stretch drive and had led the team with five runs batted in against the Atlanta Braves during the National League playoffs. As a bachelor from Austin, Texas he receives a lot of mail. "The girls from Brooklyn," Boswell said, "keep writing and inviting me to go over and try their spaghetti, but they'd have a better chance if they tried spareribs. After I woke up this morning I went down into the street and some people were saying, 'There goes Ken Boswell.' When I get home to Austin they are going to have a Welcome Home Ken Boswell Parade. I hope they mean me and not some other Ken Boswell."

Despite all the things said by the Mets about their inspired victory, it remained for Earl Weaver, the manager of the Orioles, to put his finger on the heart of the matter. After thinking over his team's defeat for two days, Weaver said, "We hit the ball right where they could show off their defensive ability." Almost unbelievably, after the first game nearly half of the balls hit by the Orioles for outs went toward either Shortstop Bud Harrelson or Centerfielder Tommie Agee, the two strongest gloves in the New York defense. Harrelson had a spectacular Series, going into the hole between third and short time and again to turn a hit into an out, and it will be a long time before anybody forgets Agee's play in center.

But the 66th World Series will be remembered for many things. Those were not really angels in the Met outfield: they were the Flying Wallendas. Donn Clendenon set a record for a five-game World Series by hitting three home runs and he only got into four of the games. For the first time in 35 years a manager, Baltimore's Weaver, got bounced from a Series game. When the Mets finally clinched the championship, a blizzard of ticker tape settled over Manhattan; and at Shea Stadium fans pulled up chunks of turf, festooning themselves with the magic sod as if its new-established healing qualities could cure all their fears and ills as merely walking upon it had cured those of their heroes.

The reason for the emotional binge, of course, was that just a short while before the Mets really had been pumpkins. Five days before the Series started, Casey Stengel, who alone made the Mets something to talk about eight years ago, stood in the victorious clubhouse after the playoff series against Atlanta. "Yes, yes, yes," said Stengel, "it's taken eight years but now the people are beginning to know their names!" Tom Seaver and Jerry Koosman and Cleon Jones, of course; but now Weis, Harrelson, Swoboda, Jerry Grote, Art Shamsky, Gary Gentry and Nolan Ryan, too. They were being talked about, admittedly as the urchins who threw the snowballs that knocked the stovepipe hats off the autocrats' heads.

In their first bungling year as a baseball team the Mets lost 120 games, and a saying developed around New York that went, "I've been a Met fan all my life." By 1967 New York had done all to baseball that could be done to it, and the natives were growing restless. During that year the Mets put uniforms on 54 different players with results that are still frightening. Players sent their laundry out and had to have friends pick it up for them and mail it on to their next destination. The fans couldn't tell the players with a scorecard.

In spring training this year Manager Gil Hodges explained how he felt about the constant shifting of personnel. "It doesn't do anything but breed unrest among the players," he said. "There's no feeling of security knowing you may be the next to go. Those days are over."

This year the Mets got to the World Series by using only 29 men, and their followers knew who they were watching. Even the banners improved. Gone were the derogatory signs, as Shea Stadium's peculiar art form assumed a positive note that made the place more fun than ever before. As the Mets drove toward the division championship a large sign made of reflecting tape appeared high above home plate, LET'S GLOW METS! During the Series a sign greeted

Baltimore's huge slugger, Boog Powell, with A 500 POUND BIRD. And in the victory crush on the field after the Orioles had been defeated for the fourth straight time, a youngster held a placard that said, TWEET TWEET.

The Mets seemed to have a unique rapport with their fans and talked about them frequently. They didn't resent it even when they were booed. Ed Kranepool won a game in July and got a tremendous ovation. Often the brunt of jokes, he said, "The last time they cheered me was when I signed." Swoboda, after striking out five times in one game, said, "They booed the hell out of me and if I was them I would have followed me home and booed me there, too."

Swoboda obviously learned something that day. In the Series he batted .400, drove in the winning run of the final game and made two magnificent catches. All the Mets, in fact, showed in the Series that they had come a long, long way. Following their defeat in the first Series game, their pitching settled down— something it was unable to do in the playoffs. After Don Buford's first-inning homer, when it seemed that Baltimore was about to decimate the Mets, only

one Oriole leadoff man reached base in the next 26 innings. Only four times in all did an Oriole start an inning with a hit.

Baltimore's failure to handle New York pitching was most evident when Buford, Paul Blair, Brooks Robinson and Dave Johnson were at bat. These four hit a composite .080 for the Series and did not produce one extra base hit after Buford's fourth-inning double in the first game. Of the skimpy total of 23 hits that the Orioles collected, five came out of the ninth spot in the order. And of the nine runs batted in by Baltimore three were accounted for by Pitchers McNally and Mike Cuellar.

If there was a turning point in the Series it came in the second inning of the third game, with the Mets leading 1–0 on Agee's leadoff homer. With two out, Grote, who caught all five games, walked and was moved to second by Harrelson's single. Jim Palmer threw a terrible pitch to Gentry, who promptly drove it into right center for a double to score Grote and Harrelson. In 74 at bats during the regular season and the playoffs, Gentry, one player who has never been accused of being a "pretty good hitter for a pitcher," batted home only a single run and hit but a solitary

Grote slides beneath the tag of future Mets manager Davey Johnson during Game 4.

double. He was sweating out an 0-for-28 slump when he jumped on Palmer's bad pitch.

The third game may well turn out to be the best that Tommie Agee will ever play; it probably is the most spectacular World Series game that any centerfielder has ever enjoyed. Agee is easily the best example of Gil Hodges' patience. Twenty-seven different players had worked in center field for New York before Agee arrived in 1968 from the Chicago White Sox. On the first pitch of spring training that year he was hit in the head by Bob Gibson of the Cardinals, and early in the regular season he went through an 0-for-34 slump. He hit only .171 in Shea Stadium and seemed to take the Great Circle Route under fly balls. He was pressing. But, although he could not seem to do anything right, Hodges kept playing him, telling Agee not to quit on himself.

At first, 1969 was not an easy year for Agee, either. He encountered slumps and Hodges benched him but, as the Mets played good ball, Agee became a vital man in the attack. He started rallies on offense and stopped the opposition with fine catches in the outfield.

But nothing he did in the regular season approached his third-game performance. Behind 3–0, Baltimore started what looked like a big rally in the fourth inning by putting two runners on with two out and Elrod Hendricks at bat. Normally a pull hitter, Hendricks hit a pitch to deep left center, and Agee, shaded toward right, went galloping after the ball. He caught it two steps from the wall with a spectacular backhand catch to end the inning. Three innings later, after an even longer run, he dove to rescue a potential triple with the bases loaded. Agee had made a difference of five runs on defense with his fielding and one on offense with his homer as New York won 5–0. The crowd of 56,335 at Shea Stadium sensed for the first time that the Orioles, doubtless a very fine team, could be had by the Mets.

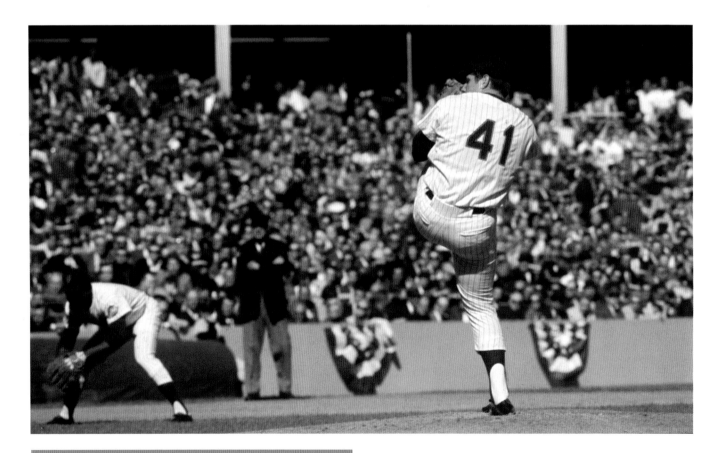

Tom Seaver delivers a pitch against the Baltimore Orioles in Game 4.

New York's drive to the division championship, the National League pennant and finally the World Championship was surrounded by such hysteria and commercialized sentimentality that certain hard statistics were all but overlooked. The foremost of these shows how well New York played in Shea Stadium. From the middle of August through their final victory in the Series, the Mets won 26 of 31 games there—a percentage of .839. Before their final playoff victory over the Braves, New York pitchers gave up only six home runs in their last 253 innings played at Shea, a remarkable accomplishment since Shea Stadium is considered by home-run hitters as a hitting successor to the Mets' ancestral home, the Polo Grounds. Little wonder Baltimore had trouble.

The Orioles must now suffer through a long winter after what had been, until they met the Mets, a superior season. When Bowie Kuhn, the imposing new Commissioner of Baseball, shook hands with Weaver after the Series he said, "I've just congratulated the Mets and told them they'd beaten the best damn team in sight." The Orioles certainly were, and had it not been for an amazing catch here, a miraculous stab there they might have reversed the whole course of what, mystically, the whole country had begun to regard as inevitable—the triumph of the rankest underdogs. Instead, they return to Baltimore, where only a million watched them this year and perhaps fewer will care to view them the next.

Probably no man has suffered through a more frustrating Series than Frank Robinson. When he wasn't being walked by the careful Met pitchers, Robinson hit the ball hard—once for a home run, in the fifth and last game. But four of his smashes ended in nothing but beautiful outs. As Baltimore packed for its return home, Robinson said, "I'm awfully disappointed it all had to end this way for us. It would be silly to try and take anything away from the Mets because they just played great ball. But don't forget about us. We'll be back."

Now the Mets feel that they will be back, too, but search and you will not find a man in the entire organization who thought that 1969 would be a year in which the team would win its division championship, let alone a World Series. This was to be a season in which the club became respectable and might even finish as high as third in the East. Just the year before they had wound up 16 games below .500 and in ninth place, 24 games behind pennant-winning St. Louis.

It was absurd to think that New York could win 100 games. But the Mets did. It is equally absurd to believe that those 100 games were won with luck. If one holds to the baseball cliché that the breaks tend to equal out, then maybe the Mets were repaid all in one season for seven long years of bad breaks.

But, more important, the Mets were a hungry club and gave of themselves as teams do only in novels. Only four of them had been regulars for as long as three years. It was a smart team. Of the 27 men who contributed to New York's rise, 22 had been to college—a remarkable percentage for a baseball club. And it was a team that was being prodded from underneath. This year the Met farm system produced four pennants in the minor leagues, twice as many as any other organization, which means that more good new Mets are on their way up.

Looking them over last week, Ted Williams said that he saw the possibility of the Mets becoming a dynasty, and it is pretty hard to doubt anything Teddy Ballgame says these days. Although dynasties have a way of lasting for about a year in the National League, the Mets, bless 'em, always seem to defy established principles. With their victory justly acclaimed as a triumph for baseball, it may be hoped that any residual tarnish from the hyperbole of Madison Avenue and New York politicians will soon wear off, leaving only the warm success that is likely to endure and honor the sport.

Anyone who drove away from Shea Stadium last week, past candy stores, playgrounds and lots in Queens and Nassau County, had to notice youngsters by the thousands throwing phantom baseballs and diving to make catches that really could not be made. The kids were dreaming that they were Agee, Jones and Swoboda; Seaver, Koosman and Gentry; Harrelson, Weis and Clendenon. And older people dreamed, too, and wondered if during any five days in their entire lives they had tried as hard as the Mets did. •

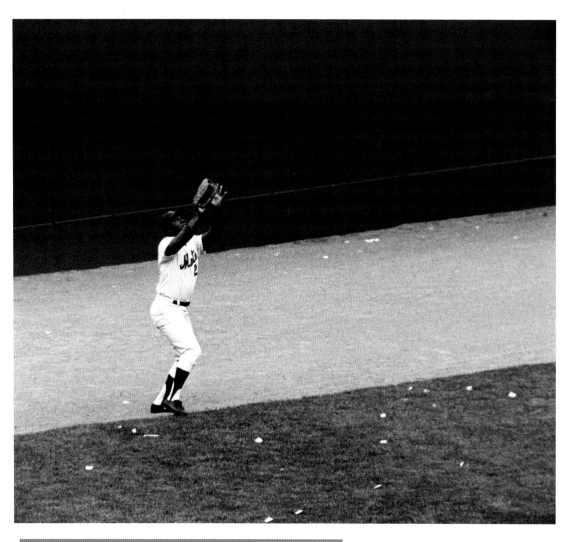

(Above) Cleon Jones squeezes the final out of the 1969 World Series.
(Opposite) Seven years after their ignominious beginning, the Mets
were champions.

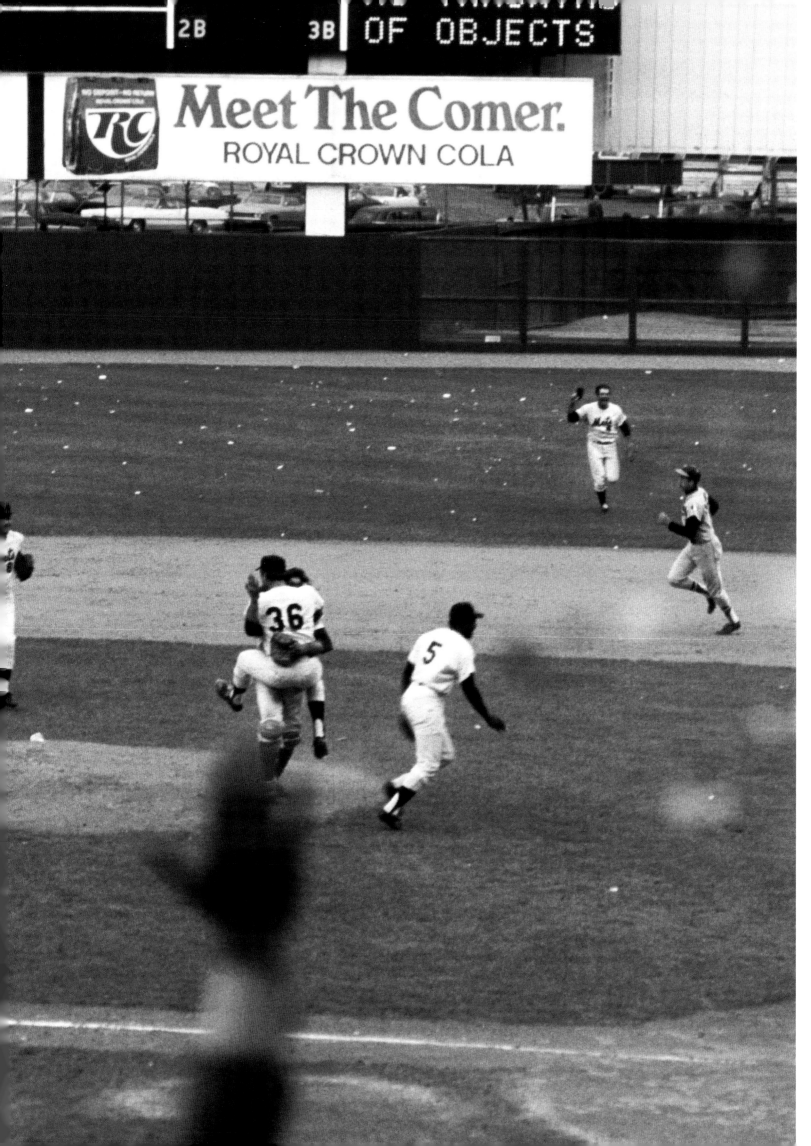

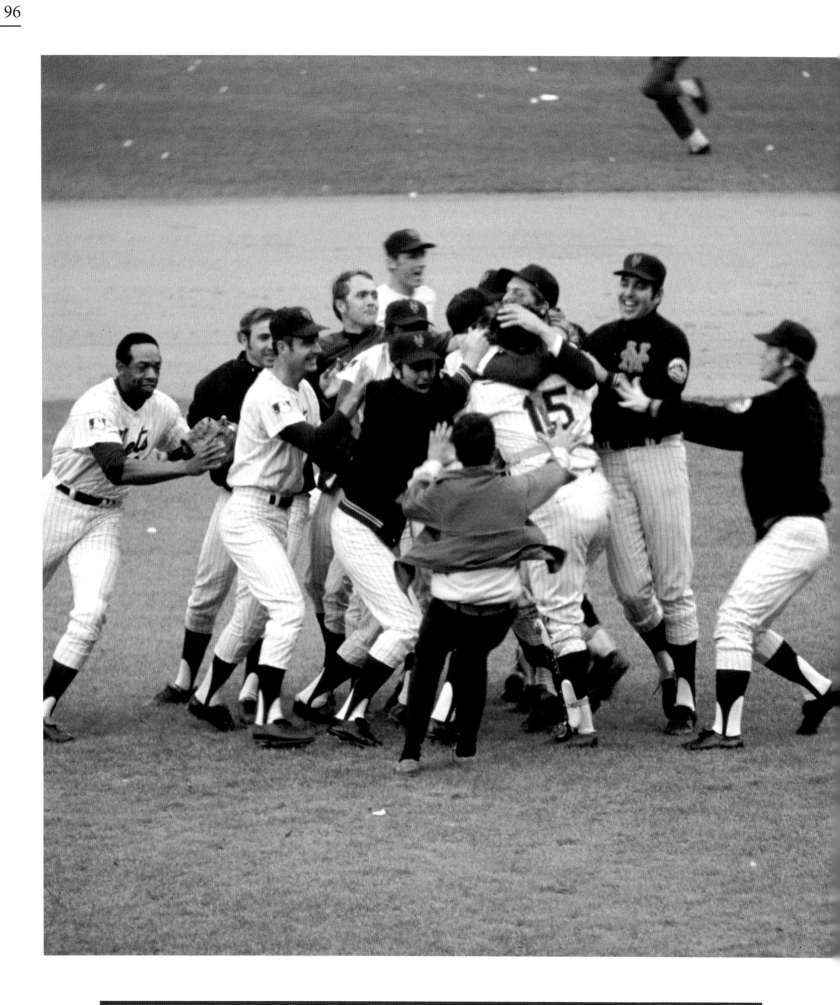

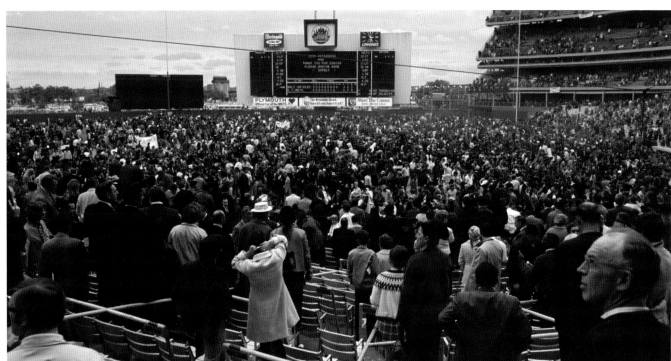

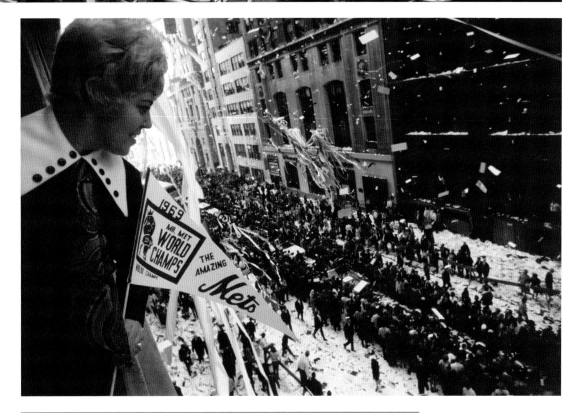

(Top) Fans flood the Shea Stadium field after Game 5. (Above) A Mets fan watches the ticker-tape parade at 50 Broadway. (Opposite) The Miracle Mets gather at the mound, champions for the first time.

Excerpted from SPORTS ILLUSTRATED, December 22, 1969

TOM SEAVER: 1969 SPORTSMAN OF THE YEAR

The Mets, the decade's symbol of ineptitude, ended the '60s as the darlings of baseball—and more. And their stud pitcher Tom Seaver, winner of 25 regular season games, a playoff game and a World Series game, was at the center of it all

by WILLIAM LEGGETT

During the fall of 1960, which was almost a decade ago, the game of baseball suffered two cruel blows. The New York Yankees took their 70-year-old rubber-faced manager, Casey Stengel, to a press conference at Le Salon Bleu of the Savoy Hilton Hotel and announced that after winning 10 pennants in 12 years he had decided to commence his retirement. And in Boston, Theodore Samuel Williams, after 19 years, 521 home runs, two wars and a lifetime batting average of .344, decided that it was time for him to depart. We were all duly told that "we would not see their like again."

So now it is a cool fall afternoon in 1969; the '60s are just about behind us. Bunting is hanging from box seats in a place called Shea Stadium in Flushing, New York. A team called the New York Mets, which had not even existed in 1960, is one victory removed from winning the baseball championship of the whole astonished universe. Seated on the third-base side of the stadium is Ted Williams. Browned and handsome, he has just completed a spectacular rookie season as, of all things, the *manager* of the Washington Senators. Casey Stengel sits on the first-base side in a green Tyrolean hat with a feather in it, clapping his hands and chanting, "Let's go, Mets!" For four years after the Yankees retired him Casey had managed the Mets,

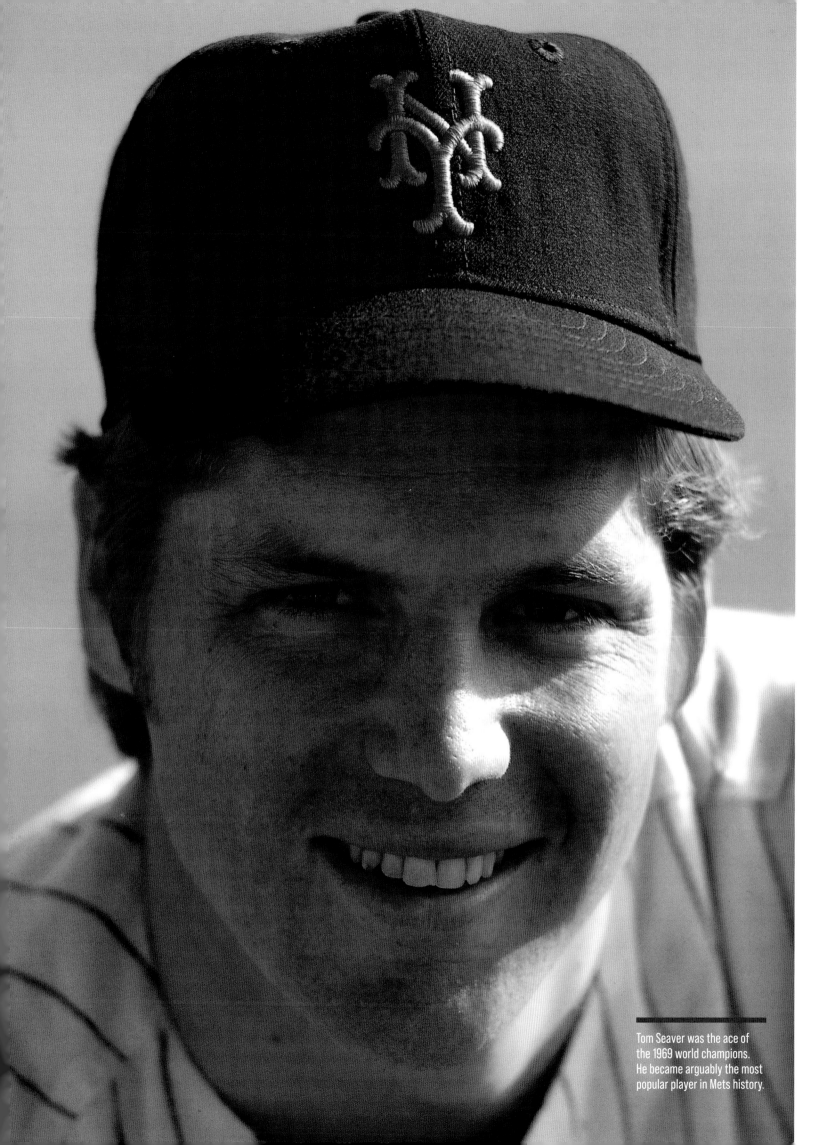

Tom Seaver was the ace of
the 1969 world champions.
He became arguably the most
popular player in Mets history.

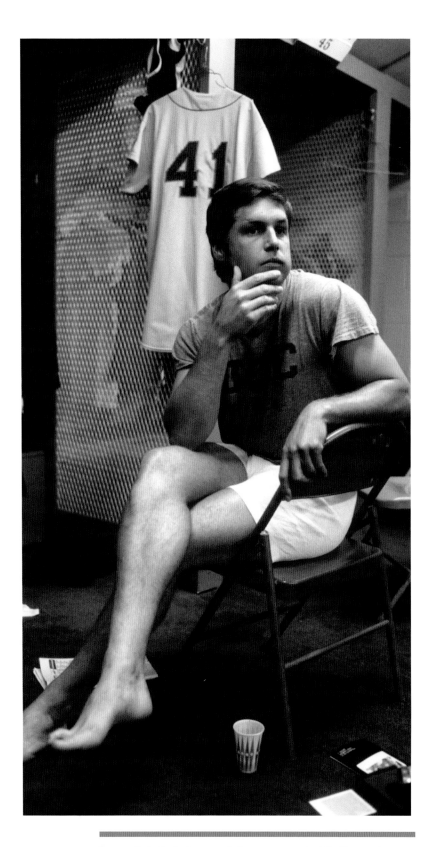

Seaver sits in the locker room before a game against the Braves at Atlanta-Fulton County Stadium.

been their Pied Piper Svengali and one-man band, encouraging what he called "the youth of America" to come and play for the "Amazin' Mets." Eventually young men of talent did arrive, and because of them the game of baseball may live happily ever after—or at least another year or two.

Of all the upsets and improbabilities that high-lighted sport in the 1960s, the victory of the Mets is likely to be remembered longer than any. Laughed at, ridiculed and adored during seven years of unequaled incompetence, the Mets became the only expansion team ever to attain a championship in a major sport. What is more, their ultimate victory came at the expense of the Baltimore Orioles, the best American League team of the decade.

The success of the Mets not only inspired a snowfall of ticker tape in New York City—such things are routine in pennant-winning towns, though Manhattan's 1,832.6-ton total was, literally, baseball's record—it triggered an unexpected national response. From the Hudson to the hinterlands people turned the Met victory into a national cliché of hope: "If the Mets can win, anything can happen." Thus the Mets, the decade's symbol of ineptitude, ended the '60s as the darlings of baseball—and more.

Who was responsible, in addition to the glorious fates, which so regularly offer up to sport the stimula-tion of the totally unexpected? Who typifies the deed?

One candidate would be Gil Hodges, who not many years before was standing on first base in a Met uniform watching with bemusement the deeds of his preposterous playmates. Few men have been replaced at first by Marvin Throneberry and then come back to manage a team to the most improbable of championships. Hodges exercised consummate skill in achieving the feat, balancing talent here, desire there, and all the while sitting expressionless in his corner of the dugout as if the victories that piled up one upon the other before his unwavering eyes were exactly what he had expected.

But Hodges is of the old order, and the Mets are not. Their achievement must be attested to by other terms: by youth, by verve, by personality, by conviction, by naiveté and finally by rare talent where it counted most—on the field. That is why

George Thomas Seaver, a 25-year-old man-child from Fresno, Calif., is 1969's Sportsman of the Year.

Because of the surprise that attended the Mets' championship, the role played by Tom Seaver throughout the season was lost to a degree amid the tearing up of Shea Stadium turf and the squirting of champagne on mayors, celebrities, television announcers and millionaires. A reminder is in order. Seaver won 25 regular-season games, plus one playoff game and one World Series game when he was decidedly not at his sharpest. He became the youngest National League pitcher in 34 years to win as many as 25 games (Dizzy Dean was the last). He won the Cy Young Award as the best pitcher in the National League and had more victories than anyone through a season that produced 15 pitchers with 20 wins or more.

During 1969 Seaver ran off winning streaks of eight and 10 games, which helped spare the Mets any long losing sieges, but win or lose he brought some very special characteristics to an unusually young baseball team. He expected to win, and he expected his team to win. Yet he had a way of handling defeat that helped everyone. An icy realist about many things, he had no use for alibis. When he pitched a bad game, he would say he was lousy. If others were lousy, he attempted to break the mood. After a horrendous Met exhibition in Pittsburgh, Seaver looked around the clubhouse and noticed his team-mates' discouragement. He rapped for attention, stood on a chair and said, "Gentlemen, after watching that performance I would like to take this opportunity to announce my retirement from the game of base-ball." Once when he thought the bench was too quiet during a game he walked along the dugout plucking spiders from the cool walls and throwing them in the laps of the silent. Seaver could get away with this, of course, only because he had earned the respect of the Mets with his talent and attitude—but, having won the respect, he made maximum use of it.

In his three years with the Mets, Seaver has won 59 games, but it must be remembered that in his first two seasons he played on teams that were a symphony of incompetence. He went to New York's spring training camp in St. Petersburg, Fla. in February of

1967 with only one year of professional work behind him. "I had no time limit set for making it to the major leagues," he says, "but I believed that eventually I would get there because I felt I was good enough. There were no self-declarations that if I did not make it in two or three years I would quit and try some-thing else. None of that. At training camp I was ready to be sent back to the minors if the Mets felt I needed the extra work. I was perfectly willing to accept that, because I believed in the absolute integrity of major league baseball. To be honest about it, I had not been overly impressed by myself during my first year in pro ball at Jacksonville. A record which shows you win only as many games as you lose [12–12] is not one you can accept or be happy with."

But following a strong spring training perfor-mance the Mets decided Seaver was good enough for them. In his first five big-league starts the Mets won four times. But more important for him and the Mets, Seaver instinctively rejected certain attitudes he detected on the team. "When I came to the Mets," he says, "there was an aura of defeatism on the team; a feeling of let's get it over with. I could not accept that. Being brought up in California, I was unaware of the legend of Marvelous Marv Throneberry. That lovable loser stuff was not funny to me. I noticed that the team seemed to play better when I pitched but, dammit, that wasn't right and I said so. I prob-ably got a few people mad, but I went around and told the guys that if they did that for me and not for somebody else it was wrong. People pay money to see professional baseball played well and they put their emotions into it, too."

Seaver's feelings suggested, and rightly, that some-thing in his baseball background was unusual. To the top of the sport, where men are men and pros are pros and all the world knows it, he brought some strange, old-fashioned, all-American boy attitudes.

"When the Mets were formed and baseball expanded from eight teams to 10 I was against it as a traditionalist," he recalls. His favorite team was the Milwaukee Braves and his favorite player was Henry Aaron. "Henry was always first with me, and I don't find it strange at all that a white boy who wanted to become a major league pitcher identified with a black

hitter. I thought of Aaron as excellence. He was so much fun to sit and watch because he was consistent, dedicated and yet capable of making the game look so easy to play. Confidence flowed out of him, and I memorized his every move. Aaron has his own way of doing things, totally unlike any other hitter."

Two other players fascinated Seaver—Stan Musial and Sandy Koufax. "Once," he says, "at a game in the old Seals Stadium in San Francisco, I saw Musial have a bad day. Four straight times he grounded out to first, but every time he sprinted down the line as hard as he could go. Now, when I see some guy not hustling it angers me and I think of Musial on that day.

"Koufax was special, too. I sat in the bleachers watching him one day and he got knocked out in the first inning, one of the few times in his life that happened. Walt Alston came out to replace him, and Sandy just walked off, but he showed so much class in the way he did it. He knew he would be back four days later and things would be different. Four days later I went back, and Koufax was just fantastic. Koufax was the pitcher I wanted to be like.

"In my first year with the Mets I finally got a chance to meet Koufax. He was announcing The Game of the Week, and I saw him standing on the other side of the batting cage before the game. I wanted to go over and introduce myself but I couldn't do it. I thought it would be rude to force myself on him. I needed some kind of excuse. Pretty soon a ball rolled near him, and I hurried over and picked it up. 'Sandy,' I said, 'my name is Tom Seaver.' Before I could say anything else, he said, 'Yes, I have heard an awful lot of good things about you.' I am really sorry I never got a chance to pitch against Koufax."

In May of his first season Seaver faced Henry Aaron. This was more testing. "I could not make my mind believe this was reality," he says. "I got Aaron to hit into a double play his first time up and I struck him out the second. The third time he hit a two-run homer to tie the game and we lost it later. I'll never forget that. Damn!"

Seaver's competitive baseball career began as early as it possibly could have. His mother remembers looking out the back window of their home in Fresno when Tom was only 3 years old and seeing him playing phantom ball games with two imaginary friends, George and Charlie. Tom would argue, jump up and down and run bases. Tom's father, Charles Seaver Sr., now a vice-president with the Bonner Packing Company, was a two-handicap golfer at the age of 15 and later played football and basketball at Stanford in addition to golf. In 1930 he came within a hole of making it to the final round of the U.S. Amateur championship and a chance to meet Bobby Jones in Jones's last match before his retirement. Two years later he won the Stanford championship by beating Lawson Little and he was named to the Walker Cup team captained by Francis Ouimet. On weekends Charlie Seaver and his wife would go golfing at the Sunnyside Country Club in Fresno, and Tom, his sisters and his brother would be taken along. "When you are the fourth child in a family," his mother says, "you probably have to be a little tougher to survive."

Of the other three Seavers, Katie was a good volleyball player and swimmer at Stanford; Charles Jr. was a swimmer on the University of California varsity; and Carol majored in physical education at UCLA. This left only one big college in California without a Seaver on its rolls, so Tom went to USC on an athletic grant-in-aid.

"Our family was always competitive," Tom says. "Even when my father was working around the house he wanted perfection, and he tried to instill that striving in us, too. I learned a real respect for the value of work, not as a means—not just for the money it can bring you—but for the pleasure of doing something as well as you can, as near perfectly as you can. I wish today that I could use the same amount of concentration on other things that I put into pitching, but if I could I would not enjoy baseball as much as I do. The thing I appreciate about the game is that it is one of the few places left where a person like myself can show his individuality."

It is, more than anything else, the striving for excellence that Seaver transmitted to his teammates. He became their leader by setting them a rare example. Two small incidents display this aspect of Seaver. He had planned, on winning his 20th game, to celebrate by taking his wife Nancy out for an

expensive dinner. But he won No. 20 as the first game of a doubleheader against Philadelphia. The Mets then lost the second game, and Seaver saw no reason to celebrate. He and his wife dined at a hamburger stand.

About a month later, when almost all of the impossible had happened and the Mets had just beaten Atlanta to win the National League championship, there was the usual wild celebration in the dressing room. Seaver stayed a few minutes, but then slipped out to find a television set where he could watch Baltimore beating Minnesota. He thought he might spot a point or two about the Oriole hitters.

This, and the Seaver who says he'll accept almost anything the Mets want to pay him next year because he can't think about pitching if he has to worry about money arguments, and the Seaver who avoids the banquet circuit because he feels too many outside interests hurt ballplayers, and the Seaver who would have gone to spring training on a certain date this year even if there had been a baseball players' strike, and the Seaver who says, "The happiness of baseball is its competitiveness; that is what I love about the game," are all one young pitcher. But so is the Seaver who throws spiders and gets in water fights with the Shea Stadium ground crew—which is why he is the man-child of the Mets.

If perfection is Seaver's goal—and already some consider him a little too perfect to be true—he came close to baseball's version of it on the one night last season that may well have made the Mets. The city of New York had gone without a significant National League baseball game for a dozen years when on July 9 Seaver took the mound to work against the league-leading Chicago Cubs. New York was only four games behind Chicago, and the biggest crowd in the history of Shea Stadium was out to see if the Mets were real. For eight innings that night Seaver did not allow a Cub on base while striking out 11 of them. Three times he received standing ovations at the end of innings, and as he went out to begin the ninth the crowd stood for him once more. "When I got on the mound," he says, "I suddenly felt my arms somehow being lifted upward, just as if I had pressed

Seaver signs autographs for fans during spring training in 1972.

them against the sides of a doorway for a long period of time."

Seaver got the first out by fielding a bunt by the leadoff hitter, but then gave up a single to rookie Jimmy Quails. Gone was the perfect game, but Seaver's performance in New York's 4–0 win had shown Met fans that the time had finally come to root for their team instead of laughing at it.

That night—Seaver now calls it the night of "my imperfect game"—Bud Harrelson, the Mets' young shortstop and Seaver's roommate, was with his Army Reserve unit at Camp Drum in upstate New York. Harrelson went to a bar in the nearby city of Watertown and, while watching the game and Seaver's performance on television, began to have an unprofessional reaction to what was happening.

"It was like I was being pulled into the set," he says. "I had so much pride in the team and in Tom that I guess I kind of lost my head a little. When he went out to pitch the ninth inning I did something only a kid is supposed to do. I turned around to a guy standing next to me and said, 'Hey, I know him. I know Tom Seaver. Tom Seaver is a friend of mine.'"By the time the 1969 baseball season was over, a large number of Americans were having the same kind of reaction to both Seaver and his Mets. The Mets excited them. The Mets cheered them. The Mets were friends. The Mets, in fact, were the only possible ending to a decade of wondrous performances, surprises, shocks. Sport had never seen anything like the '60s. But what better way to go into the '70s than to be borne there by the Mets? ●

No Mets pitcher has won more games in his career than Seaver's 198.

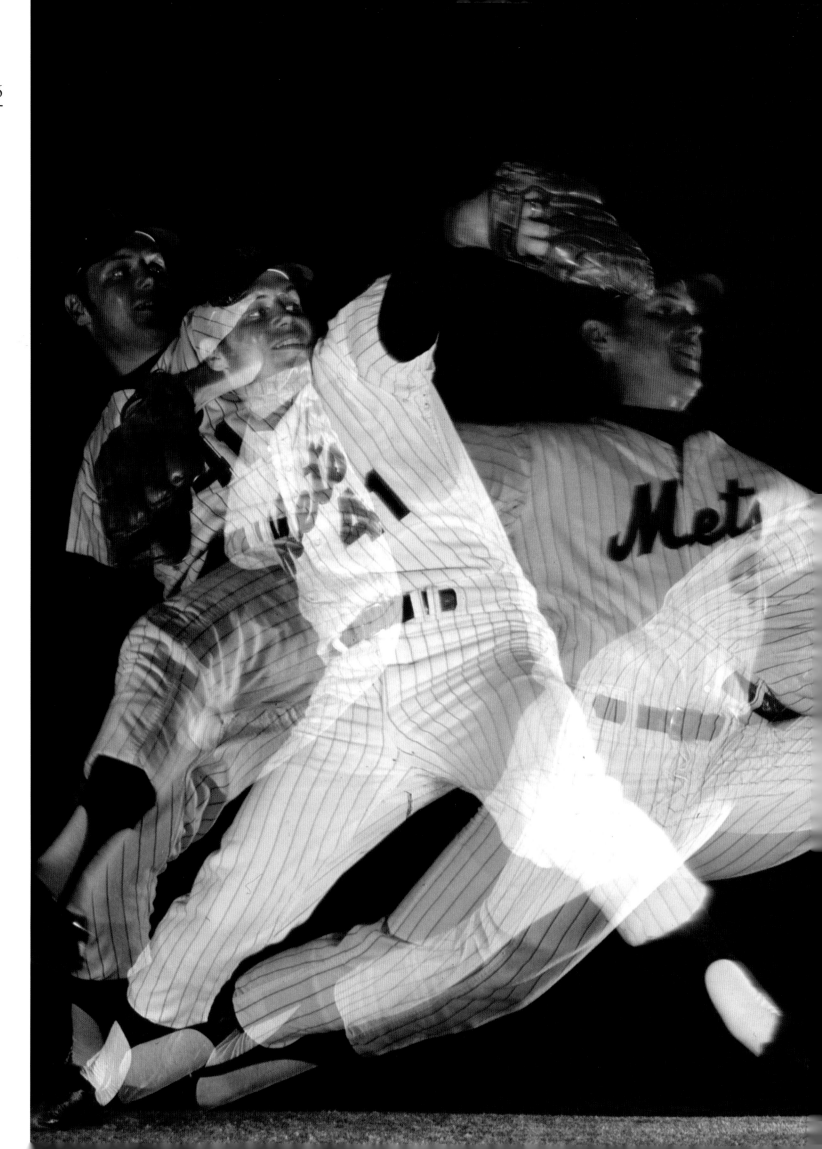

(Above) Seaver relaxes in the dugout in 1975.
(Opposite) Photographer Neil Leifer created this
multiple exposure portrait of Seaver during a photo
shoot in 1972.

Excerpted from SPORTS ILLUSTRATED, April 23, 1984

THE PERILS OF DARRYL

A rugged apprenticeship behind him, Darryl Strawberry could be swinging into an amazin' future

by WILLIAM NACK

Standing in the on-deck circle, Darryl Strawberry looked at the man on the mound, Cincinnati righthander Mario Soto, and then started for the batter's box. "I was a little excited," Strawberry would say. And with reason. It was April 2, a sunny Opening Day in Riverfront Stadium, the start of a new baseball season and the first at bat of the year for the Mets' 22-year-old rightfielder. In fact, Strawberry had been waiting all winter for this moment, knowing that the Mets would be opening in Cincinnati and figuring that Soto, the star of the staff, would be the opposing pitcher.

Now there was Soto, sure enough, with that hopping fastball and the nastiest changeup in the National League. Walking to the plate that day, Strawberry thought: This is it. This is the challenge all over again, me and Mario Soto.

Strawberry didn't particularly cherish the memory. The only other time he had faced Soto was in Shea Stadium last May 6—in his first big league game after the Mets called him up from Tidewater. Soto fanned him three straight times, then popped him up, keeping him off-balance and tentative with an array of heat and changeups that bedazzled the young rookie and left him muttering to himself in the clubhouse. "I remember thinking after that game, 'Whew! I never saw that kind of stuff in the minor leagues,'" Strawberry recalls.

That performance, not incidentally, launched the rookie on an excruciating slump that lasted weeks and that found him, on June 5, batting .161. The Met front office wondered whether he should be dispatched back to the Class AAA Tides. Strawberry eventually got on track, of course, hitting .313—with 14 home runs and 34 RBIs—over the last 54 games of the season. Indeed, despite the depressing start,

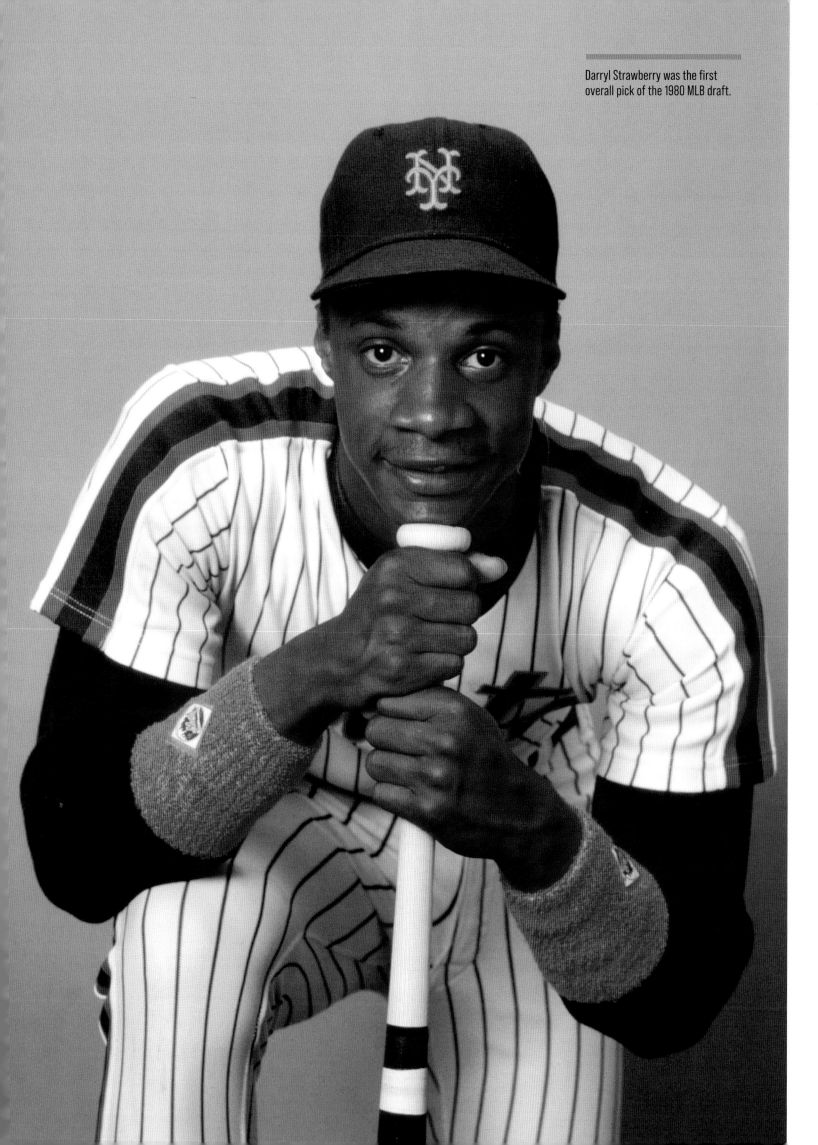

Darryl Strawberry was the first overall pick of the 1980 MLB draft.

he ended up hitting .257, with 26 dingers and 74 RBIs, and was voted the National League Rookie of the Year.

But that was then and this was now. Strawberry says he wanted to prove to himself that "I can hit anybody." Anybody in this case was Mario Soto.

On the first pitch Soto offered a changeup down and inside, and Strawberry swung mightily but missed. "I was too excited," he says. So he stepped out of the box and told himself: Just relax. Be patient. Wait for your pitch. Soto's second pitch was a carbon copy of the first, and Strawberry kept the bat on his shoulder. Ball. On the third pitch, he took Mario Soto downtown.

It was another change inside, only slightly higher, and Strawberry crushed it. Uncoiling his 6'6", 195-pound body, his unusually quick hands whipping the 32-ounce bat into the pitch, he drove it in a long arc into the second deck in right-field, the ball caroming about the seats some 450 feet away. He felt a rush. "It felt good getting ahold of it," Strawberry says. "As I rounded the bases, I thought, 'I did it!' It was an important at bat for me. I had something to prove, and it tickled me."

For Darryl Strawberry, acting out a seemingly fanciful script that was even better in reality, the 1984 baseball season had begun. By Sunday he had hit three home runs in nine games, helping the Mets to a division-leading 6–3 record, and was batting .294, with three runs batted in. He has just turned 22 but already there are signs that he might fulfill the promise seen by Brooks Hurst, his baseball coach at Crenshaw High in Los Angeles. "You could be a black Ted Williams," Hurst had told him. To which Straw replied, "Who's Ted Williams?"

"Ted Williams is an awful large order," says former Met manager George Bamberger, "but if someone asked me, 'Who coming up will be another Ted Williams?', well, I'd have to say Darryl Strawberry. I've compared ballplayers to other ballplayers but never to Ted Williams. Fifteen years from now this kid will turn out to be one of the greatest ever to play the game."

"If he continues to try to improve and he takes the game seriously, both offensively and defensively and as a base runner, within three years Darryl Strawberry

can probably be as valuable a ballplayer as anybody in the game," says Chicago Cubs manager Jim Frey, who, as the Mets' batting coach in '83, was Strawberry's guru. "The whole question is his continued motivation and ambition and willingness to work."

"If we miss on this young man, we all better look for a career change," says Frank Howard, Strawberry's manager last year after Bamberger resigned on June 3. "He can go as far in baseball as any man living."

Strawberry sighs and rolls his eyes. He has heard it all—the Ted Williams talk and the sky's-the-limit stuff—and he wants it to go away. "I don't believe that," he says. "I don't want to get my mind confused with all that crap. That's what I call it: crap. I just want to be myself. I just want to be me. To have fun and play baseball."

Strawberry has been playing ball since he was growing up in the parks and playgrounds of the black ghettos of south Los Angeles, the third of five kids raised in a three-bedroom stucco ranch by his mother, Ruby. Today she is an engagingly bright, charming and youthful woman of 43, who works as a circuit designer for the phone company. The Strawberry children—Michael, 24, Ronnie, 23, Darryl, Regina, 21, and Michelle, 19—never went hungry, but it wasn't an easy childhood. Their father, Henry, a postal worker and frequenter of racetracks, moved out when Darryl was 13. Ruby objected to his gambling their money away and finally filed for divorce.

"I couldn't live like that," she says. "We had the house to take care of, the children to take care of, and everything that goes along with it. He played the horses. He wasn't responsible."

"If you don't take gambling, you don't take me," Henry says now. "It's a part of my life…. I loved her, but she says that I didn't show it. I hated to leave."

Darryl felt the split more deeply than the other four children, and today he still is angry at his father, though his mother says, "Be forgiving." Darryl is trying. "I'm getting better about it," he says. "It's kind of out of my mind now. It was very tough to handle, being young." His father's leaving home was, to be sure, the central trauma of his youth, and he's still searching for a guiding male hand to lead him. That he has repeatedly found it, from Little League to high

school to minor and major league ball, makes him say, "Hey, I've been blessed."

First there was John Moseley, a 66-year-old retired truck driver who's an assistant baseball coach at Compton College and a neighbor of the Strawberrys. In his spare time Moseley gave baseball tips to Michael and Ronnie Strawberry. "When I talked to Mike and Ronnie, Darryl listened and absorbed," Moseley says. "Darryl was never a guy to mess around with girls. Baseball is all Darryl talked about. He was a baseball fanatic."

Moseley took the boys to the park every day, drilling them in fundamentals, and treating them as if they were his own kids. "He'd hit a hundred fly balls a day to each of us," says Ronnie. "Then we'd sit at his house and talk about ball—'Anybody can pull the ball,' he'd say. 'Can you go the other way with it? Or up the middle?'—and he'd take us to the Jack-in-the-Box to eat." And he'd preach—in favor of studying in school and against fighting in the streets. "Your hands are too important to be punching a guy around," Moseley would tell them. "How you gonna play ball with a broken hand?"

"Mister Moseley taught me everything I know about the game," Strawberry says. "I heard it first from him."

In sandlot ball Darryl was renowned for his towering home runs. "When my brother gets to high school, you're going to see something," Michael, already a star centerfielder, told Hurst. When Darryl finally got to Crenshaw, Hurst found he was a moody, troubled youth, still bitter about his father's leaving home. "I think that had a lot to do with it," Straw says. "We had to go through a lot of rough times. I carried a bad attitude around with me. I believed I didn't have to listen to anyone, didn't have to do anything."

One day, coming in from the outfield between innings, he jogged partway, then walked the rest. Hurst tapped the "C" on Darryl's Crenshaw baseball cap and said, "You want to wear this C, you've got to hustle." Darryl turned to him and snapped, "Nobody touches me!" Then he took off his uniform shirt, handed it to Hurst and quit the team. "I just can't play anymore," he said. Strawberry later appealed to Hurst

for reinstatement, but the coach refused to take him back, in the belief that this might straighten out his head. It did, at least for a time. "It was the best thing that happened to me," Strawberry says.

In his junior and senior years, Darryl became the Straw that stirred Crenshaw's drink, a selfless player on both the basketball and baseball teams, and what struck both Hurst and assistant basketball coach Joe Weakley were qualities that Moseley had seen years before: an inordinate sense of pride—a real distaste for losing—and a willingness to learn, a receptiveness to teaching. "He hated to look bad; he hated to lose," says Hurst.

Playing rightfield and pitching occasionally, Strawberry hit .400 his senior year, with five home runs and 18 RBIs; he was the high school sensation of the country. He had it all: power, speed and an arm to boot. In June 1980 the Mets made him the No. 1 choice in the free-agent draft. Brother Michael joined the Dodgers' farm system that same year, but by now it was Darryl, heading for Kingsport, Tenn., in the Rookie League, who was the Strawberry picked to make it.

"That little town of Kingsport had a press conference," says Chuck Hiller, the team's manager at the time. "I never saw that in the Rookie League before. I just broke him in slow, a big old gangly guy, like he is now." And more lonesome than he thought it possible to be. Ruby had woven a tight family ("I'm close with all my kids," she says. "We're just like brothers and sisters") and it was the first time Darryl was away from home. He called every day, collect, his voice mournful and subdued. "He was so pitiful," Ruby says. "He was just lost. I'd get the phone bill and almost faint. I told him, 'The money you got is going to be gone if you keep calling.'" Strawberry had arrived in Kingsport about a month late, after successfully holding out for a signing bonus of $200,000, and what Hiller recalls most vividly is Darryl hovering outside his office door, standing there before and after games, wanting to talk about anything. "Well, come on in," Hiller would say. The whole season was painful. "It was very lonely," Strawberry says. "Gee, they were very kind people, but I didn't think I'd ever get out of there." When he finally did, hitting .268, with five

home runs and 20 RBIs, there were murmurings among Met officials that perhaps they had made a mistake in drafting him.

So, too, in 1981, when he went to Lynchburg, Va. and again struggled during the first part of the season. But then he got himself together and wound up hitting 13 homers and knocking in 78 runs. "His work habits on the field weren't real good the first third of the season," says his Lynchburg manager, Gene Dusan. "Then he started pushing himself and concentrating." At one point, Strawberry thought of checking out and going home. "I was confused," he said.

"There was a lot of pressure on him, and he didn't know how to handle it," says catcher Lloyd McClendon, his roommate and confidant in Lynchburg for a spell. "He went into a shell and tried to deal with his problems on his own. He was troubled. There were times when he talked about going home. I told him, 'Hang in there. Keep your head on right.' He was young, he didn't have good work habits. In this game, it's easy to stay in bed all day, especially on the road. What Darryl didn't understand is that you have to get your body regulated. You've got to get up early, walk around and do things—go to the mall, take in a movie. It's very easy to lie around and grab a bite and go play. But you're not getting yourself ready either physically or mentally to play the game."

Whatever it was that hounded him in Kingsport and Lynchburg and raised doubts about his future in the game, vanished in 1982. Playing for the Jackson (Miss.) Mets, he tore up the Texas League, hitting 34 home runs with 97 RBIs and becoming the league's Most Valuable Player. "In Jackson, he just put it all together," says Dusan, his manager there, too. There were days Strawberry astonished his coaches. In Shreveport that year, after dropping a fly ball that cost a run, he came to the plate with two men on to a standing chorus of hoots and jeers. "With one swing of the bat, he silenced that crowd like I'd never heard a crowd silenced in my life," says Bobby Valentine, Jackson's first-base coach at the time. "The ball went so high and so far, I was in awe."

Strawberry went to spring training with the Mets in 1983 and played extremely well—but the team cautiously decided to send him back to Tidewater. However, when the parent club floundered, he was called up with predictable hype and hoopla. It's no wonder, then, that Soto fanned him three times, that he froze and grew tentative at the plate, and that the savior of the franchise collapsed so totally into that slump that he seemed about to disappear altogether.

"It was the most difficult time of my life," Strawberry says. "I was nervous, scared. Being in the majors, going to play in all those big parks in front of all those people. And you hear your name announced. It kind of gives you the jitters. That's what it did to me, especially when I tried to pressure myself to do well, to try to hit home runs, to show people what I could do. I got off wrong, thinking that way. I wasn't staying within myself. I was overswinging, uppercutting, giving the pitchers too much credit. I came in cold, trying to save the ball club. I was trying to do things I couldn't do. I had to find myself again, to really believe in what I could do at this level of ball."

In the midst of these agonies, during a three-day road trip to Montreal in mid-June, Howard and Frey decided to bench Strawberry in hopes of getting him to relax and regroove. And also to make him work harder. "They felt I wasn't putting out enough, and they were right," Strawberry says. "But I didn't know it. I wasn't aware of it. It wasn't attitude. I was struggling, confused. I was thinking of so many things: girlfriend, family, being in the big leagues, going from city to city, new pitchers. I was suddenly in the majors with all these guys I'd been watching for years. Wow! I didn't know where I fit in. It hit me all at one time."

Strawberry had always had pillars to lean on—Moseley when he was a young boy, Dusan when he was a young man—and he suddenly had another in Frey. Says Strawberry, "I didn't know which way to turn, who to turn to, and Frey steps in like a father and says, 'I'm going to help you, but you got to help yourself, too.' I'm still green, but then I was really green. Frey's a great guy. He really helped me."

The two spent hours walking ball parks together in the quiet mornings and afternoons before games. They sometimes spent 40 minutes before a game just walking together. Some passages from the gospel according to Frey:

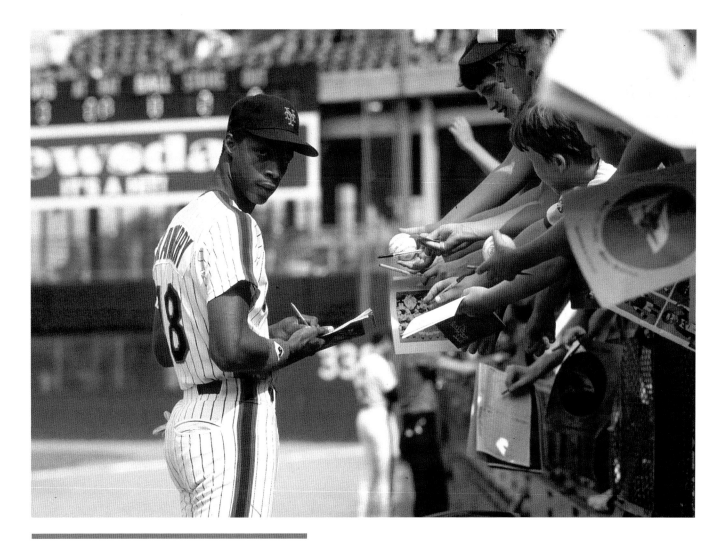

All eyes were on Strawberry throughout his Mets career.

"A lot of good things are going to happen over the next 15 years if you put in the work.... Study pitchers and get a feel for what each one is trying to do. Baseball can be so much fun if you think of playing in the majors as a gift. Fans and writers are dying to appreciate you and respect you if you just give them a chance.... Work on your defense.... A big salary is a player's reward for what he has already done. Most of the players you hold in awe aren't the players they once were.... Think, 'I'm the best player on the field tonight,' and you will be. Lock that in your head and nobody can take it away."

Only once during that first week did Strawberry fail to show up early. Frey upbraided him: "I'm not

going to chase you around the clubhouse, and I'm not going to call you and I'm not going to beg you to do what you should be doing."

Over the next 10 weeks, Strawberry never again missed a session with Frey, and gradually he came out of the slump. He grew more aggressive at the plate, and he shed his reluctance to hit balls to the opposite field. "I started turning things around," he says, "and all of a sudden I was back to myself."

Strawberry began 1984, his first full year in the big leagues, after an outstanding spring training in which he worked to level off his stroke, cut down on strikeouts—he fanned 128 times in 420 at bats last season—and hit to the opposite field. With Frey

gone, Strawberry's guru now is the well-traveled Bill Robinson, the new Met batting coach, who preaches from his own text: "The money lies in the RBIs. You don't have to hit a home run to drive in a run.... Think left-field, up the middle. Wait longer on the pitch. If a man can drive a ball to the opposite field like you can, doesn't it behoove you to use two-thirds of the field instead of just one-third?"

During the winter in L.A., Strawberry practiced batting in a park near his mother's home, where he was living. He's not a partygoer or a carouser. "I wanted to stay close to the family," he says. "I wanted to share my moments with them." He broke up with his fiancée, USC basketball star Paula McGee, last fall, but this winter he found another in Lisa Andrews, a former model who is now a loan coordinator in a Pasadena bank. They plan to marry in January.

"I'm going to take care of my whole family," Strawberry says. "I'm battling for all of them." Except for Henry Strawberry, of course, who has remarried and deeply feels the estrangement from his youngest son. "I've never been a part of his success," he says. "Sometimes I feel down about it, but what can I do? As long as he's happy, I'm happy."

At the moment, Straw is. He took some mild heat for statements he made this spring that he planned to take over as team leader, but he doesn't care. The Mets have needed a leader for years. "Leadership is going to be another challenge to me," he says. "I'm tired of getting ripped about how terrible the ball club is. How can this club get out of the cellar if it doesn't have any leadership?"

The question answers itself. For Strawberry, leadership began the only way it can begin, on the third pitch of the new season, when he took Mario Soto downtown. •

Strawberry spent eight seasons with the Mets, and led the NL in home runs in 1988, with 39.

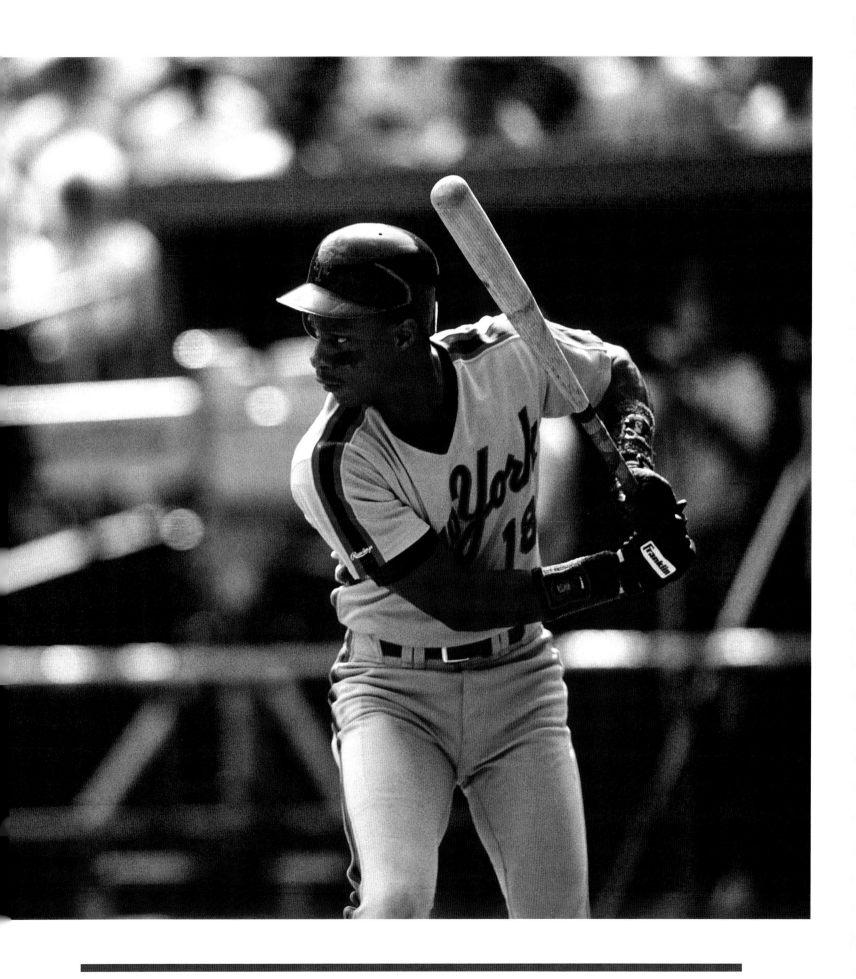

Excerpted from Sports Illustrated, October 13, 1986

HE'S STILL NOT HOME FREE

The Mets' brilliant first baseman and team leader, Keith Hernandez,
an indispensable man in the playoffs, must, as always, deal with doubts
and demons and a love-hate relationship with his father

by WILLIAM NACK

"Everybody thinks, because you make a lot of money, that you have a lock on happiness. It's not true.... I most fear boredom and loneliness, life after baseball. Life after baseball equals boredom and loneliness. I don't want to be a 50-year-old guy sitting and drinking beer in some pickup bar with younger people. I've seen it. I don't want to be that."

—KEITH HERNANDEZ

There is only one place where Keith Hernandez feels truly safe, only one place on God's green earth where he is at home. To be Keith Hernandez—arguably the finest fielding first baseman of all time, a lifetime .301 hitter, the indisputable leader of the New York Mets—requires just such a place, complete with a moat, wherein he can make a separate peace.

Oh, to be sure, he has that two-bedroom condo in that high rise in Manhattan, where he lives alone with his paintings and his books on the Civil War and his racks of wine and his new suits of clothes. Way up there, he can stand on the balcony on a summer night and look up at the lights on the Chrysler Building and down at the masses flowing along Second Avenue and say, as he did recently, "They can't get at me here."

But other things can, and they do. There is the telephone ringing, often incessantly. There are those long, empty spaces in his life in which self-doubt mounts and rides him like a witch. There are the periods of loneliness between girlfriends, which compel him to call his older brother, his closest friend, in a state of panic and say, "God, Gary, I don't like being by myself! There are 10 million people in New York and it's so lonely. I don't think I'll ever meet anybody again."

There is only one place of retreat away from all that turmoil, and that's where the earth is really green

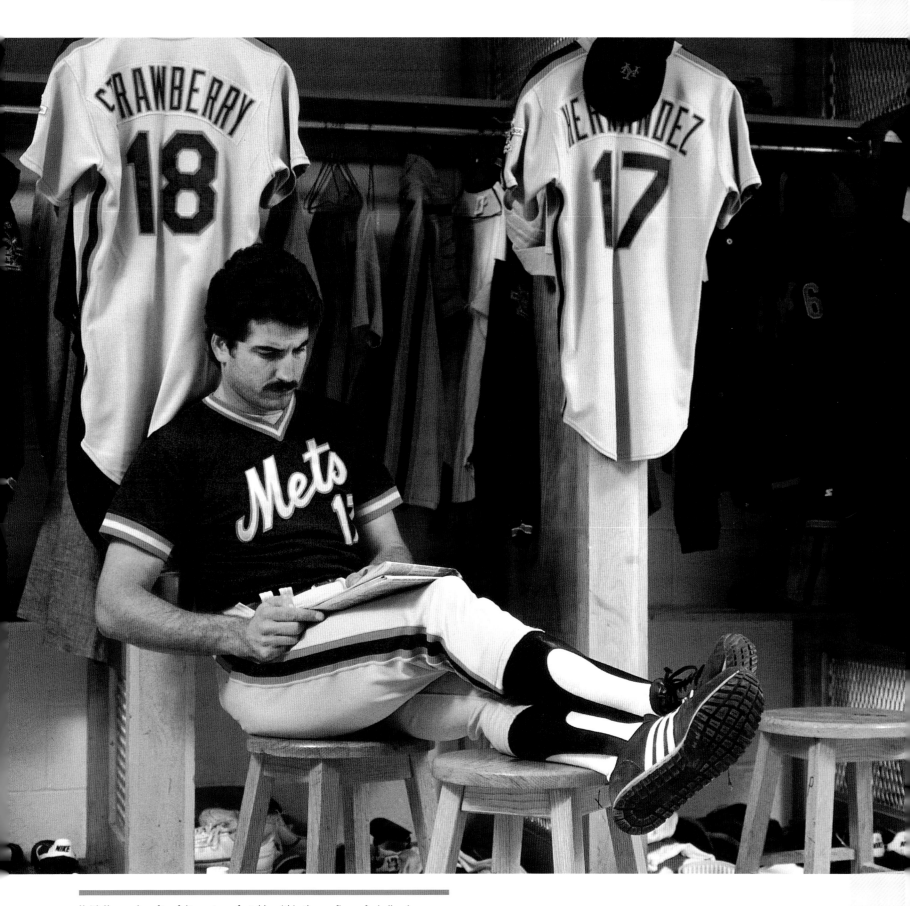

Keith Hernandez often felt most comfortable within the confines of a ballpark.

and the bases are white, where those wonderfully straight chalk lines embrace him in the orderly universe of baseball. Nothing intrudes upon him there. In fact, such is the intensity of his focus on the field that fellow players still marvel at Hernandez's performance in that fateful month of September 1985.

He had separated from his wife and three children and was in the first throes of a hostile estrangement. On Sept. 6 he appeared before a widely publicized Pittsburgh grand jury investigating drug dealer Curtis Strong, and for four hours testified about his use of cocaine between 1980 and early 1983, when he was playing for the St. Louis Cardinals. On the field, he was literally leading the Mets through a tight divisional title race with the Cardinals. In fact, just four days before he testified in Pittsburgh—an ordeal so physically draining that his suit was soaked through with sweat—he went 5 for 5 in San Diego.

Hernandez was captain of the Mets from 1987 to 1989.

Gary, a former minor leaguer who now sells insurance in northern California, says, "If I was about to go before a grand jury, I'd have been so distracted that I probably would have put my uniform on backwards. Keith seems to do better when he is under duress."

"I've never seen a guy, no matter what he has gone through, play like that under pressure," says Expo shortstop and former Met teammate Hubie Brooks.

Hernandez played with passionate clarity and grace that September. Despite what he was going through, he hit .373: 38 hits in 102 at bats. And he worked his usual wonders at first base on his way to winning his eighth straight Gold Glove.

So it's in that haven of the ball field where he finds his safety. "Baseball totally consumes me while I'm at the ballpark," Hernandez says. "If it hadn't been for baseball, I might have cracked. I've always been able to separate everything from baseball for three hours. Out in the field, no one can touch me. In a sense it's my sanctuary, a glass-house sanctuary. They can look in and see, but they can't touch."

There is one man, though, who can break through. John Hernandez, Keith's 63-year-old father, has been the most influential and dominant presence in his son's life. He is the man who taught him to play the game. He is the man who has so pushed and ridden him that at times they are barely on speaking terms. Only John ever broke into the sanctuary.

Just this summer—after a bitter falling-out over a dispute that had nothing to do with his father's being on his back, the usual source of their conflicts—Hernandez became so distracted that he sank into a batting slump that lasted two months. Keith had bought his father a satellite dish so that he could watch him play all over the country, yet the very thought that his father was watching infuriated him.

"I knew he was watching and I couldn't stand him watching," Hernandez says. "I'd be in the on-deck circle and I'd be thinking about him. I'd get up to the plate and be thinking about him. I'd go oh for 4 and I'd say to myself, 'Sit there and squirm.' I called Gary and said, 'I can't stand him watching me play.' I didn't have the concentration. It's the one time something got in between me and my play, and he doesn't even know it. That's why my slump was so bad."

Their relationship is complex, as is often the case between a father and son, but theirs is one right out of *The Great Santini*, filled with the sounds of clashing egos and the fury of resentments. John Hernandez, Juan to his son, is an obsessive and overbearing man who taught Keith how to hit and field, and the simple truth is that no one, no manager or batting instructor, knows the nuances of his swing half as well as his father does.

For years, John's understanding of Keith's stroke has been the tether that has kept these two men together. Keith knows that no one can help him out of a slump as quickly as his father can, and so, throughout his career, he has often turned to his father for help. At the same time, he has felt the compelling need to break away from his father and make it on his own, to be his own man.

"It's a paradox," brother Gary says. "Keith wanted to feel he could stand up and do it on his own. By the same token, my dad gave Keith a real big advantage—an ace in the hole. For Keith not to use it, to go through the miseries of a slump when he could get out of it much sooner, was really ridiculous."

Ridiculous or not, Hernandez has tried over the years to cut the cord. "I've tried to pull away but he won't let me," says Keith. "We've had major falling-outs. I'd tell him, 'Dad, I'm a man. I don't want to be reliant on you for my career. Dad, I'm 28.… Dad, I'm 30.… Dad, I'm 31.… Dad, I'm 32; I'm a man.' There would be no conflicts ever if he wouldn't force his help. If he had said, 'Anytime you need me, I'm here,' things would have been much better."

But, no, says Keith. "It was, 'If you don't want to hear this advice, you'll hit .240 this year.' He wants to take credit. He's told me, 'You wouldn't have made it without me pushing you.' You mean to tell me that of all the professional athletes in the world, all of them had a father that pushed and pushed and pushed on them? I find that hard to believe."

This relationship with his father has been the central conflict in Keith Hernandez's life. "He's got a love-hate thing for me," John says. "He loves me, but he hates me for some of the things I've made him do. He wants to love me, but he wants to fight me. He has so much natural ability that he takes the easy way

out. I would step on him for getting bored. I forced him. 'Put out!' I told him. People have said, 'Hey, you made Keith.' No, I didn't make him. You could take another kid and do the same thing with him and he wouldn't do a damn thing. He had the talent, so he could do it.… So many people have told him that I've made him, and that is just burning inside of him."

The love-hate thing, if that is what it is, developed long after the carefree days when John first put bats and gloves in his sons' hands. That was in the blue-collar town of Pacifica, a coastal community embraced by the San Bruno mountains some 20 miles south of San Francisco.

John's parents emigrated to America from Spain in 1907 and settled in San Francisco. John was a Depression child, and he grew up in the city channeling most of his energies toward baseball. He was a high school phenom as a first baseman. He hit .650 his senior year. The Brooklyn Dodgers signed him in 1940, for a $1,000 bonus, and he began his minor league career in Georgia. "An outstanding hitter," said Al Rosen, who played against him.

Whatever, the end came too quickly. He was at bat. The lights were bad in centerfield, and he lost sight of a pitch; he was beaned so badly that his eyesight was never the same. He played some baseball for the Navy in World War II—alongside Stan Musial, in fact—but gave it up shortly after the war. "It was a blow not being able to play again," John says.

He eventually joined the San Francisco fire department and moved with his wife, Jackie, to Pacifica. "It was a great place to grow up," Keith says. "Got home from school, cut through the fence and ran through the artichoke fields. There was love in my home. I have fond memories. Summers. Good weather and no school and a neighborhood of around 15 kids. We'd follow the creek back up to the mountains. Almost Huck Finn kind of stuff. And we played ball."

And played and played. Of course, John was the pusher and the shaker behind all this, determined to make his sons into ballplayers. "Baseball was like Dad's vocation," Gary says. "The fire department was something that put food on the table and paid the

bills. His passion was baseball and teaching us to play it."

John Hernandez threw himself into it. In their garage he attached a rope to a ceiling beam and at the end of it tied a sock containing a tennis ball. He watched for hours as the two boys swung at it. John can still hear them whacking at that ball. "They'd swing, swing, swing," he says. "Bang, bang, bang. You could hear them all day long. When the sock wore out, I'd replace it. A jillion of them."

And there were all those days of batting practice. John threw the BP, teaching them the strike zone and how to hit to all fields. Now and then, he would pile the bats and gloves and balls in the car and announce, "We're gonna go hit!"

"Nah," Keith would say, "we don't wanna hit today."

And Dad would say, "Get your butts in the car. We're gonna hit!" Into the car they would go. John would spend hours hitting them ground balls and pop-ups at first base. They were going to be first

basemen, just as he had been, by God! And then there were the baseball quizzes. "He gave us written tests," says Keith. "On situations. Thirty or 40 questions. I was eight years old when these started. He would write out situations and read them to us, and we had to answer where we'd be on the field, where the first baseman was supposed to be on the field at all times. On cutoffs. Double plays. I knew fundamentals when I was eight years old."

John made his wife a part of his private baseball school, too. At Little League games, Jackie was in charge of taking the home movies. These were not home movies to be enjoyed on a Sunday afternoon. No. "We'd get the film back and he would go over the swings," says Keith. "Fundamentally. Every at bat."

John immersed himself in his boys' athletic lives, particularly in Keith's. In Keith he saw early a potential major leaguer—the player that a high inside pitch out of those bad lights had kept him from becoming. Gary didn't have Keith's natural gifts, but he could play, too.

Hernandez finished his Mets career with a slash line of .297/.387/.429.

"If I hadn't had Dad's help, I wouldn't have become the baseball player I was," says Gary, who won an athletic scholarship at the University of California at Berkeley, where he became an All-America first baseman. "I don't think I could have gotten an education at Berkeley without that help. I was never one to turn my back on any advice my father gave me. I handled that differently than Keith did. He went through growing pains, and I think Dad was a little tougher on my brother. He was too hard on Keith.

"Don't get me wrong, though. Dad was always family-oriented. You could hug and kiss him, and you knew he was always going to be there for you. He'd stick up for you, not let you down."

But whereas Gary was outgoing, sociable and, in his father's words, "happy-go-lucky," Keith was intense, hyper, introverted and driven to succeed, even as a youngster. "He wanted it," John says. "He wanted it bad. I told him, 'If you want it that bad, I'm gonna teach you.'"

The thing about Keith, too, was that he was so sensitive and easy to hurt, prone to nightmares. "He'd wake up screaming," John says. "We'd try to calm him and he'd go 'No! No! No!' He told us later on that everything was moving fast and we were bigger than what we were and everything around the room was big. You could hardly wake him up. He had the fear of God in his eyes."

In contrast, his dad was tough and intimidating— from the old school of very hard knocks. John recalls the day when Keith came running up to the front door screaming that a neighborhood bully was after him. "Let me in!" Keith said. "Wayne's beating up on me!" His father opened the door and scolded him: "If you don't go out there and fight back, you can't come in the house anymore!"

John then slammed the door in Keith's face.

Like any son, Keith sought approval from his father, and it wounded him when he did not get it. Sitting in his den one evening last month, a reflective John Hernandez said, "Keith had that little inferiority complex, and I think he feared he would disappoint me. He thought I would never be satisfied with him."

And no wonder. When Keith was 13, his father thought he saw his son quit on the field, and when the ball game was over, he screamed at him: "Listen, don't you ever quit like that again! I don't care if you strike out 5,000 times! I don't want you to quit!" Keith was so shaken by the tirade that he went home, in tears, in the car of someone else's father. In another game, he went 2 for 3 at the plate, but his father chewed him out in front of several people: "You can't be a ballplayer the way you're hitting! You've got to come back on the ball and rock into it! All you were doing is hitting the damn ball!"

He drove his son. "Sure, I drove him," said John. "You can put that in the magazine. Put it down. That wouldn't bother me." [John Hernandez, however, did not want his picture in the magazine. He refused to pose. —Ed.]

The Hernandezes moved from Pacifica to the nearby town of Millbrae when Keith was a sophomore. At Capuchino High, a school steeped in athletic tradition, Hernandez starred as a quarterback in football, a ball-hawking guard in basketball and, of course, a first baseman in baseball. Thinking that Keith the basketball player was passing off too much, John once got so furious that he told him, "If you don't take 18 shots a game, you come in here and I'll kick you right in the butt! They're making an ass out of you out there." Keith didn't see it that way and kept dishing off to the open man. So, there was John, screaming in the gym at his son, "Keith, don't be a fool! Shoot!" John regrets this now. "I agree it's wrong. I could not control myself. Jackie was embarrassed. I embarrassed Keith."

All of this hyperventilating came to a head in Keith's last game as a senior. He was just a few points shy of breaking a scoring record, but in the second half, the opposing team went into a full-court press. Keith wisely passed the ball off to the open men breaking for the basket. Capuchino won because Keith broke the press, though he fell just short of the record. He returned home smiling, until John, furious and upset, began berating his son, calling him "stupid" for not shooting and not breaking the record. Keith fled the room in tears.

That spring, the star first baseman for the Capuchino Mustangs quit the baseball team, with his father's support, after a dispute with the coach.

That obviously spooked big league teams about his attitude, so the Cards were able to pick him up in the 40th round of the 1971 free-agent draft. When they showed little interest in signing him, Keith was ready to go to college. But that summer he tore up the Joe DiMaggio League, and the Cards went after him and signed him for $30,000. "Great coordination, a great stroke," says Bob Kennedy, then head of player development for St. Louis. "And he could really play defense. Very knowledgeable." At times the old man may have ridden Keith too hard, but he taught his son how to play the game.

Kennedy sped him through the farm system, and in 1974, his third season, when Keith was hitting .351 in Tulsa, he got the call to join the Cardinals. He batted .294 in 34 at bats and made the club to start the 1975 season. He was being hyped as the next Musial, a lefty with a sweet, fluid stroke. But he was suffering on and off the field.

Hernandez was filled with self-doubt about his playing, with all the insecurities of a rookie in the bigs. Away from the park he was extremely shy, often lonely, uncomfortable in crowds and wary of women. He had done the bar scene with the players since he hit the minors, and that had fostered in him a negative attitude toward women. Even today he tends to pull back when he begins to feel emotional intimacy in his relationships.

"One of the negatives of the game is that you're 18 and impressionable, and you have the veterans drinking in bars, and you meet night people," he says. "Ballplayers are night people. You meet people who hang out in pickup bars. You meet more undesirables than desirables. At that age, I think it makes a lasting impression. You're guarded, really guarded. I pulled away, but I wanted a good relationship. I wanted to be happy with one woman."

He had no one, so he lived alone in an apartment outside St. Louis, at times in despair. "I didn't like myself," Hernandez says. "I didn't like that I was a grown man and didn't talk to people, that I was afraid and so shy. Invariably I called Gary. I was a grown man, an adult, and couldn't socialize. Not just females. People in general. I would go to baseball functions, anywhere there were people, and I'd stand by myself

and hope that nobody would talk to me. There were a lot of nights back in '75 when there was no one to go out with. I was the only single guy on the team. I was lonely, and I'd go home and cry because there was no one to go out with. At times it would just build up and build up: 'Why can't I meet somebody?' Brutal. I was miserable…a stranger in a strange land."

Just as bad, he was feeling no acceptance in the clubhouse. One day he was listening to a conversation between pitchers Bob Gibson and Al Hrabosky two lockers away, and he chimed in with a thought of his own. Gibson snapped at him: "Shut up, rookie! You're just a rookie. Speak when you're spoken to!"

Later that year, he was sitting at the end of the bench just before a game when Gibson, of all people, walked over and sat down right beside him. For seven straight innings, Gibson lectured Hernandez nonstop about baseball: "Now watch the pitcher. Pitchers have patterns and you can pick up patterns. Watch the lefthanded hitters and how a pitcher throws to them, how he works them. And know your catchers. They often call pitches that they can't hit themselves."

Gibson explained that if a catcher is a dead fastball hitter and he has trouble with the breaking ball, he may tend to call the breaking ball. If a catcher is a breaking ball hitter and has trouble with the fastball inside, he may tend to call the fastball in. And on and on it went, the great Gibson presiding.

"I was stunned," Keith says. "In the seventh inning I had to urinate, and he's in the middle of a sentence and I said, 'Bob, excuse me, let me go to the bathroom. Be right back.' I couldn't pee fast enough. I couldn't get back fast enough." Dashing back, he sat down, and Gibson glared and said, "Don't you ever get up when I'm talking to you! Don't you ever do that again! I'm sitting here trying to help you, and you get up and leave!"

Hernandez is not being critical of Gibson. "He was the old school," says Keith. "It just blew my mind. I swore after that year I would never do that to a rookie, and I've never given a rookie any crap my whole career. I go out of my way to help them."

Hernandez was hitting .250 for the Cards when they sent him back to Tulsa in June 1975. The St. Louis batting instructor, Harry (the Hat) Walker,

had been asking him to hit every pitch to the opposite field, no matter where it was in the strike zone. John Hernandez had taught him to go with the pitch, to all fields, and now Keith could no longer pull the ball. Slumping, he was benched and finally sent back to Tulsa. There, manager Ken Boyer tried to help him regain his old stroke. He ended up hitting .330 in Tulsa, and that was it for minor league ball.

From 1976 to '79 Hernandez evolved into the complete ballplayer. But his development was far from a smooth sail. There were those damnable slumps, those calls to his father to ask what he was doing wrong, those periodic collapses of confidence. But there always seemed to be someone willing to push him and nudge him in the right direction. "I always had people there for me as I was coming up, because I always doubted myself," he says. "I still have my doubts. I've always needed someone to push me."

The year 1976 was pivotal in his life, both in and out of uniform. The nightmarish sense of aloneness that had hounded him in 1975 vanished when he got himself a roommate, pitcher Pete Falcone. And that was the year, at last, that he found himself a girlfriend, Sue Broecker, whom he first spotted sitting behind the dugout at a home game. He had a batboy pass her a note—"Something I'd never done in my career"—and they began a courtship that led to their marriage two years later.

When he was in a slump that year, veteran outfielder Willie Crawford forced him to take extra batting practice. "He made me come out every day," says Hernandez. "Made me! He said, 'You're not playing, you've got to hit to stay sharp.'" And Preston Gomez, the third base coach, forced him to take 20 minutes of ground balls a day. "Preston knew how to hit ground balls hard, where you had to stretch out. He improved my range by five feet. He made you go that extra half-step to get there."

And there was his father again, trying to help but pushing too hard and embarrassing his son. One day in Candlestick Park, Falcone looked from the dugout at Hernandez in the field and saw him waving his bare hand up and down by his face. "It was like he was waving at a bee hovering around his ear," Falcone says. Actually, Keith was signaling his father to be seated,

please. John was in the stands, waving his arms to get Keith's attention so as to give him some advice. Keith later told him, "You look like you're waving planes in on an aircraft carrier. Sit down!"

With all the advice and help he was getting from all directions—everyone was always waiting for him to be the next Musial—he particularly cherished the counsel of Lou Brock. "My philosopher," Keith calls him. As a son of John Hernandez, Keith has long dwelled on the mechanics of his hitting stroke. When he would make an out, Hernandez would tell Brock something like, "Gee, my hands weren't right." To which Brock would reply, "Ah, shut up! I don't want to hear that. Keith, when you go to hit, there are only three factors involved: you, the pitcher and the ball. Once it's released, it's only you and the ball. It becomes the question of who's better, you or the ball."

Perhaps the most valuable message he heard from Brock was to take charge of the infield. "Be an agent of action," Brock would tell him. "Don't be an actor affected by events. When a pitcher looks over his shoulder at you, he's looking for a sign of strength. A nod. A fist. You're the first baseman. You're the last guy to hand the ball to the pitcher. Give him a sign of strength."

"I'm not comfortable doing that," Keith would tell him. "That's not me."

"You have to do it!" Brock would say. "Take charge!"

The teachings of Brock eventually sank in, but it took time. After hitting .291 with 91 RBIs in 1977, he got off to a fast start in '78—he was hitting .330 at the All-Star break. But he promptly went into a swoon that left him with a .255 average by season's end. "I don't know what happened," he says. "I fell apart."

At the beginning of 1979, his most important year in baseball, he was hitting .230 in April, and St. Louis sportswriters were calling for his benching. He seemed lost. The year before, his father had felt the growing resentment whenever he intruded with advice. Falcone's metaphor took on new meaning as John Hernandez's words buzzed around Keith's ear.

"I don't want to hear it," he told his father. "I'd rather 9-to-5 it than hear this." That is, leave baseball

and get a 9-to-5 job. "Don't butt in anymore." It used to be that they would talk by phone, before the days of the satellite dish, and John could tell him what to do without seeing him. "He would describe his feeling up at the plate, and I would tell him what he was doing wrong, and it worked," John says. "But now he shunned me."

Boyer, managing the Cardinals by then, finally pulled Hernandez out of that April shower. On a team flight one day, Hernandez's old Tulsa manager told him, "You're my first baseman. Don't worry about what's being written. I don't care if you hit .100. You'll be there every day." That's all Hernandez needed to hear. At year's end he was the NL batting champion with a .344 average, and he had 105 RBIs. Along with the Pirates' Willie Stargell, he was voted the co-MVP of the National League.

Suddenly, no longer was he the shy, insecure ballplayer he had been. He felt more comfortable in crowded rooms, mixing at banquets and parties. "I overcame it because of ego," he says. "The MVP! All of a sudden everybody was lauding me. All that public adulation. It helped me become more secure."

He put two exceptional years back to back, hitting .321 with 99 RBIs in 1980. He seemed to have finally found himself. But 1980 was the year, too, that he separated from his wife and found cocaine. In front of that Pittsburgh grand jury, he called it "the devil on this earth" and described how he went on a three-month binge during the 1980 season, suffering nosebleeds and the shakes. He says that he began using it when someone offered it to him and that he did not know much about the drug at the time.

"It was ignorance," he says. "Not much was known about cocaine then. It wasn't supposed to be addictive. You can do it once in a while and that's it. It will not have the lure to draw you back. That's false. It was the biggest mistake I ever made in my life. To this day I think about it and say, 'Oh, damn! How stupid can you be?'"

He says he used it only recreationally, mostly on the road and after games, and got off it on his own in early 1983 because he no longer liked the high. "You can't turn it off like a light switch," he says. "It has to

run its course. You want to go to sleep and you can't. I didn't like the high anymore. I'm glad for that. It made it easier to get off. There is nothing good about it. I'm really proud I got off the stuff myself. I didn't go into rehab." In the meantime, Keith had led the Cardinals to the 1982 world championship.

There were rumors around baseball in 1983 that Hernandez had a drug problem, and Mets general manager Frank Cashen had heard them. When Cardinals G.M. Joe McDonald called Cashen and offered him Hernandez for pitchers Neil Allen and Rick Ownbey, Cashen made some inquiries about the rumors. "It did concern me, but I was told there was nothing to it," Cashen says. Cardinal manager Whitey Herzog says, "We needed pitching. Besides, Keith wasn't running out ground balls, and if there's one thing that gets to me, it's that. I would have traded Babe Ruth if he wasn't running out ground balls. The funny thing is, Keith never loafed on defense."

After the deal was made on June 15, 1983, Herzog called Hernandez into his office and broke the news. "We traded you to the Mets," said Herzog.

"Who?" said Hernandez, in shock.

"The Mets," said Herzog.

At the time, the Mets were in last place and appeared to be going nowhere. One of the first things Hernandez did was call his agent. Jack Childers, and tell him he wanted to quit baseball. "Can I live off my deferred income?" Keith asked him.

"Wouldn't be enough," said Childers.

So off Hernandez went to join the lowly Mets. "I had probably the worst attitude in my career playing out that '83 season," he says. Soon after the trade, brother Gary watched Keith take batting practice one day in Candlestick Park. Mets coach Bobby Valentine, now the manager of the Texas Rangers, was throwing, and Hernandez was simply waving at the ball, sending dribblers back to him. "I wanted to throw up," Gary says. He followed Keith to the clubhouse and confronted him: "What was that out there? Who do you think you are? That man was out there throwing batting practice and you were wasting his time! Do you think you're better than the guys here? You're not! You've embarrassed yourself and you've embarrassed me."

One of the finest defensive first basemen of all time, Hernandez won 11 Gold Glove Awards.

Keith took the scolding and started playing ball. He finished the season at .297. At Gary's prodding, he signed a five-year, $8.4 million contract with the Mets. Gary told him that New York was a place where his skills would be showcased, where he would be at the top of the heap, where he could meet people and make connections for that life he feared after baseball. Gary told him, "The team is not that bad. They have young players coming up. You could be a vital cog to get the whole thing going. This is your chance to shine."

In spring training of 1984, Hernandez could see the promise, the many fine young players in the organization. What he brought to that '84 Mets team was everything he had learned from his father and all the helpmates who had followed. He emerged as what Brock had always told him to be: the agent of action. "That's the great bonus we got," says Cashen. "We knew he was a great fielder, a great hitter, but the thing that nobody knew here was that he was a leader. He took over the leadership of this ball club. Gave it something it just didn't have."

In 1984, with rookie Mike Fitzgerald catching, Hernandez not only took over the positioning of the infielders but also chattered constantly at the pitchers. "He knew every hitter in the league," says former Mets pitcher Ed Lynch. "He always reminded you: 'This guy is a high-ball hitter. Make him hit a breaking ball….' 'Good fastball hitter.' If the count was 0-2, he'd say, 'Way ahead. Don't make a mistake.'" It got to the point, says Lynch, that he was always looking inquiringly to Hernandez when a hitter came to the plate. "If Einstein starts talking about the speed of light, you better listen to him," says Lynch.

While running the team, Hernandez also hit .311 for the year, with 94 RBIs. "That was the first time I was looked to for support," he says. "It was an emotionally draining year for me. When it was over, I was tired. I gave more of myself than at any time in my life to anybody else." When the Mets got catcher Gary Carter the next year, the pressure to guide the pitchers was off, but everywhere else Hernandez's presence was still felt. "I can't remember an at bat I've had when he's not on the on-deck circle giving me information," says Lenny Dykstra. "He'll tell you,

'Make this pitcher get his curveball over. If you get on base, you can run on him.' What is so important is he knows the catchers. 'This guy's a pattern catcher: curveball, fastball outside, fastball inside.'"

He had become, to the Mets, simply the best and most valuable player in the franchise's history.

Now, three years later, Herzog says of the trade, "I think we did him a helluva favor. I think he knows we did."

He certainly does. "It was a rebirth for me," Hernandez says. "Something I needed. I was kind of dying on the vine in St. Louis. I had played there 8½ years and everything was the same. I came here and got a new park, a new atmosphere, a new city. I got rejuvenated, like a complete blood transfusion. I've had more fun playing in New York the last three years than I ever had in my career."

It surprised him how much he came to enjoy New York. "There's so much here to fill your time—plays, parties, sporting events, great restaurants, museums. I love art." In fact, Hernandez owns a large impressionistic painting by the Spanish artist Beltran Bofill. He also has rows of books on the Civil War; he has been a buff for years. Hernandez, who has spoken at West Point on that war, will all of a sudden start chastising General George Meade for letting Lee get away after Gettysburg, as if it happened yesterday.

One of the first things Hernandez does when he gets up in the morning is begin *The New York Times* crossword puzzle. He'll take it with him to Rusty Staub's restaurant, where he often goes for lunch, and then he'll finish it in the clubhouse. "Lachrymose," he says as he lights up a cigarette. "That's probably 'teary.'"

His smoking habits are worthy of careful study. Hernandez usually smokes only at the ballpark, never at home. Two weeks after the season ends, he loses the urge and does not smoke again until he hits the clubhouse in spring training.

Despite his inner turmoil, Hernandez is a calming, reassuring influence on his teammates. He is looked upon with a reverence and affection rarely seen in a game played by men with large and often fragile egos. When Rafael Santana joined the club as a shortstop in 1984, it was Hernandez who took him aside. "He

told me, 'Anything you need from me, any advice, just ask,'" recalls Santana. "He's my best friend on this ball club," says Darryl Strawberry. "I love him."

Ron Darling and Hernandez are especially close, and Darling sees a man of many natures: "He has a dichotomy of personalities—very personable, very caring, very loving, yet very tenacious and aggressive." Darling recalls the night this season in San Diego when he got yet another no-decision after manager Davey Johnson pulled him after seven fine innings. "The no-decisions had been piling up, and I was a little down. When I got back to my room, there was a bottle of Dom Pèrignon waiting, with a note from Keith." The note said, "Enjoy this. I hope it will help you forget. Your friend, Keith."

If only all of Hernandez's relationships were as smooth as the ones in the clubhouse. The divorce fight has grown more bitter, and Hernandez fears that it will end up in court and that his three children—Jessica, Melissa and Mary Elise—will suffer the most. His relationship with his father is more strained than ever, worsened now because Gary no longer mediates their disputes. The falling-out between Gary and John happened after baseball commissioner Peter Ueberroth ruled last February that Hernandez was one of seven players who had to either accept a one-year suspension from baseball or donate 10% of his base salary to a drug prevention program and 200 hours over two years to drug-related community service work. John wanted Keith to take the suspension, telling him, "You'll be subservient to this man the rest of your career!" Gary argued that Keith had gotten off easy and that he should pay the fine and serve the time. Gary and John haven't spoken since.

One day Keith asked his father, "Dad, I have a lifetime .300 batting average. What more do you want?"

His father replied, "But someday you're going to look back and say, 'I could have done more.'"

Hernandez's friends well know the conflict. Lynch says he once heard Keith say, "God, why doesn't he leave me alone?"—then a half hour later he heard Keith on the phone asking his dad for help with his stroke. After a game one night last year, Keith, whom everyone calls the Mex, turned to Staub, formerly Le Grand Orange, and said, "Orange, the Mex stinks. I talked to Juan last night."

"You look a little different swinging the bat," said Staub.

"Yeah, I talked to Juan and he said, 'I used to not see the word Mets on your shirt. Now I can. Bring your hands up.'"

Soon after Hernandez made the adjustment, he went on a tear. That is how well the father knows his son's batting stance. Lynch recalls answering the phone in Keith's condo and speaking to John, whom he had never met. "After I told him who I was, you know what he said? He said, 'You're pitching against the Cubs next week. Ryne Sandberg has been swinging at the first pitch lately.' I thought, this is Keith's dad."

Thanks, or no thanks, to John, Hernandez keeps performing at the highest levels. "I'm expected to hit .300 and drive in 90 runs," he says, "but there are times when I wish I were a .250 hitter. There are times when I go out there and wish Darryl had this at bat, or Gary [Carter]. It doesn't happen often, but I'm human."

Gary Hernandez looks forward to the day when Keith retires. "There won't be the pressure that Keith puts on himself to be the top player that he is," says Gary. "He won't feel the pressure from Dad. And Dad will have to think about other things to do. They will be able to relate as human beings and not have everything keyed around Keith's performance. I won't be stuck in the middle. So things will be better all the way around."

Keith, too, thinks of retirement, of his life 10 years hence and the future he fears. He has this dream. "I want to be on the Pacific Coast. An accomplished sailor. A 30-foot boat. Sailing to Hawaii. Lying on the deck with a beer, with friends. Deep-sea fishing. Drop anchor and fish at night. Tranquil. The seas are calm. Nice breeze. The water is hitting the boat. Birds. The wind flapping a flag on the boat. The sound of water."

But of course. There he is, floating in middle age across the ocean. The boat, you see, is yet another sanctuary, surrounded by the biggest, most embracing moat of all. •

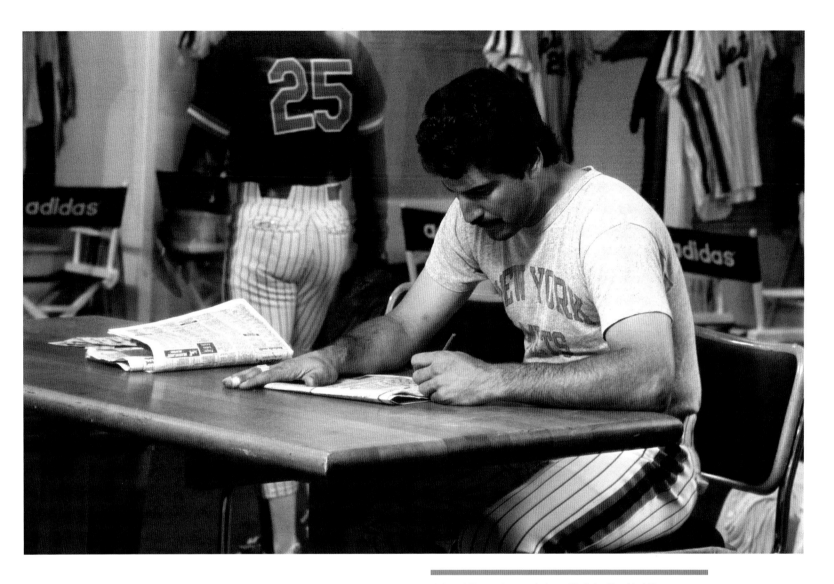

(Above) Hernandez regularly tackled the *New York Times* crossword puzzle. (Opposite) Hernandez and the Mets are introduced during the NLCS in 1986.

Excerpted from SPORTS ILLUSTRATED, November 3, 1986

GOOD TO THE VERY LAST OUT

The Mets, one strike from defeat, staged a couple of remarkable comebacks to deny the Red Sox their first World Series in 68 years

by RON FIMRITE

There were two outs in the ninth inning Monday night, and the Mets were ahead for good, 8–5, in the seventh game of the 1986 World Series. The Shea Stadium fans, frenetic but orderly for a change, were on their feet crying for the final blow, and the mounted police were preparing a charge from the bullpen to barricade the field. Boston's Marty Barrett, who had tied a Series record in the second inning when he got his 13th hit, was standing at the plate in swirling mists, a ghost of Series past for all those Red Sox fans who have dutifully borne more than their share of suffering.

And then someone tossed a red smoke bomb onto the grass in left centerfield. What cruel symbolism. There went a season of hope, an incredible escape from defeat in the playoffs and a World Series of such promise (two straight wins at the start) and maybe the last chance for New England fans to believe that it's possible for their team not to bomb in the big ones. There it all went, up in a puff of red smoke. When Shea functionaries finally defused the bomb, the determined Barrett resumed his stance at the plate—and struck out.

Actually, the season had gone up in smoke for the Sox two nights earlier in Game 6 when they came within one strike of their first world championship in 68 years. Even in this final game, they were breezing along with a 3–0 lead entering the bottom of the sixth, but as students of Red Sox history recall, they also led 3–0 in the seventh game of their last Series, in 1975 against the Reds.

It was in this Series' sixth inning that Boston's tiring starter, Bruce Hurst, manfully trying to win his third game of the Series, finally pooped out. Hurst had pitched 17 innings entering the seventh game and had allowed only two earned runs. He had held the Mets, swinging viciously, to one hit and no runs for the first five innings, but he was trying to pitch

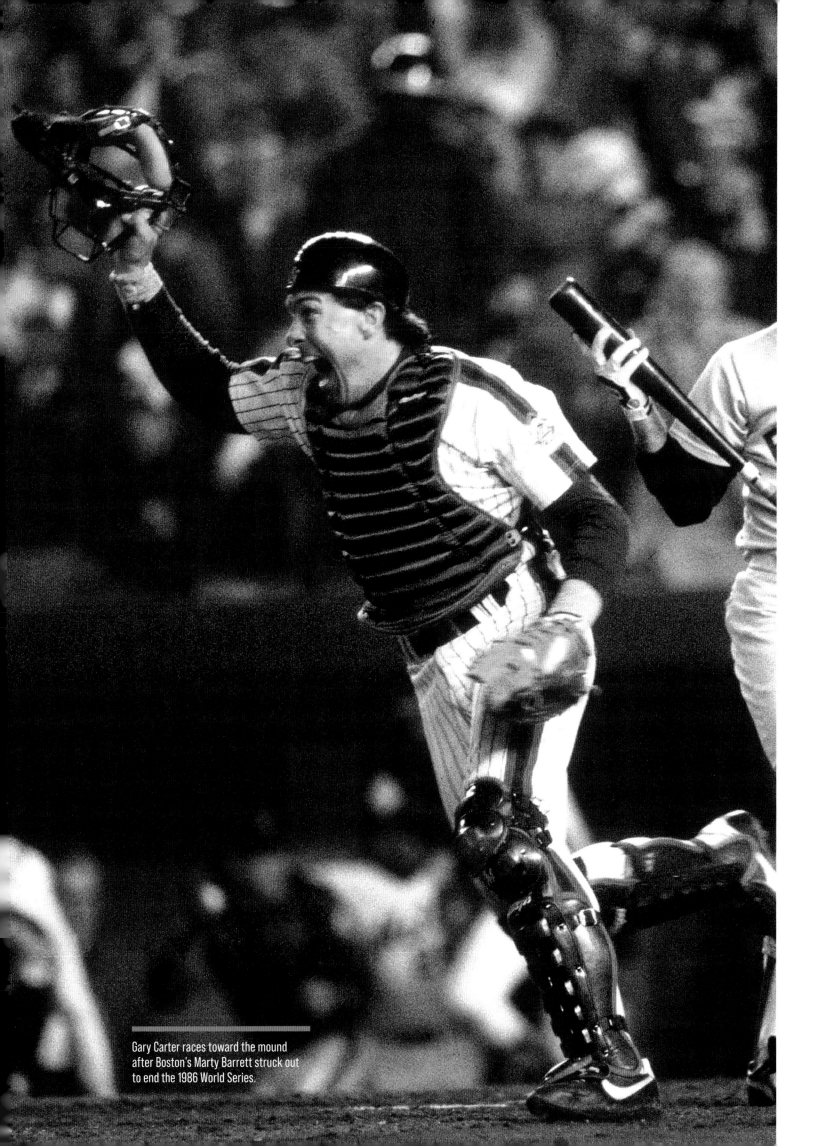

Gary Carter races toward the mound after Boston's Marty Barrett struck out to end the 1986 World Series.

on only three days' rest, and after 74 pitches, his arm simply gave out.

Hurst was starting in place of Dennis (Oil Can) Boyd, the pitcher manager John McNamara had originally ticketed for the Series finale on Sunday. But Sunday was a day of rain, and McNamara decided to go on Monday with his proven winner. The manager informed a distraught Boyd that he would be the first one out of the bullpen should Hurst encounter trouble, but McNamara, as it turned out, would break his promise. Boyd was inconsolable both before and after the game. "I wanted the call," said the Can, sobbing in front of his locker after the loss, "but I didn't get the call." Hurst did, and he carried that 3–0 lead into the sixth, the result of a three-run, second-inning outburst against the Mets' starter, Ron Darling, who, like Hurst, was making his third Series start. But in the sixth, consecutive hits by

Game 6 was briefly interrupted by an uninvited parachutist.

pinch-hitter Lee Mazzilli and Mookie Wilson and a walk to Tim Teufel loaded the bases. Then Keith Hernandez hit a ball "up in my lips" to center to score two, and Gary Carter looped another ball to right that Dwight Evans almost caught. That tied the score, although Hernandez was thrown out on a rarely seen 9–6 fielder's choice.

The Mets' strategy throughout the Series had been to somehow get past Boston's effective starters and get to a bullpen that lacked depth and, especially, lefthanders. "I wouldn't have said this during the Series," Mets second baseman Wally Backman said after the big win, "but we knew that if we got to the bullpen, it would be no contest."

Hurst was gone after his sorrowful sixth, replaced by Calvin Schiraldi, a sad-faced righthander who had suffered the wrath of the Bosox gods two nights earlier. Schiraldi got to 2 and 1 on Ray Knight, leading off the seventh, then threw him a fastball that Knight lined into the drapery beyond the leftfield fence for the tie-breaking run. Knight, who had three hits in the game and was named the Most Valuable Player of the Series, bounced around the bases in obvious recognition that the game was now going New York's way. That's what Frank Sinatra's voice on the deafening loudspeaker system also seemed to be saying—"I want to be a part of it"—as Knight made his gleeful journey. "I proved I'm not Ray Lopez," he said later, in reference to his more celebrated wife, golfer Nancy Lopez. "I've told Davey [manager Johnson] that I'm a winner."

The Mets got two more runs in the inning off Schiraldi and Joe Sambito, a seldom-used lefty, and seemed to be winging. But the Sox were far from finished. In the eighth, they closed the gap to 6–5 on singles by Bill Buckner, the limping first baseman, and Jim Rice and a long double in the gap to right center by Evans, who had started the evening's scoring in the second with a leadoff homer completely over the leftfield pavilion. But in the eighth, McNamara, still passing over Oil Can, reached deeper into his bullpen and brought in Al Nipper, nominally a starter. Nipper threw two strikes to Darryl Strawberry, leading off the inning, and then another pitch, which Strawberry hammered over the fence in rightfield. Strawberry did

a very slow turn around the bases to show up the Red Sox, and if these two teams meet again in the near future in the Series, or if baseball institutes interleague play anytime soon, the Mets' star can expect to hit the dirt.

Streamers were sailing from the stands now onto the field as the crowd readied itself for the big celebration. The Mets' last run was almost an insult, as Jesse Orosco, the ace lefthander of the New York bullpen, faked a bunt and bounced a single through the infield to score Knight from second. McNamara replaced Nipper with Steve Crawford, his sixth pitcher of the night. But the damage, the final damage, had been done.

The Mets were right. The secret was getting to the bullpen. In the last two games in New York, McNamara's relievers gave up 10 hits and 9 runs in 4⅔ innings. For the whole Series, the sorry numbers were 13 runs in 15⅓ innings. Pitching depth had won the Series. The Mets went with only three starters—Darling, Gooden and Ojeda—in the Series, but they got good bullpen mileage out of regular starters Sid Fernandez and Rick Aguilera, who joined the star relievers, Orosco and Roger McDowell. Orosco retired 16 of the 18 batters he faced, earning two saves without giving up a run. Fernandez, who relieved a tiring Darling in the fourth inning of the final game, shut down the Sox in the middle innings. "He was the unsung hero of the game," said Hernandez. Fernandez had wanted a start, but Johnson, reluctant to use lefthanders in Fenway Park, kept him in the pen, with salubrious results. Fernandez was disappointed that he didn't start, but in the glow of victory he could say, "Hell, we won. Just to pitch in a World Series means a lot. After all, it may never happen again."

Orosco was the mop-up man in this one, and he threw nothing but breaking balls, setting down the Sox in the ninth as he retired his 11th, 12th and 13th straight batters in the Series. "I had a good slider," he said, "and if you have a good pitch, you should stay with it." Orosco was also pitching with a mild case of strep throat, but he did manage a victory yelp when Barrett went down swinging for the final out. Orosco's teammates buried him in an avalanche of bodies.

The Mets had cause to be jubilant. Although they were overwhelming favorites to win the Series, they did it the hard way, losing the first two at home, just as last year's champion Kansas City Royals had. And though the Mets were undisputed winners, they were never exactly America's team. Their aggressive play, general cockiness and habit of high-fiving and showboating before their home fans—who expect it of New York teams—made them decidedly unpopular around the league, as four bench-clearing brawls during the season would seem to attest. But so what? They won. They were what they had been saying all along—the best team in baseball. And when the mayor of their city walked into their roaring clubhouse after the final out, the gangling Strawberry did a very Metsian thing. He kissed hizzoner, Ed Koch, on the top of his bald head.

"No one," said Carter, "can take the world championship away from us now, regardless of envy, hatred or jealousy."

The Sox? Well, they came close again, just as they did in '75 and '67 and '46, but they haven't won one of these things since Babe Ruth was their best pitcher, and the frustration of such a sorry history is beginning to sink in. "I don't believe in luck," said a melancholy Evans. "I don't believe in history, either, but maybe I'm starting to." And so what got off to a good start for destiny's stepchildren had a sorry ending. But there were some memorable moments along the way.

On Saturday, after a run of desultory yawners, the Series got the game it deserved, an improbable melodrama, wild and ragged, desperate and fierce, heartbreaking and heart-lifting. Somehow, in all the confusion and excitement, the Mets won 6–5 in 10 innings and tied the Series. This was hardly World Series play at its most efficient. There were five errors (and no more only because the official scorers were uncommonly charitable) and the two managers, bent on outsmarting each other, actually outsmarted themselves. But this game must be considered one of the most thrilling in Series history, one that combined equal parts of the famous Game 6 at Fenway in 1975 with its Carlton Fisk homer and Game 4 of 1941 when that Hugh Casey spitter and a Dodger win got

away from catcher Mickey Owen in the ninth. Until Saturday, Owen had been rated the World Series' top goat. Alas, now there is a new kid on the block. The tone for this one may have been set in the very top of the first when a parachutist in canary yellow, carrying a placard that said LET'S GO METS, dropped from the skies above Shea onto the infield with Bill Buckner at bat. Before the night was over, Buckner must have felt as if the sky itself had fallen in on him.

Roger Clemens started the game for Boston against Bob Ojeda, the Game 3 winner. Ojeda was pitching with only three days' rest while Clemens had had five, and during this, his wonder season, Clemens had been unbeaten in the eight starts he had had with five or more days' rest. After winning the first two Series games, John McNamara had decided, undeterred by the loss of Game 3, to throw a fourth starter, Nipper, to the wolves in the fourth game so that Hurst, Clemens and, if necessary, Boyd could finish up strong and well-rested. There had been so much talk in this Series about the therapeutic values of rest that one half-expected the participants to be wheeled, lap robes in place, to their positions by white-jacketed attendants.

Though neither he nor Ojeda finished, Clemens did indeed come on strong at the start. His fast-ball reached 95 miles an hour or better 27 times in the first two innings, when he struck out four. The trouble was, he was throwing too many pitches. By the sixth he had thrown more than 100, and a blister was developing on the middle finger of his pitching hand. He had reached 137 pitches after seven, so McNamara took him out in favor of Schiraldi, the Sox' ace "closer" since arriving in midseason from Pawtucket. Schiraldi immediately got into trouble, throwing a bunt away when he had a sure out at second base and finally giving up the tying run on a sacrifice fly by Carter, who swung with the count 3 and 0. And that was that until the 10th, an inning the likes of which the Series may never see again.

Dave Henderson led it off for Boston by club-bing an 0-and-1 fastball over the leftfield fence off Rick Aguilera. There's your story right there. It was Henderson after all, who got the Red Sox into the Series in the first place, rescuing them with a saving homer in the fifth game of the league playoffs, when they were all but dead, and then winning it for them with a sacrifice fly in the 11th. Henderson had started the season with Seattle and was not traded to Boston until August, when Mariner manager Dick Williams decided he was dispensable. He had hit only one homer for the Red Sox throughout the rest of the season, but the would-be Series winner on Saturday was his third of the postseason, as well as his ninth RBI. Presumably, Boston fans were even at that moment erecting his monument in Kenmore Square. Henderson was moved to lyricism by his own accom-plishments. "I thought it was the closing chapter of a fairy tale," he said. Just for good measure, the Sox got another run on a double by Wade Boggs and a single by Barrett. Normally fatalistic Red Sox fans began to smile.

Schiraldi quickly got two outs in the bottom of the 10th, the second on a long line drive to center by Hernandez that Henderson—who else?—caught up with after a heroic run. Hernandez flung his batting helmet onto the turf in disgust and repaired to the clubhouse for a contemplative smoke and to plan what was left of his ruined evening—"I was going to go out and get drunk and stay up all night." Two outs now, two runs up. The Red Sox were on their feet in the dugout. Boyd was doing an amusing dance. Their first World Series championship since 1918 was there for the taking. No more talk of Johnny Pesky holding the ball, of Joe Morgan hitting that blooper, of Bucky Dent lofting that damn homer into the screen. Now there was only Henderson and champagne. But hold on….

Carter, the would-be final out, hit a single to left on a 2-and-1 count. No big deal. Then Kevin Mitchell, a righthanded hitter who had to be fetched from the clubhouse because he thought his season was over, came in to hit for Aguilera, who was batting in Strawberry's fifth spot, the result of a soon-to-be-controversial batting-order double switch that had been arranged by Davey Johnson. Aguilera was watching in misery from the bench. He would soon be, he thought, the losing pitcher of the final game of the 1986 World Series. "My heart was breaking," he said. But Mitchell fought off an inside fastball and

looped it to center for another hit. Red Sox coach Bill Fischer trotted out to the mound to still Schiraldi's nerves. Hey, kid, only one out to go. Schiraldi quickly got two strikes on Knight. Then Knight singled to center and Carter, arms flailing, crossed the plate. Five to four. Mitchell made it all the way to third on the play. That was it for Schiraldi. McNamara replaced him with Bob Stanley.

This has not been a banner season for the 31-year-old Stanley, once the million-dollar ace of the Bosox bullpen. Some lackluster performances, coupled with his high salary, made him seem overpaid and overrated to the Fenway cynics. His every move was booed. One day last summer when he was driving to the ballpark, a car pulled up alongside, and the driver stuck his head out the window to berate him. Stanley's assailant became so exercised by the mere sight of the despised pitcher that in the next block, still distracted, he crashed his car into the rear end of another. Stanley is untroubled by such abuse. "That's O.K.," he said of his unpopularity. "When I'm on the mound in the World Series, they'll cheer me."

And so there he was, on the mound in the World Series only one out away from the anticipated cheers. "It's the dream of every major league pitcher to be on the mound for the world champions, to be there for the final out," he said. Mookie Wilson was the hitter standing between him and the dream, and Wilson, by his own admission, is inclined to "swing at balls over my head and in the dirt." This time, though, he was determined to have a memorable at bat.

Stanley went 0 and 1 on him, then 1 and 1, then 2 and 1, then 2 and 2. Wilson fouled off two breaking balls. Stanley decided to go inside with a fastball that would run away from Wilson toward the plate. Mets third base coach Bud Harrelson, meanwhile, had advised Mitchell, the rookie running at third, to be alert for wild pitches. Mitchell nodded nervously. Stanley threw his fastball. But it didn't sail away from the hitter; it stayed inside, heading for Wilson's ribs. If it were to hit him the bases would be loaded, but, said Wilson, "As intelligent as I am, my instincts took over, my instinct for self-preservation. I didn't want to get hit." He flung himself aside with a mighty jump, momentarily blocking catcher Rich Gedman's sight of

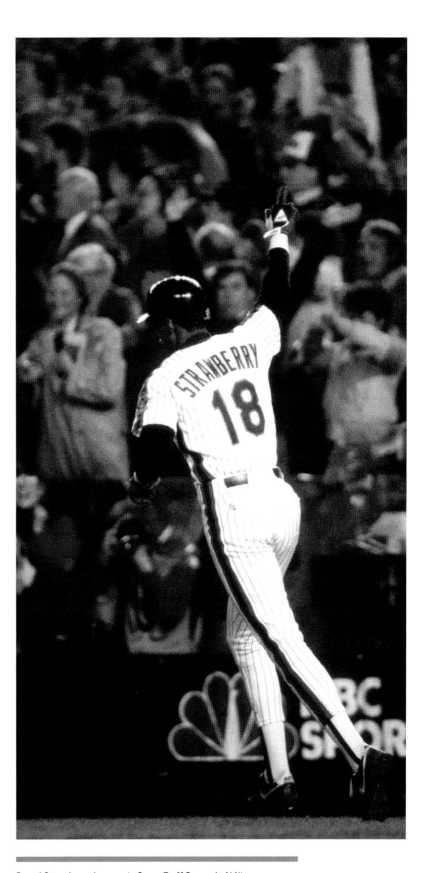

Darryl Strawberry homers in Game 7 off Boston's Al Nipper.

the ball. Mitchell also had trouble following the ball. He hesitated before making his break, unaware of Harrelson's shouts for him to go, go, go! At last he did go. "I didn't know if I'd make it. Four steps from the plate I was going to dive. Then I saw I didn't have to." The ball had bounced away from a cursing Gedman all the way to the backstop for a wild pitch. Score tied. Knight now on second.

The count now was 3 and 2 on Wilson. He fouled off the next pitch. He could see that Buckner at first was playing him deep, perhaps 30 feet behind the bag. With his speed, he knew he had a chance to beat out a ball hit down the line. Buckner knew that, too, and when Wilson hit the next pitch directly at him, the first baseman decided against going to his knees to make the catch, knowing that a throw from that position might not have enough on it. The ball was not hit all that solidly. "It bounced and bounced and then it didn't bounce," said Buckner. "It just skipped." It skipped under his glove and between his aching legs as Knight hopped crazily home with the winning run. The Mets were still alive in the World Series.

"I can't remember the last time I missed a ground ball," said Buckner. "I'll remember that one." So, he must know, will a lot of people.

The suddenness of the Red Sox' demise in Game 6, and their proximity to the Promised Land, might best be illustrated by what happened to NBC broadcaster Bob Costas and his crew in the bottom of the 10th. Costas was perched in the corner of the visiting dugout nearest to the runway leading to the clubhouse. It was past midnight, of course, because with the television-induced late starts, this had become the Witching Hour Series. Costas had taken up his position in anticipation of the historic Red Sox victory. The rest of his crew was already inside the clubhouse, busily setting up the interview platform, positioning the cameras and aiming the lighting. They were ready for the big moment.

When Backman flied out meekly to open the 10th, Costas edged toward the tunnel. Then when Hernandez lined out, Costas headed for the clubhouse, mentally preparing himself for the champagne-soaked interviews that would follow within minutes. Inside the locker room, Costas

learned that he would be flanked on the platform by Red Sox president Jean Yawkey and chief executive officer Haywood Sullivan, both of whom were waiting in the wings. Baseball commissioner Peter Ueberroth would be there to present the World Series trophy to them and to read a congratulatory message from President Reagan. Costas was told that Hurst, winner of two Series games, would be given the Most Valuable Player award. The cellophane was draped over the players' cubicles to protect their belongings from the spray of champagne. Costas decided to check the NBC monitor. Hmmm, Carter was on first base. The game hadn't ended. Then Mitchell got a hit, and Knight another. The game was far from over. Dave Alworth, the commissioner's liaison man for television, dashed nervously into the busy room. If the Mets tied the game, he told Costas and crew, they would have to clear out of there, bag and baggage, in a big hurry.

Then came the wild pitch to Wilson. "I swear," said Costas, "that ball had not stopped rolling before the technicians had packed up and gotten out of there. I had never seen anyone move so fast. I stayed behind to watch the monitor. And when that ground ball rolled between Buckner's legs, they just pulled the plug on me and hustled me out of sight. We were all gone by the time the Red Sox, uttering what epithets you can imagine, got back there. It was amazing. It all happened so fast. We just disappeared." And so did victory for the Red Sox.

McNamara will, of course, have to live with his decision to keep Buckner, hobbling on two injured ankles, in the game on defense with a world championship on the line. In the past, he has replaced him defensively in similar situations with the much more mobile Dave Stapleton—usually, however, after Buckner has been lifted for a pinch runner. McNamara actually had an opportunity to pinch-run for him in the Red Sox' half of the 10th when Buckner was hit by a pitch. But he left him in. "He has good hands," his manager said, "and he was moving pretty well tonight." McNamara's decision will also be long remembered.

Not as memorable, certainly, but equally baffling was Johnny Mac's continued reluctance to employ

his leading home run hitter, Don Baylor, in these Shea Stadium games. The designated hitter, Baylor's position, was allowed only in the American League park this year, but Baylor was certainly available for pinch-hitting service. And yet when the opportunities to pinch hit did arise, in Games 1, 2 and 6 at Shea, McNamara went to lefthand-hitting rookie Mike Greenwell all three times. Greenwell went 0 for 2 with a walk. Baylor played in more games, 160, than any of his teammates in the regular season, and he hit 26 of his 31 homers off righthanded pitching. Surely, he could not be expected to lose his touch in the Series. There was some speculation, for that matter, that Baylor might even play first base in Buckner's stead on Saturday against the lefthanded Ojeda. But no. The World Series for this fine player and dangerous clinch hitter had become strictly a home-field affair.

Johnson, for his part, certainly made a similarly unpopular decision when he did his switcheroo in the ninth, having Mazzilli bat in the pitcher's spot in the order and Aguilera bat fifth, in Strawberry's position. Johnson's reasoning was that Strawberry had made the last out in the eighth and his spot would not come up again soon. But it did in the 10th, and Johnson had to use the rookie Mitchell—a righthanded hitter, at that—in that critical position. Deprived of a chance to participate in the last glorious, gutwrenching rally, the biggest ever produced by a World Series team in extra innings, Strawberry was enraged. "The manager didn't show confidence in me," he said, overlooking for the moment the fact that he had not had a Series RBI and that, therefore, such a lack of confidence might have been justified. "I don't like the idea that it happened in a World Series. I was shocked. Of course, it was embarrassing. I'll never forget this. I have nothing to say to [Johnson].... He can go his way and I'll go mine."

Manager Johnson also made a peculiar move in the ninth when, with runners on first and second, nobody out and the score tied, he did not call for a sacrifice from pinch-hitter Howard Johnson. The man they call HoJo actually did foul off a bunt attempt on the first pitch, but swung away thereafter and struck out. The strategy of showing bunt, then hitting away,

turned out to be a dismal failure. The Mets' runners were left stranded on the bases.

A decision earlier in the week by Johnson to give his team a day off after the first two Series losses was, however, gratefully applauded by one and all. The Mets were, in fact, dragging badly after their playoff squeaker over Houston, and playing under the relentless scrutiny of their perfervid fans and the press had done little for their recuperative processes. They were actually looking forward to getting out of town to play in Fenway, which they talked of fondly as the antidote to their postseason hitting malady. And so it was. They had 13 hits in Game 3, a 7–1 romp behind Ojeda, over Boyd, and they had 12 more the next night in a 6–2 win over Nipper, the sacrificial lamb. Ojeda became the first lefthander to win a World Series game against Boston in Fenway since James (Hippo) Vaughn shut out the Sox in the fifth game of the 1918 Series. He also became the first pitcher to appear in a Series against the team he had played for the previous season. Asked afterward if he had any mixed, bittersweet feelings about demolishing his old teammates, Ojeda fingered his jacket with the New York logo and replied in amazement, "See this jacket? The last thing I feel is any bittersweetness. It's competition out there. Everybody wants to knock everybody else's socks off."

The Bosox turned out not only to be powerless against their former teammate, but they also embarrassed themselves mightily afield when in the first inning, having trapped both Hernandez and Carter off base on a ground ball, they failed to catch either of them. Lenny Dykstra had hit a home run as the game's leadoff hitter, and with the aid of the Sox' bungled rundown, the Mets emerged with a four-run inning, giving them more runs before Boston came to bat in Fenway than New York had managed in the whole first two games at Shea.

In Game 4, McNamara must have hoped that Nipper, who had missed six weeks of the season with a cut knee and had never regained past form, might become another Howard Ehmke, Connie Mack's surprise starter for the A's in the opening game of the 1929 Series. Ehmke, who had pitched only 55 innings all season, beat the Cubs 3–1 and established

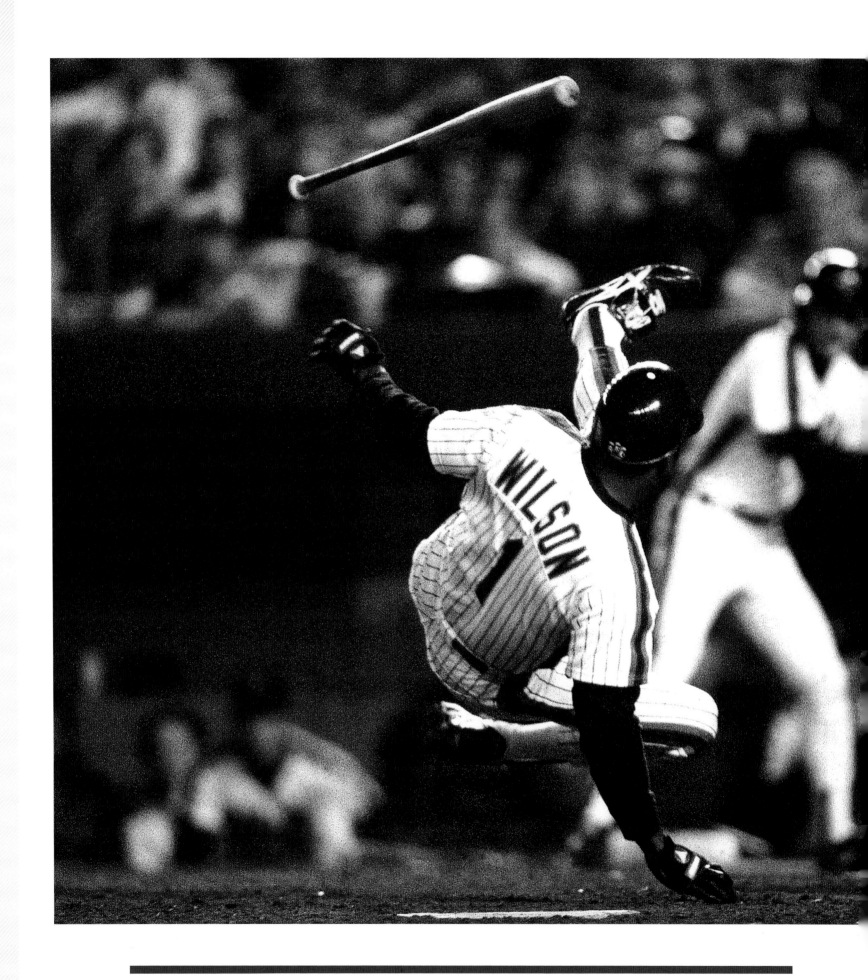

a Series record with 13 strikeouts. Nipper certainly had Ehmke-esque credentials. His season earned run average of 5.38 was the highest for a Series starter since Hal Gregg's 5.87 for the Dodgers in 1947. Nipper, it turned out, was no Ehmke, but he performed quite respectably. He shut down the Mets for the first three innings, then gave up three runs in the fourth. His successor, Crawford, served up a two-run homer to Dykstra, the littlest Met's second homer at Fenway in two games. Evans did get a glove on Dykstra's ball over the bullpen gate, but—shades of Henderson's quasi-catch of Bobby Grich's playoff homer—this one also got away. Darling, the winning pitcher, shut out the Sox for seven innings, running his string of earned-runless Series innings to 14. This was the fourth straight win for the visiting team, proof in Darling's view that "baseball makes no sense."

The home team finally won on Thursday, the Red Sox giving Hurst his second win, 4–2. This was the last game of the year at old Fenway, and thousands of fans stayed on afterward to revel in the wonder of it all. "Bruce...Bruce...Bruce," they chanted as the pitching hero waved to them during a postgame television interview. There was a sense of high anticipation in the air. The Sox were up, three games to two, and because their manager had been wise enough to start Nipper, they were going into the last two games with their pitchers in peak condition. For the second time, they had beaten the purported New York ace, Dwight Gooden. Surely, they could handle lesser men in the stretch. Even Buckner, who looked throughout as if he should be parking in handicapped zones instead of playing first base, was able to half-crawl home in the Fenway finale on an Evans single. Buckner may have been revitalized by an elixir sent to him by a holy woman from the La Salette Shrine in Attleboro, Mass. He examined the curious vial before the game, then, with a shrug, drained half of it. "Well, I've tried everything," he said, accurately enough.

Perhaps if he had chugged the whole thing, he would have saved the Red Sox and their faithful a great deal of grief. •

Mookie Wilson was nearly hit by a Bob Stanley pitch in the 10th inning of Game 6. Three pitchers later, he cemented his place in baseball history.

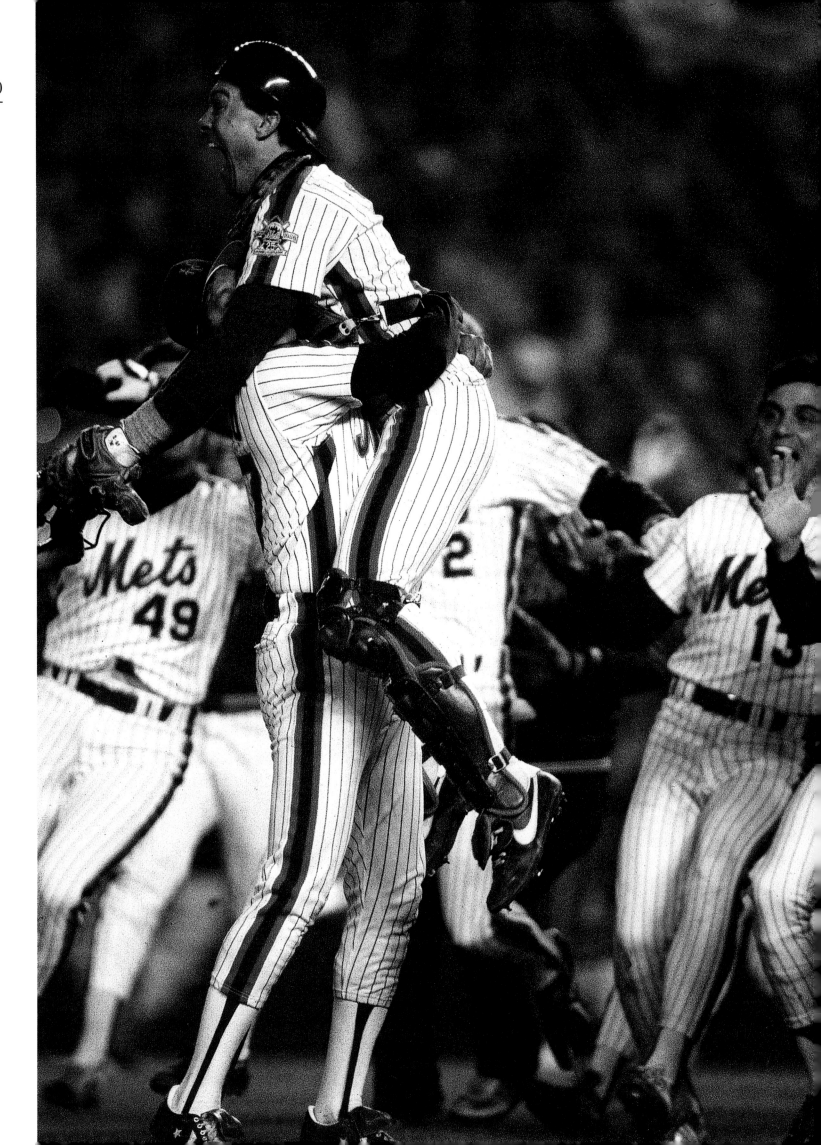

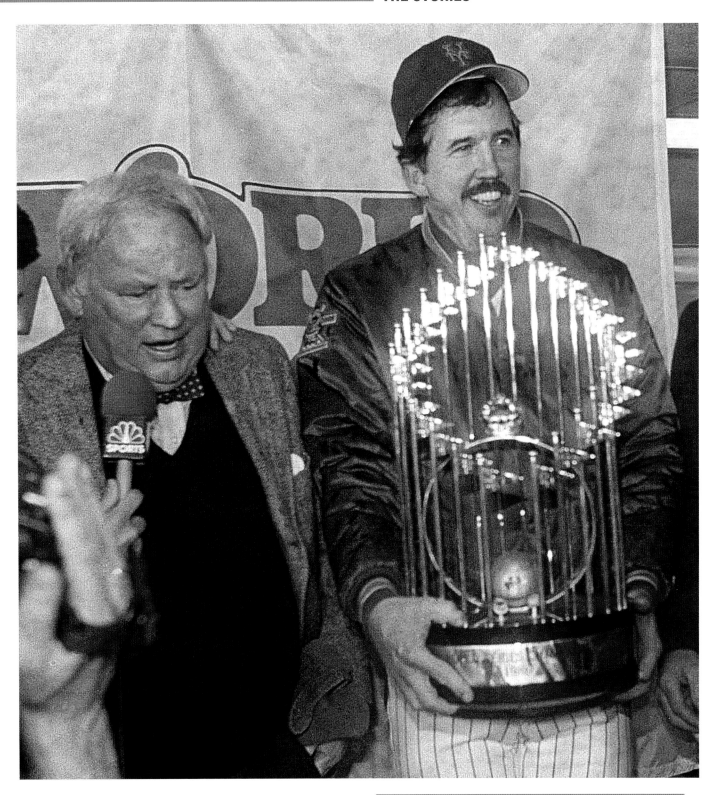

(Above) Mets GM Frank Cashen and manager Davey Johnson with the Commissioner's Trophy after winning the 1986 World Series. (Opposite) Carter jumps into the arms of reliever Jesse Orosco.

NOVEMBER 3, 1986

HE KISSED IT GOODBYE

BY ALEXANDER WOLFF

Amid all the "prettys" ("pretty unbelievable" and "pretty spent" and "pretty emotional"), and the hugs and the kisses, and the love—has any major leaguer, least of all a World Series MVP, ever professed love for *both* managers after a Game 7?—the emotions gushing forth from the Cabbage Patch face of Ray Knight early Tuesday morning made for a refreshing, sugary, Grand Old Game, Dating Game frappè.

Why, if you're counting Game 7 kisses alone, you'd have to include: the one Knight planted on Boston manager John McNamara ("The first manager I ever played fulltime for [with Cincinnati in 1979]. First day in spring training told me I'd be his everyday third baseman"). The one he blew toward his wife, Nancy Lopez, after he had completed his seventh-inning home run trot. The one he got from Mets coach Vern Hoscheit. ("I was one of those who wanted to get you off the club in spring training," Hoscheit said. "I've never been so wrong about anything in my life.") And the ones that Nancy fielded as if they were one hoppers to third. "Crybaby!" Keith Hernandez called her between busses. "MVP!" Right behind Hernandez, even commissioner Peter Ueberroth himself stepped forward to give Nancy a chaste peck. Later in a less gushy moment, Red Sox starter Bruce Hurst congratulated Knight in the hall outside the Mets' clubhouse. "You were the key," Hurst said. "You killed us."

Knight had wanted to hear those words all season. "I've been obsessed this year with coming back," he would say. "Tonight just capped it off." Indeed, the World Series was Knight's season in miniature. Benched cold for Game 2 after going hitless in the opener, Knight confronted manager Davey Johnson, saying that sitting him down was a mistake. Johnson said the matter wasn't up for argument. "It crushed me," Knight says. "He

underestimated my desire to win. I told him I loved him, but I didn't like him today." But just as Knight won the third base job in the spring, ignoring rumors he wasn't long for the club or would be platooned, he delivered an RBI double when Johnson started him again in Game 3.

Then, in Game 6, telling himself that "concentration is the ability to think of nothing," Knight sent his little Sof-Serv single into centerfield to score the Mets' first run in their improbable, impossible last at bat. And no, Knight says, he hadn't prayed for that hit in the on-deck circle in the 10th inning. He simply wanted a chance to redeem himself for the throwing error that had helped the Sox take the lead in the seventh inning. The homer, in the seventh inning Monday night off Calvin Schiraldi, came on a 2-and-1 fastball that ran inside. "I knew I'd hit it hard enough," he said. "I just wasn't sure it would be long enough." As the Mets took their first regulation-time, Shea-side lead of the Series on the first homer hit by a player in his home park, Knight fairly skipped around the bases. "What you saw is pretty much how I felt," he said. Nancy Lopez wasn't surprised by what she saw. "He got a lot of rest and slept late before he left for Shea," she said. "I told him if he played as good as he looked, he'd get three hits and a home run. I was pretty close, wasn't I?"

Right on the kisser.

All the embracing was just the logical culmination of the touchy-feely rituals Knight has practiced all season. Before every game, he shook coach Bud Harrelson's hand. He slapped two fingers with hitting instructor Bill Robinson, too. And touched everyone on the club before every game. "I'm not superstitious," he says. "I don't believe in voodoo. But I get a little bit from everybody, and I want everybody included."

Ray Knight scores the winning run in Game 6.

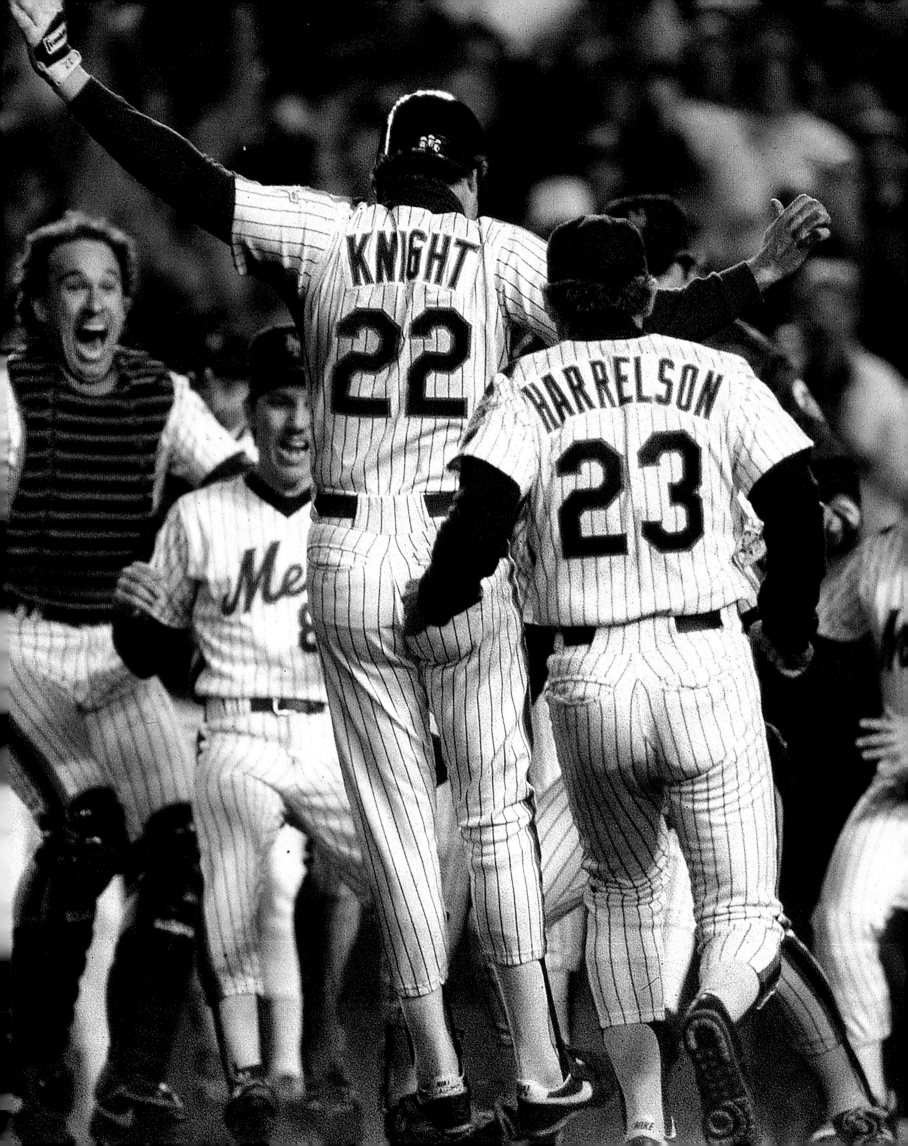

Excerpted from SPORTS ILLUSTRATED, April 6, 1987

MORE THAN A MEDIA DARLING

That Yale stuff is just so much boola-boola. Ron Darling of the Mets is first and foremost an excellent pitcher

by PETER GAMMONS

The subject was children, understandably. Ron Darling was driving his silver 1967 Mercedes back to St. Petersburg, Fla., to be with his wife, Toni, and three-day-old son, Tyler Christian, who had arrived one month prematurely. Darling had just pitched 3⅓ innings in Tampa against the Reds, and now, weaving through cars driven by suntanned and senescent drivers, he excitedly bounded from thought to thought, from Bernie Carbo to Noël Coward. Darling's mother, Luciana, was right when she said, "Ronnie has never had a thought that didn't create a spark—and he has a lot of thoughts."

"The better the children we produce," says the 26-year-old pitcher for the New York Mets, "the better the chance we have in this crazy world. I hear people say, 'We've got to wait to have children until we have accumulated enough wealth to afford them.' What does money have to do with raising children? It's the time you spend with them that matters. I know because I have the best parents in the entire world, and they came from nothing. I understand what it really means to be a parent because of them. Everything I am is because I'm Ron and Luciana Darling's son."

What he is and what the media would have us believe he is are two very different people. Yes, he seems to have the world at his feet. He's a Yalie and a pitcher for the world champions. His wife, Toni O'Reilly, is a model. He has appeared on *Good Morning America* and *Sesame Street*, as well as on the cover of *GQ*. Husband and wife have been featured in *People* and *USA Today*. HIGH GLITZ read the headline on *USA Today*'s front-page profile. SEXY, SMART, STYLISH—THE PERFECT COUPLE FOR THE WORLD'S BIGGEST STAGE.

"I get sick of myself," he says, "even though I know I'm not the person I'm portrayed as. People think

After studying at Yale, Darling faced questions about his commitment to baseball.

I'm a curio because I have what is perceived as an interesting résumé: Yale, English/Chinese/Hawaiian background, supposed Renaissance man, lives in Manhattan, married to a model, makes a million dollars. But that *USA Today* story ran the morning before the third game of the playoffs and never mentioned that I was pitching the next night." It also didn't mention that one of Darling's favorite childhood memories is of being with his dad on the early morning run to drop off garbage at a pig farm. Not exactly "high glitz."

"If I win 20, maybe I'll lose the Yalie tag and just be a pitcher," says Darling. However, he has yet to figure out how to get rid of the nickname Mr. P. The name, which stands for Mr. Perfect and which he resents, was given to him by Gary Carter, of all people.

"My parents taught me to strive to be great at one thing and to keep my eyes, ears and mind open to everything else," says Darling. "Sure, I'm one of those people with a curiosity about everything. But I'm also driven to the point of ridiculousness, and that drive is channeled into baseball. It is in baseball that I hope to achieve greatness."

Darling's father, Ron Sr., was what he himself calls "a welfare brat." His parents abandoned him at age four in the Vermont town of Danville, and thereafter Ron Sr. bounced from farm to farm, from family to family, from Lyndonville, Vt., to St. Johnsbury, Vt., to Coventry, Conn. He thought of studying agriculture at the University of Vermont, but he decided to see the world instead. So he joined the Air Force. While stationed in Hawaii he met Luciana Mikini Aikali, who was 14½ and going to school at the time. Her Chinese mother had died giving birth to Luciana and her twin sister. After her Hawaiian-Chinese father left home, she was raised by her grandmother. "Stray dogs, perfect for one another," says Ron Jr.

In 1962 the Darlings moved from Honolulu to the central Massachusetts town of Sutton, near Worcester, where Ron Sr. had found a job in a machine shop. Two years later they moved to Millbury, Mass., where they have raised their four sons. After Ron Jr. came Eddie, now 25 and a former Yankee farmhand, then Brian, 20, a student at New York University, and

Charlie, 18, a pitcher for St. John's, a parochial high school in nearby Shrewsbury.

"We knew what opportunities we didn't have," says Luciana, who once loaded UPS trucks to help support her sons' education. "So we wanted our children to have all of them."

Says Ron Jr., or R.J. as his father calls him, "Mine was a great upbringing. There was a time to work and a time to play. Certain things, especially homework and bedtime, were non-negotiable, yet it was an opinionated household that encouraged dissenting thought. When I was bored, my mom would leave me off at the library. My dad worked as many as three jobs. When I was five or six, I remember going with him to collect garbage. Every morning we'd get up at 5:30, dump pails of the garbage into a truck and take the load to the pig farm. Time with a brilliant man."

As soon as his eldest son was old enough for Little League, Ron Sr., now a supervisor in the machine shop, started coaching his baseball teams—and did so all the way through American Legion ball. Ron Sr. would give his namesake 100 ground balls and 100 swings every night. He was always there for his boys. He and Luciana never missed a practice, and even now they seldom miss one of Ron's starts at Shea Stadium or one of Charlie's at St. John's.

"Still," says Ron Jr., "the most important thing in my life, the thing that brought my family the most happiness, wasn't starting the first game of the World Series or winning the fourth game or being a first-round draft pick; it was the day that I was accepted at Yale."

It's hard to believe now, but Darling says of his undergraduate days, "I felt like a guy off the farm, without a social grace, who was always making a fool of himself. I was always one step behind in everything: Have you heard such and such a song? No. I was a year behind, unless they wanted to talk about Chuck Berry and The Coasters. How about this new film? I was a month behind. I was so shy, I didn't know how to ask a girl out on a date. I wanted to be a thespian, but I was too shy to go on stage. I'm still shy, only now people think that I'm snooty."

Darling had been a good quarterback, but at Yale they put him in the secondary. "I didn't want to be a defensive back, and my world was being opened to

too many other things. I didn't want to deny myself afternoon classes the entire year." He also began to grow physically with a little help from some weightlifting. "I went from 6 feet, 170, to 6'2½", 190, and when I went out for baseball that spring, I threw the hell out of the ball." Darling had mostly been a shortstop, but he became a pitcher as a sophomore and went 11–2 that year.

It was during his junior year at Yale that Darling lost an epic game to Frank Viola of St. John's University in the NCAA regionals, a game later immortalized by Roger Angell in *The New Yorker*. For 11 innings of the scoreless tie, Darling had a no-hitter, but he lost the game in the 12th on an error and a double steal. Darling probably would have been the very first pick in the 1981 amateur draft, but he wanted $150,000 to make it worth his while to leave Yale, which was too much for the pocketbook of the Seattle Mariners. The Rangers were willing, though, and took him as the No. 9 selection in the first round.

As a professional, Darling has had to cope with the Yalie label. "Immediately, there was the question of my dedication to baseball," he says. "People would say things like, 'Baseball isn't his priority.' Or 'He doesn't really like baseball.' That has always infuriated me. I *love* baseball. What was I taking those 100 ground balls and 100 swings for every night? Why was I in the bleachers, right where Carbo's homer went in that *other* sixth game? Why did I always stay up late when the Sox were on the Coast to watch Yaz bat against Nolan Ryan?"

That first professional summer, Darling made 13 appearances at Tulsa (4–2, 4.44 ERA). He went to the Rangers' camp the following spring. Manager Don Zimmer thought he needed only a couple of months of Triple A experience before he would be ready for the majors, but others in the organization ignored Zimmer. The Yalie was a disappointment to them. On April Fool's Day, 1982, in a trade the Rangers will long regret, Darling and pitcher Walt Terrell went to the Mets for Lee Mazzilli.

After two years at Tidewater, Darling made the club, and in 1984 he had a 12–9 record and a 3.81 ERA. But he was the other rookie on the club, because Dwight Gooden was 17–9 with a 2.60 ERA.

In 1985 Darling went 16–6, and Gooden went 24–4 and won the Cy Young Award. Darling understood pitching in Gooden's shadow. What he didn't understand was that he was still the Yalie.

"What people didn't realize was that I had very little pitching experience. At first I thought I was a power pitcher, when I'm not at all. My biggest problem was throwing enough strikes. I was behind 2 and 0 too often. I walked too many and made the game too difficult. I didn't know how to pitch. I'm such a perfectionist that I let my temper get the best of me at times. It just took time."

Little doubt now remains about Darling's ability. Paparazzi flashbulbs and Gooden's presence can't obscure the fact that he is one of the premier pitchers in baseball. He has added a devastating split-finger to his moving 88-mph fastball, his curve and his slider. Not only was Darling picked to open the World Series for the Mets, but in Games 1 and 4 he did not allow an earned run. "We hadn't heard all that much about him," said Boston's Dwight Evans after Game 4, "but he's the Mets' best pitcher. A fearsome competitor."

What still dogs Darling is his inordinate number of no-decisions—39 over three seasons, 13 in 1986. But the Mets were 26–8 in his starts last season, the best such percentage in the National League. "That is one statistic that I'm really proud of," says Darling.

Off the field, Darling has a multitude of interests. "I love New York," he says. "It's the greatest city in the world, whether it's a walk in Central Park, an art exhibition, a Noël Coward play or just the people." He's involved in a new restaurant in downtown Manhattan. Darling enjoys working in New York Governor Mario Cuomo's drug program. He has already written two plays and numerous short stories, and now he's writing a book about baseball.

"I believe that this is going to be a great year for me," says Ron Darling Jr., "beginning with the birth of Tyler Christian. What's my definition of great? As a pitcher, great is going out every fifth day, not missing a start and being a consistently productive element—the wins and the honors will follow. As a person, great would be to give my children half of what my parents gave me. Children are what the world's all about." •

(Above) Darling posted a 99–70 record during his years with the Mets.
(Opposite) He joined the Mets broadcast team in 2006.

Excerpted from SPORTS ILLUSTRATED, March 22, 1993

FROM PHENOM TO PHANTOM

A ghost of his former self, Dwight Gooden, at 28, tries to recapture the glory of his youth

by TOM VERDUCCI

There is one special memory from his wonder years that Dwight Gooden carries around like a black-and-white photograph tucked in a wallet. An image, until now, not for public display but for his own quiet comfort. "Do you want to know what it was like?" he asks, recalling the years in the mid-'80s when he was known as Dr. K. "If I had a one-run lead in the third or fourth inning and we were batting, I would sit there in the dugout and say to myself, 'Hurry up and make an out.' I mean, I wasn't exactly rooting against my teammates. But I was so pumped up that I couldn't wait to get back out there on the mound. That's what it was like. That was the feeling."

He laughs gently and tucks away the thought. "Now," he says, "it's like, Damn, three outs already?"

In sports, except for Olympic gymnasts and Filipino Little Leaguers, has age 28 ever seemed so ancient as it does for Gooden? Wasn't that another decade, another era—another pitcher—when he was great? He is starting his 10th season with the New York Mets. Among the current National Leaguers who have played for a single team, only Tony Gwynn of the San Diego Padres and Orel Hershiser of the Los Angeles Dodgers have been with their team longer than Gooden has been with the Mets.

If it seems long ago that Gooden became the first pitcher to strike out 200 batters in each of his first three seasons, that's because he reached that threshold only once in the six years that followed. And if his 24–4 Cy Young season of 1985 seems to have fossilized, that's because he has never again won 20 games. It is no surprise then to find Gooden at the Mets' camp in Port St. Lucie, Fla., as hittable as Jose DeLeon and as hopeful as Ponce: He is in Florida looking for his youth.

Before reporting to spring training, he shaved his head and requested that he be temporarily given

Sports Illustrated

What's Up, Doc?

Even Dwight Gooden doesn't know how much stuff he has left

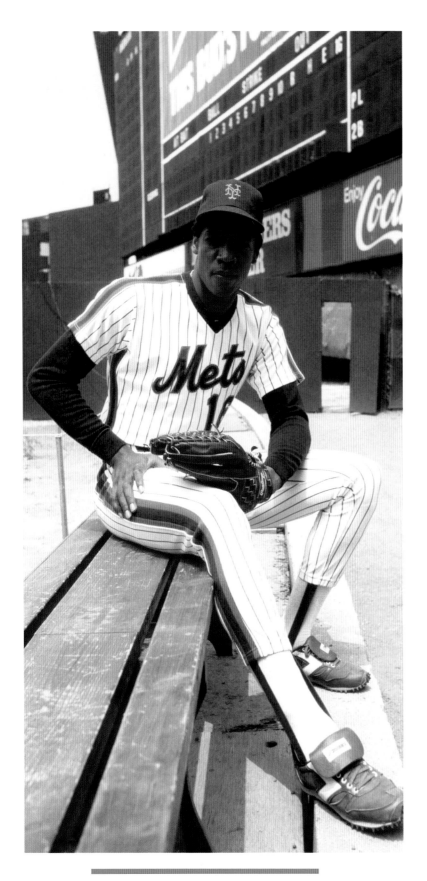

The Mets rookie poses before a game in 1984.

uniform number 64—the same numeral he was issued, at age 19, at his first big-league camp in 1984, the year he went on to win 17 games and strike out a rookie-record 276 batters. "I'm sound physically, my shoulder's fine, so I said, 'Let's go upstairs,'" he says. "You know, be sound mentally, too. I thought about my first camp, when I was just trying to make the team. Just get back to basics. Keep it simple and have fun."

But Gooden is as much an uncertainty to the Mets as any scrub, the kind of player who would normally be assigned a number more often found on a pulling guard or a speeding ticket. He is coming off the first losing season of his career, a 10–13 clunker made slightly more palatable by his having worked 206 innings in the year after he underwent arthroscopic surgery to his pitching shoulder.

The Mets aren't sure what they have in Gooden anymore, though he continues to be the emotional cornerstone of the franchise, a player revered in his own clubhouse and unfailingly respected in others'. "There is an almost universal affection for him," Met general manager Al Harazin says. "For us, he represents the best of the '80s, a symbol of that success."

On the mound, though, the Mets can be sure only of what he is not. The organization has finally let go of the notion that Gooden is the dominating pitcher he was in his first three major league seasons. It has come to grips with the fact that Gooden, even when healthy, has not been that pitcher for several years. "I think the fans have accepted it, too," Harazin says.

Gooden's earned run average over the past three seasons is 3.71—more than a run higher than his 2.64 mark over his first six years. His career ERA has risen for seven consecutive seasons, starting at 2.00 after the 1985 season and climbing to its current 2.99. He has pitched just two shutouts in his past 109 starts, or one fewer than he had as a teenager in 1984. After racking up 52 complete games in his first five seasons, he has completed just eight starts in the four years since.

"I don't see him getting back to where he was early in his career," says Gerry Hunsicker, the Mets' assistant vice-president of baseball operations. "I don't see him dominating hitters like he once did. I think this

year you'll get a look at the future. You'll get a lot of clues as to what to expect from him. It's been a year since he had surgery. He's 100 percent. He's entering a new phase in his career, and this is the year it will begin to take shape."

"He's right," Gooden says. "This year will tell. I'm anxious to see, too. It's funny, but I used to come to every spring training with certain numbers in mind, usually an ERA in the twos, 20 wins, 200-plus innings and 200 punch-outs. This is the first time I haven't thought that way. I just want to be consistent, that's all."

His comeback this spring has not begun without an occasional stubbed toe, which is what he got while covering first base in a fielding drill last week. Though the big toe on his left foot was not broken, it was tender enough to sideline him for several days and cause him to miss a start in what has been an underwhelming spring. (Before that, on Jan. 14, he was lucky to have suffered only contusions to his chest and forehead when, while driving his truck on a rain-slicked St. Petersburg street without his seat belt buckled, he veered to avoid hitting a car and slid into a mailbox.) Gooden has allowed eight runs in six innings without convincing himself that he can once again finish off hitters. His last start, a scheduled four innings against Montreal, ended after three because he had thrown 61 pitches. "I get the count to 1 and 2, and I'm still not putting them away," Gooden says. "I start overthrowing. I'm still in that rut."

Having lost his greatest gift as a pitcher, the natural movement on his fastball, he is Thor without the thunder.

He arrived in the big leagues as supple and as slender as a garden hose and with the perfect arm extension and release point for a power pitcher. "Every pitch he let go out in front with real good extension," Met pitching coach Mel Stottlemyre says. "That's where all the life on a fastball comes from. Most guys, you have to constantly remind them. With him, it was always there. Every pitch. Now it comes and goes."

Gooden started losing the hop on his fastball in 1987, after his return from a drug rehabilitation program. He began using a cut fastball, dropping his

arm a little in his delivery, which produces a pitch with a slight break that resembles a slider. "I got caught up in what people expected of me," Gooden says. "They'd say, 'You won 2–1, but you only had three strikeouts. What's wrong?' I said to myself, 'Maybe I need another pitch.' I had fooled around with a slider, but I experimented with a cut fastball and said, 'I'll try this.'" He threw so many cut fastballs that he became sloppy with his highest-octane heater, letting that pitch go from a lower angle, too. His fastball had deteriorated so badly by 1991 that, after one pasting by the Philadelphia Phillies that year, former teammate Wally Backman marched into the Met clubhouse and asked him, "Doc, what are you doing? That thing is about a yard shorter."

"He said he wasn't even trying to cut the ball," Backman says. Gooden had lost the natural action on his fastball. Though the Mets still clock his heater around 93 mph on the slower of the two radar guns used by major league teams, Backman says, "It doesn't have that rise to it anymore."

"He lost the movement because of throwing the cut fastball over time," Stottlemyre says. "And because of injuries to his shoulder, his arm strength wasn't always there to get the proper extension."

Gooden has been placed on the disabled list with shoulder trouble three times in the past six seasons. His natural looseness betrayed him. The ligaments that held his shoulder in place were so loose that they put a greater burden on his rotator cuff, which began to fray.

"That same looseness that made Doc such a great pitcher is part of what led to his physical problems," says Met physician David Altchek. Thirty-three pounds heavier than when he began his career, Gooden now throws with a more erect delivery. He has junked the cut fastball and still resists the urging by Stottlemyre to embrace the changeup—he throws it occasionally but with little confidence—as a legitimate third pitch. Despite his troubles, Gooden has remained essentially a two-pitch pitcher. "But I throw my curveball at different speeds and my fastball with different grips," he says.

Moreover, Gooden's personal life frayed as his shoulder did, at a rate of nearly one crisis a year.

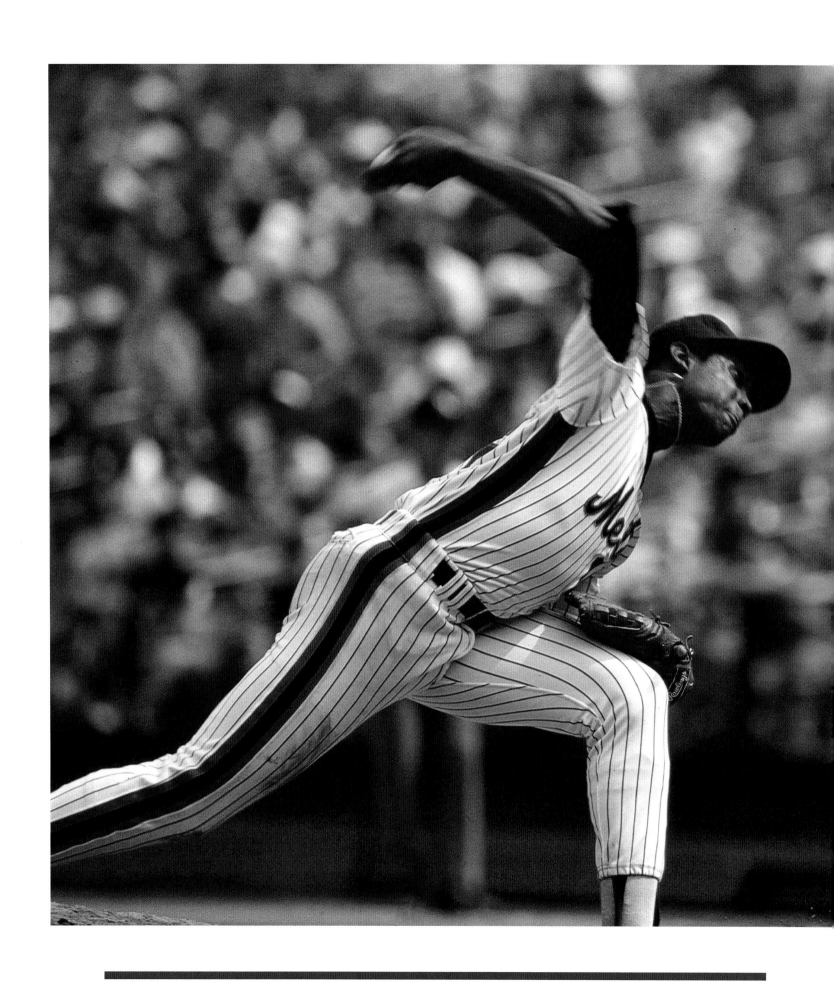

There was the off-season tussle with Tampa police officers in 1986; the drug test that turned up positive for cocaine in '87; the prolonged hospitalization of his father in '91; the allegations by a woman that she had been raped in Port St. Lucie by Gooden and two teammates in '92 (Florida law enforcement officials declined to press charges); and the deaths, in the last three years, of his maternal grandparents and an uncle.

"I haven't been happy," Gooden says. "The worst of it was last year. I was playing Nintendo, and my mom's mom had just died, and the rape thing was going on, and it all just hit me. It's been one thing after another for years. I was like, 'Why me? When does it stop?' This spring, for the first time since I can remember, there's nothing on my mind. No arm trouble, no controversy. I know baseball is my job, and I'll do the best I can. But I want to be happy again, too."

Life and baseball were once so simple for him. Calling up that fading photograph in his mind, he remembers how he neither knew nor cared who the hitter was or what pitches he liked to hit. He just *threw*. When he broke Herb Score's rookie strikeout record, Gooden now says, he "had no idea who the guy was."

"He's the only pitcher I know," Backman says, "that hitters were *scared* to face. It's one thing to be intimidated, but there were guys who were actually *scared*. In the major leagues."

Though Gooden dresses each morning in a Met jersey bearing the number of his youth, he knows he cannot be 19 again. "The strikeouts," he says. "I'll never be that pitcher anymore. I can't. But maybe I can be back at that level in other areas."

Like any good pitcher in a jam, Gooden is reaching back. What, at 28, is still there? •

Gooden pitches against the Phillies at Shea in 1985.

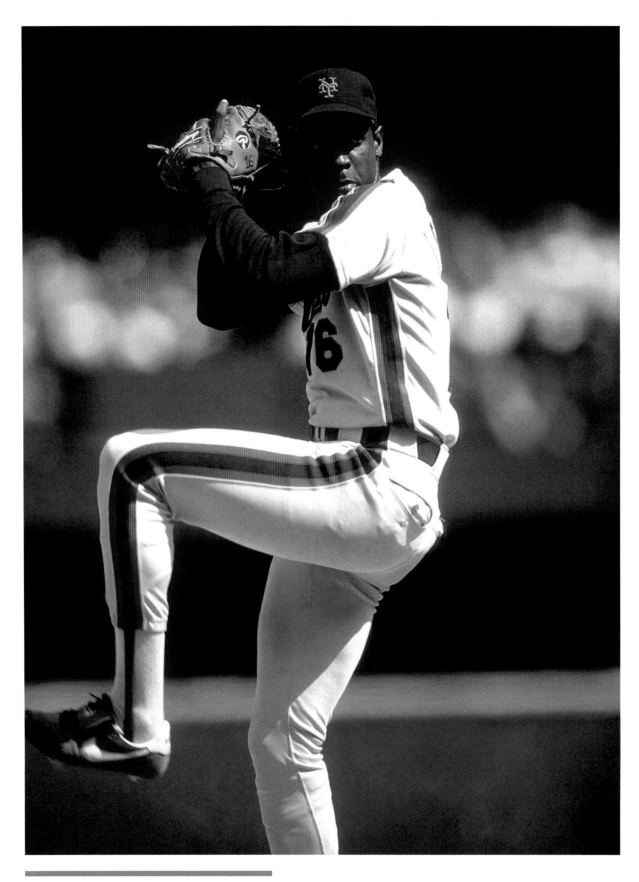

In '85, Gooden posted one of the greatest pitching
seasons in history: 24 victories (including 14 in a row),
268 strikeouts and a 1.53 ERA all led the major leagues.

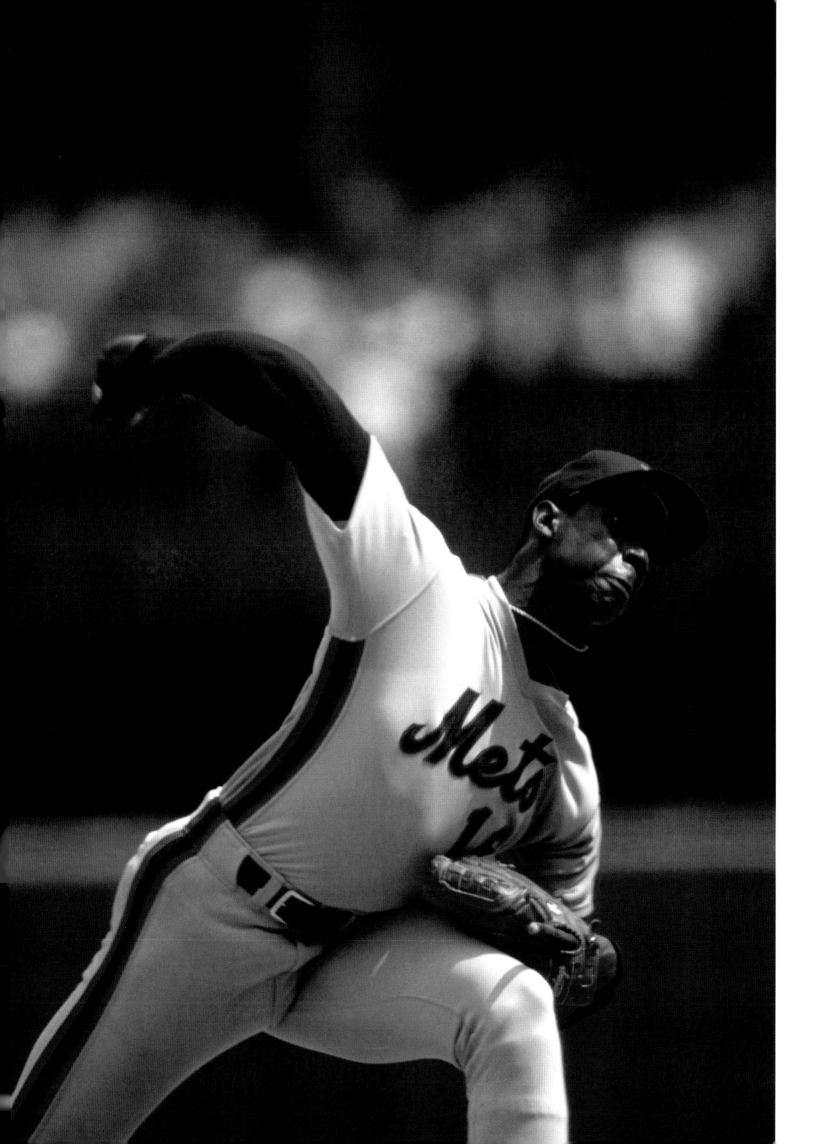

Excerpted from SPORTS ILLUSTRATED, August 21, 2000

CATCH THIS!

**Mike Piazza isn't just the best-hitting backstop of all time.
He's also the leading man on baseball's hottest team**

by TOM VERDUCCI

When Mike Piazza left the New York Mets' clubhouse last Friday night, he looked as if he were living out the parlor game in which everyone imagines how they would spend the perfect day. He had just hit a game-breaking home run in yet another Mets win, he had the Playmate of the Millennium, Darlene Bernaola, awaiting him on the other side of the clubhouse door, and in his right hand were the complete works of Led Zeppelin, digitally remastered and fresh out of the box's shrink-wrap, ready to rattle the windows of his Cadillac on his commute home. Talk about your hitters on a hot streak.

These are heady, lamp-rubbing good times for Piazza, whose at bats at Shea are greeted with music to the metalhead's ears: Led Zeppelin riffs and booming chants of "MVP! MVP!" Further, by taking three straight games last weekend from a possible playoff opponent, the San Francisco Giants, New York affirmed itself as the hottest, and perhaps most balanced, team in baseball. The Mets are built like what Piazza left with on Friday night. (No, not her.) New York is a boxed set, with nothing left out.

"There's not one part that we're leaning on," Mets manager Bobby Valentine said after a 2–0 win on Sunday. "That means that if one area of our game slips, we can still win another way."

At week's end the Mets had ripped off a 16–3 run that left them, at 69–47, with just one more loss than the first-place Atlanta Braves in the National League East and with six fewer losses than their closest pursuer in the wild-card race, the Arizona Diamondbacks. All but four of the wins in this spurt have come after the Mets closed the last two obvious holes on their roster. On July 28 they obtained sure-handed shortstop Mike Bordick from the Baltimore Orioles to replace the unproven Melvin Mora, who was filling in for Rey Ordonez (out for the season with a broken left forearm). That day they also traded for Tampa Bay Devil Rays righthanded reliever Rick White to add depth to what was already a good, but taxed, bullpen. Bordick hit .300 in his first 15 games for New York while providing defense that instills confidence in pitchers. White allowed only one run and six hits over his first nine innings with the Mets.

Sports Illustrated

The Chicago
White Sox'
Secret Weapon

The Man

MIKE PIAZZA is the
greatest hitting catcher
ever and the heart of
a team on a tear

AUGUST 21, 2000
www.cnnsi.com

"Before, there were questions of how long our bullpen could last and what kind of development Melvin would have this year," Valentine says. "Those questions are gone now. When Mike makes an error, it's, Ho-hum. When Melvin made an error, it was, Oh, god. Can he do it? Can he make the plays down the stretch? That affects the team psyche."

The Mets are also winning tightly played rehearsals for October. They won three playoff-quality games against San Francisco last weekend: 4–1, 3–2 and 2–0. Their pitchers suffocated the highest-scoring National League team outside of Colorado. The Giants never put together back-to-back hits in 94 at bats, scored only one earned run, went 2 for 20 with runners in scoring position and batted .043 (1 for 23) in seven scoreless innings against a Mets bullpen that hadn't lost a game since July 13.

New York, meanwhile, showed the opportunism that San Francisco lacked. Piazza's 411-foot rocket on Friday night, a two-run homer that broke a scoreless tie in the fourth inning, came with two outs and first base open. "Why would they pitch to him?" asked Todd Pratt, Piazza's backup. "I don't understand why anybody would pitch to him. He's that good."

The Mets won the next two days with rallies in the seventh and eighth innings, respectively, that began with leadoff walks and climaxed with two-out hits. "We have no glaring weakness," lefthander Al Leiter said after he dominated San Francisco on Sunday with 12 strikeouts over eight shutout innings. "I like what I see. Now let's see how far it takes us."

As complete a team as they may be, these Mets—like the Led Zeppelin oeuvre—do have a signature piece: Piazza, 31, is their stairway to playoff heaven. "What does he mean to this team?" Leiter says. "Everything."

At week's end the Mets were 37–13 when Piazza drove in a run and 32–34 when he didn't. He ranked fourth in the league in batting (.351), seventh in home runs (31) and fifth in RBIs (97), extraordinary numbers for any player, but phenomenal for a catcher. "Look at this," Piazza says, offering his right index finger as proof of the hazards of his job. The finger zigs and zags like a lightning bolt.

Piazza is not a smooth receiver, but his efforts behind the plate, considering his enormous offensive production, recall what Samuel Johnson remarked about a dog's walking on two legs: The wonder is not that he does it well, but that he does it at all. "It's incredible to think what he would do [offensively] if he weren't crouching every night," says Mets catching instructor John Stearns.

Piazza is embellishing his legacy as the greatest hitting catcher ever, even as fresh evidence of the position's daily danger emerges, as it did last month when the Texas Rangers' Ivan Rodriguez, whose bat has begun to rival Piazza's, broke his hand. Piazza has the best batting average, slugging percentage and rates of home runs and RBIs among all catchers who have caught at least 1,000 games. What makes Piazza so exceptional, however, also makes him and the Mets vulnerable, as last season proved. "Once you get around 100 games caught," Piazza says, "that's when you hit a wall you have to break through."

Piazza was batting .323 at his 100-game mark last season. He hit only .231 thereafter, including .182 while wobbling through the postseason with the sad stagger of a beaten prizefighter. Valentine started Piazza in all but two of New York's final 32 regular-season games. "I had to," the manager says, referring to a pennant race in which the Mets needed to win a one-game playoff to clinch the wild card. They lost the National League Championship Series in six games to Atlanta.

"I went home after the season and did absolutely nothing for three weeks," Piazza says. "I couldn't. It was basically just sleep and massage. Thank God for satellite TV. I'd watch NFL games all day and night on Sundays without getting out of bed. It was just complete exhaustion. Complete body soreness. It was the feeling you get after running a marathon, but feeling that way every day.

"Mentally, it was as draining as the physical part. It's like you just got out of the room after taking the SATs and there are little dots floating around your brain. Which guys are low-ball hitters? High-ball hitters, first-pitch fastball hitters, breaking ball hitters, what to throw in certain situations, and after

all that you still ask yourself, What could I have done differently?"

The Mets have looked for ways to keep Piazza fresh this season. Stearns moved Piazza closer to the plate in spring training to cut down on the high incidence of foul balls that hit him. "It has worked a bit," Piazza said on Sunday after taking a foul off his left thigh. Stearns also helped Piazza kick the lazy habit of catching pitches backhand, with his left thumb pointed down, which often caused late-breaking pitches to smack awkwardly against the meaty base of the thumb. Stearns taught him how to tuck his left elbow against his body, rather than stick it out to the side, as he caught the ball. That maneuver, which Piazza does not always employ, keeps his thumb pointing upward and out of harm's way. Piazza's difficulties catching and throwing the ball are exacerbated by his smallish hands. "I have very small hands for a catcher," Piazza says. "It's harder for me to throw. People get on me about my throwing. [He has caught only 15.4% of base stealers this season.] I have a good arm. It's just that a lot of times I don't get a good grip on the ball because my hands are so small."

What is imperative in order to keep Piazza healthy is rest, which is why a September lead for a playoff spot is more important for the Mets than for any other club. "Sure, everybody wants to finish first," Leiter says, "but I've won a World Series [with the Florida Marlins, in 1997] being a wild card. If we have a lead in the wild-card race, I say, rest, rest, rest people."

Says Valentine, "We have the bench to do that. I have a lot of faith in Todd Pratt."

Valentine has played Piazza slightly less often behind the plate this season (88 games) as compared with the same point last year (94). The manager resisted using Piazza last Saturday, for instance, even though San Francisco started a lefthander, Shawn Estes, and Piazza was hitting .400 against southpaws this year. Piazza, however, still influenced the game. With first base open and Todd Zeile at the plate in the seventh inning, the Giants opted not to intentionally walk Zeile because Piazza was limbering up in the dugout for a possible pinch-hitting appearance, and Zeile banged a game-winning two-run double.

"You know Mike Piazza's over there," Giants manager Dusty Baker says. "You want to face anyone over there but him."

"Mike's stronger this time of year than he's ever been," Valentine says. "He looks to me like he's more driven. It may be just that time in his career."

Piazza's made-for-Cooperstown career also includes pockets of unfulfillment. He has finished in the top four in the batting race four times, yet never won it. He accumulated more points in the National League MVP voting during the 1990s than anyone except three-time winner Barry Bonds but never won the award. (He finished second twice; no Mets player has ever won it.) His teams have lost three of four postseason series and never reached the World Series. Each year the whispers grow a bit louder that he and his teams would prosper more if he would switch to a less strenuous position, such as first base.

"Dude, I can honestly say there is no concern on my part about my legacy in the game," Piazza says. "That's not in my consciousness. I love to catch. It's that simple. I like walking to the mound after the last out of a win and shaking hands and knowing maybe I called for the right pitch in the right spot or blocked a pitch with a man on third or, even though I was 0 for 4, did something to leave an imprint on the game. Don't get me wrong. Hitting a home run is a great feeling, but there's no greater feeling than that [catching]. I'm not ready to give that up."

"Mike," Leiter says, "is a man with intense pride. He never wants to be embarrassed. Not even for one at bat. That's why he plays the game so hard."

Teammates have seen him attack clubhouse furnishings after a three-hit night in which the fourth at bat wasn't to his liking. More often, they've watched him hit baseballs as hard as any player in the game. Piazza walks to the batter's box slowly, even sleepily, as if he's been jostled from a nap. He swings a big bat (34½ inches, 33 ounces) with an unusually thick barrel that gives it the appearance of a club. His swing is frighteningly fast, though controlled.

"Almost never do you see him take a swing in which he's not in balance," San Francisco pitching coach Dave Righetti says. "He used to be a guy you'd

try to get to chase a pitch, but he hardly does that anymore. Sure, you have to get the ball in on him, but you'd better not miss. He's got great hands. You just watch him hit, and you know he could do anything that requires great hands, like hitting a golf ball, shooting free throws, whatever."

Last week in Houston, Piazza hit a ball so hard off the leftfield wall at Enron Field that the shortstop fielded it and nearly threw him out at second. The Mets chuckled and added it to their own boxed set of Piazza's greatest hits. Pratt's favorite is the 480-foot home run Piazza blasted in 1998 that was the longest ever at the Astrodome. Third baseman Robin Ventura prefers the line drive homer Piazza crushed in July off Atlanta's Terry Mulholland that "never had a chance to curve foul. It was out before you looked up." Piazza has hit a ball out of Dodger Stadium and another nearly out of Coors Field, but he selects a home run he pounded in 1995 that flew into the centerfield tunnel in Philadelphia's Veterans Stadium.

"I remember it was the perfect swing," he says. "I'm telling you, Dude, it's just a feeling in my hands. I can tell you if I'm going to have a good day or a bad day at the plate just by the feeling in my hands. It comes and goes. When it's there, I feel like all I have to do is drop the barrel of the bat on the ball and *boom!*"

He looked at his hands, as if they were a riddle he couldn't expect to solve. What becomes of the Mets, however complete they seem, may very well rest in those hands. •

A former 62nd-round pick, Piazza spent 16 years in the major leagues, eight of them with the Mets.

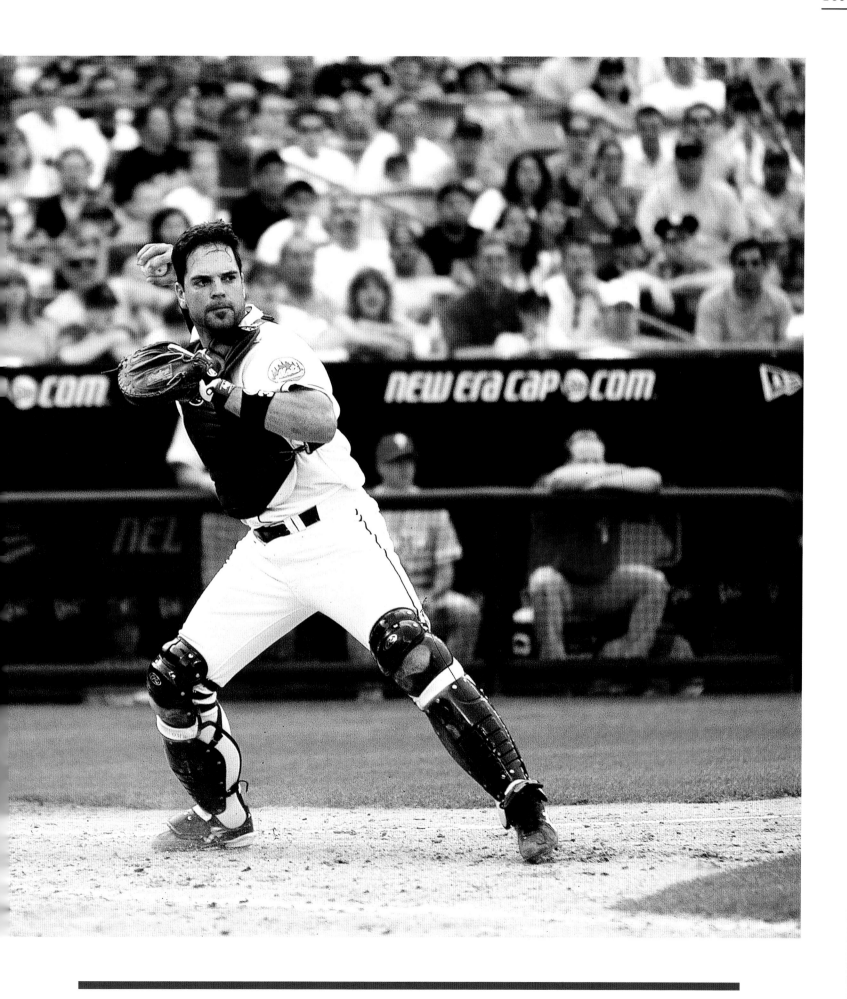

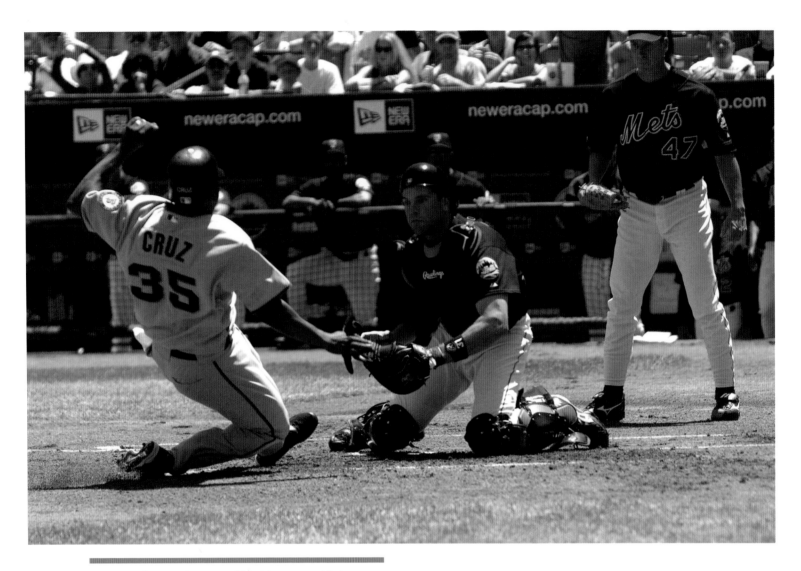

Of Piazza's 427 career home runs, 396 of them came while he was playing catcher, a Major League Baseball record.

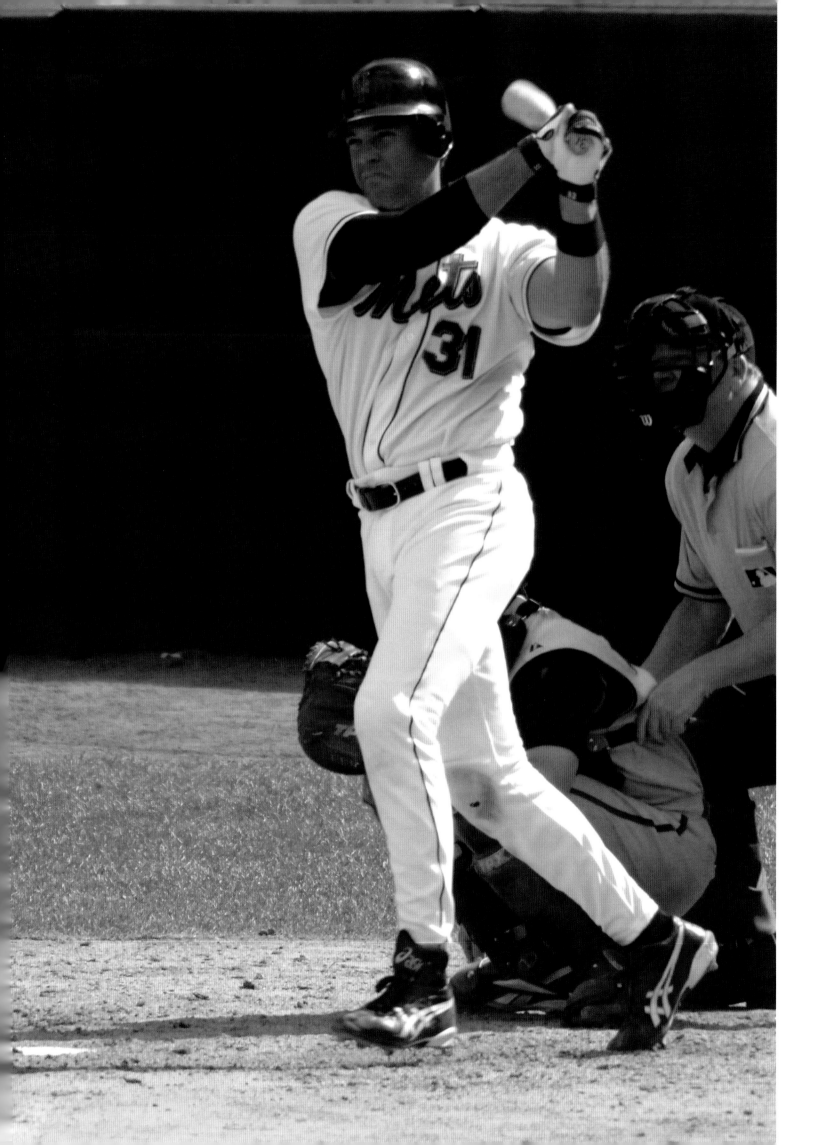

Excerpted from SPORTS ILLUSTRATED, October 23, 2000

N.Y., N.Y.

With Gotham transfixed by the prospect of a Subway Series, the Mets got through the turnstile by beating the Cardinals while the Yankees took command over the Mariners

by TOM VERDUCCI

The dress rehearsal for Armageddon was a success. Baseball staged five League Championship Series games over seven days in New York City last week without paging the medical examiner's office once. That was accomplished with the help of some 600 uniformed police officers, many festooned in full riot gear; bomb-sniffing dogs; concession-stand vendors who, while trying hard to comply with the NO SPITTING signs posted behind their food counters, removed the caps from water bottles lest their customers use them as artillery shells; the greatest gathering of celebs this side of the Dorothy Chandler Pavilion; wild-eyed fans who are obsessive-compulsive about conjugating the verb "to suck"; and one massive city-owned sanitation truck positioned to fend off vehicles potentially engaged in suicide-autograph runs by Mets fans.

The truck barricaded the entrance to the players' parking lot near rightfield at Shea Stadium, and as players arrived for work, it would roll out of the way, allow them to drive through, then roll back into its defensive position.

Like it or not—and is there anybody in between?—this is baseball New York–style: obnoxious, oversized, provincial and a bit dangerous, which, come to think of it, also describes the indigenous pastrami on rye. As Clemens once wrote about the place, "There is something about this ceaseless buzz, and hurry, and bustle, that keeps a stranger in a state of unwholesome excitement all the time, and makes him restless and uneasy." That Clemens would be Samuel, the 19th-century Connecticut Yankee humorist, and not Roger, the one-hit, 15-strikeout Yankees righthander.

Clemens's description also applies to the kind of baseball played last week by the Yankees and the Mets as they forged toward an intramural World Series matchup two generations in the making. Thankfully, the wildest incident last week was the pitching of Cardinals rookie lefthander Rick Ankiel in St. Louis,

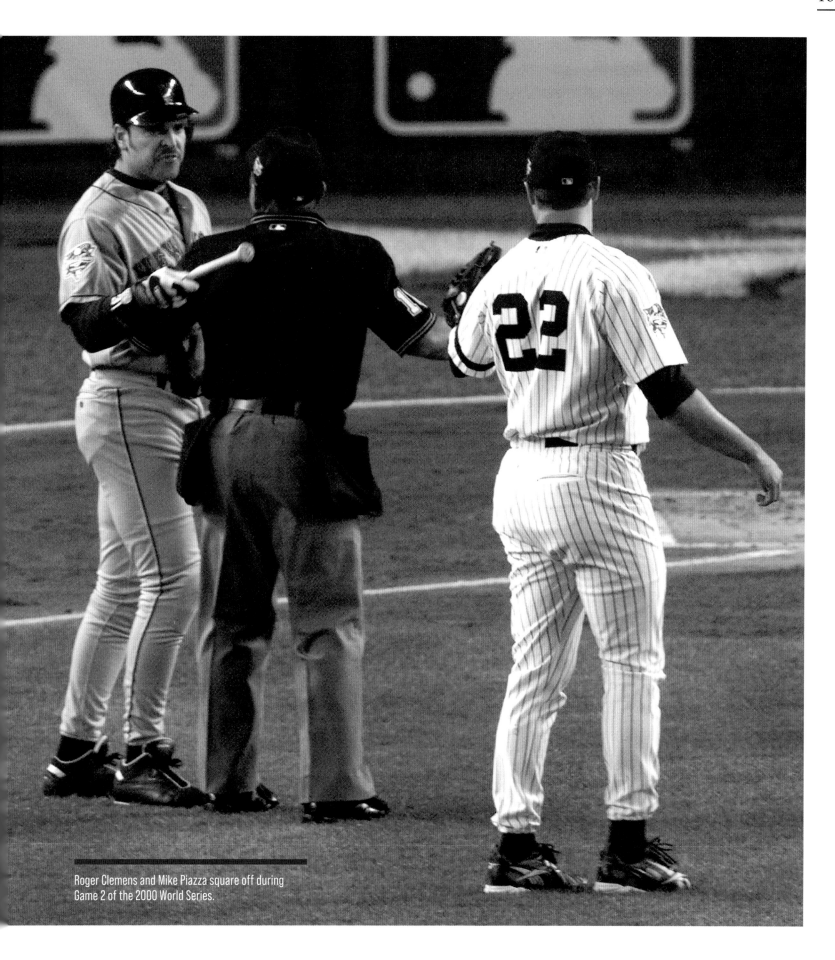

Roger Clemens and Mike Piazza square off during
Game 2 of the 2000 World Series.

and the only time the bomb-sniffing dogs barked with alarm was before Game 4 at Shea when they picked up the scent of St. Louis righthander Darryl Kile as he entered the Stadium before giving up seven runs in an incendiary three-inning stint.

Would a Yankees-Mets World Series keep the rest of the country in that state of unwholesome excitement all the time? The answer may be forthcoming. With lefthander and National League Championship Series MVP Mike Hampton tossing a masterly three-hit, 7–0 Game 5 win on Monday night, the Mets clinched the pennant and did their part to bring to town the first Subway Series since 1956. The Yankees, holding a three-games-to-two lead over the Seattle Mariners, needed only to win one of two possible games at Yankee Stadium on Tuesday and Wednesday to hold up their end.

The rest of the country might watch out of prurient interest, with nobody to root for. Iran versus Iraq in spikes. "I think they would watch," Mets lefthander Al Leiter says, referring to baseball fans outside earshot of the obscenely loud Shea Stadium speakers, or roughly beyond a 200-mile radius. "If nothing else, they'll want to see the security aspect of it: the police officers, the fights in the stands, the scene around and outside the stadiums, the snipers on the rooftops, things like that."

"If a Subway Series ever happened," says Brooklyn-born Yankees manager Joe Torre, "it would be absolutely crazy in New York. I was growing up in New York in the '40s and '50s when the [Brooklyn] Dodgers and [New York] Giants played all the time, and that was wild. Of course the Yankees were always in the World Series, sometimes playing the Dodgers and sometimes the Giants. That was crazy. But a Subway Series now would be far wilder than that."

The game is a more bloated spectacle since the Yankees' seven-game win over the Dodgers in '56. For one, the teams played those games in an average of two hours, 34 minutes. The 10 League Championship Series games through Monday night lasted an average of 3:31. The Yankees and Mariners took a ghastly 3:45 to score all of two runs (both by Seattle) in Game 1 of the American League Championship Series. Rickey Henderson, a former Yankee and Met, drove

in the first run with a fifth-inning single while the Yankee Stadium crowd serenaded him with its usual vulgar chant. This is, after all, the city that never bleeps. "Rickey still the best, Rickey still the best," the Mariners leftfielder crowed to his teammates after the hit.

Baseball, too, is immensely more popular, if not as emotionally ingrained, today than it was in the nostalgically gilded postwar "golden age." From 1949 through '56 all but four of the 46 World Series games were played in New York. Yet at the climax of that Gothamcentric success—the '56 season—the Yankees, Dodgers and Giants combined to draw 3,334,525 fans. This year the Yankees by themselves came within 106,868 paying customers of that total.

Without a third team, New York no longer has disinterested third parties for a Subway Series. Choosing a team is an either/or proposition, which is why even the mayor, Rudy Giuliani, wore a Yankees cap to Yankee Stadium last week but a generic city Parks Department cap to Shea Stadium. It also is why Senate candidate and erstwhile Cubs fan Hillary Clinton—running against a Mets fan, Rick Lazio—suddenly reiterated her "longtime affection for the Yankees," though she did not break into discourse on the Horace Clarke–Jerry Kenney era. Billy Crystal made sure postproduction work for his baseball movie, 61*, much of which was shot in Detroit, took place in New York so he could attend the games at Yankee Stadium. The Backstreet Boys, Penny Marshall and *NSYNC also turned up in the Bronx. Jerry Seinfeld, Goldie Hawn and Kurt Russell, Jay-Z, Sarah Jessica Parker, Tim Robbins and Chris Rock showed up at Shea.

St. Louis? Uh, the Republican vice-presidential candidate, Dick Cheney, received polite Midwestern applause for attending Game 2 at Busch Stadium.

Indeed, against the incessant drumbeat of a potential all–New York series, the underdog Mariners and Cardinals sometimes seemed as insignificant as the rest of the country in *The New Yorker*'s famous cover cartoon depicting a New Yorker's self-absorbed view of the world. On Wednesday, however, the Mariners were six outs away from a Yankee Stadium sweep of the first two games. The home team hadn't

scored a run in 21 straight postseason innings, tying a franchise record, when the Yankees busted loose in a New York minute with seven runs in the eighth inning.

That same night in St. Louis the Mets, behind seven innings of shutout ball from Hampton, opened the National League Championship Series with a 6–2 win. The next night, in their 6–5 victory, the Mets parlayed a ninth-inning error by St. Louis first baseman Will Clark into the winning run, which scored on a single by centerfielder Jay Payton. In a reprise of his one Division Series outing, which included five wild pitches in the third inning, Ankiel opened Game 2 by missing the plate with 20 of his 34 pitches, five of which hit the backstop. "The backstop isn't a pitchback," Clark told the rookie during a conference on the mound.

The Busch Stadium fans weren't nearly so cruel. They gave Ankiel a sympathetic cheer as he trudged off the mound after getting only two outs and yielding two runs. "You could tell they felt for him," said Mets first baseman Todd Zeile, a former Cardinal. "If it had happened [in New York], whoa, they would have buried him."

The Mets under manager Bobby Valentine are an energetic bunch, the kind of team that actually engages in Little League–quality dugout chatter, such as "Good eye! Good eye!" They stormed back to their clubhouse after Game 2 in a noisy frenzy. "Six more! Six more!" they yelled, counting wins toward a world championship. The clubhouse boom box blared the 1979 nugget "Ain't No Stoppin' Us Now." It was then that the Mets deeply sensed that a path had opened for them, a process that began when St. Louis took out New York's nemesis, the Atlanta Braves, in the Division Series.

"I can't sleep at night," lefty reliever John Franco said after Game 2. "There is a different feeling this year than last year. Atlanta was always in our way. Now it's different. There's a long way to go, but the guys can smell it."

On Friday at Seattle's Safeco Field, the Yankees stayed hot, getting back-to-back, second-inning homers from centerfielder Bernie Williams and first baseman Tino Martinez in their 8–2 victory. Leiter,

watching at home during the Mets' off day, rooted for the Yankees. "Sure, [a Subway Series would] be great for the city," he said. Mets owner Fred Wilpon added, "I wouldn't go as far as to say I was rooting for them, but I'd like to see them get in against us."

The weekend brought New York a pair of split decisions. On Saturday at Shea the Mets lost 8–2 to Cardinals righthander Andy Benes, who threw eight solid innings despite a right knee so wobbly he had nearly 100 cc of fluid drained the day before he pitched. Later that night Clemens—the one not noted for his sense of humor—threw his gem, coming within about one inch of a no-hitter in winning 5–0. Leftfielder Al Martin's line drive scraped the glove of Martinez at first and went for a double. The Rocket set the tone in the first inning by coming high and inside on consecutive pitches to Mariners shortstop Álex Rodríguez, who walked. "I was just trying to go for his hands inside and, actually, for strikes both times," Clemens said afterward.

Said an enraged A-Rod, with a straight face, "Maybe his control was off a little bit."

Said an incensed Mariners manager, Lou Piniella, "He wants to throw at our guys, we'll throw at his guys, period."

Sunday brought a reversal of fortunes. At Shea the Mets were up (a 10–6 romp), and at Safeco the Yankees were down (a 6–2 dud). Each game underscored the doomsday strategy of using pitchers on short rest. Cardinals manager Tony La Russa did so with Kile, though Kile had an awful history when starting on three or fewer days of rest (4-8, 6.66 ERA). His first 17 pitches resulted in five doubles and four runs. He was gone after issuing a leadoff walk in the fourth. Kile was the ninth pitcher to start on three or fewer days' rest over the past two postseasons. Those pitchers were 0–4 with a 16.83 ERA; they lasted an average of only 2⅔ innings.

"It doesn't work—ever," said Valentine, who survived a wobbly outing from his No. 4 starter, righthander Bobby J. Jones. "I don't do it in the regular season, never mind October."

Torre was nearly burned in the Division Series by using Clemens and lefthander Andy Pettitte on short rest. Both threw poorly. This time he

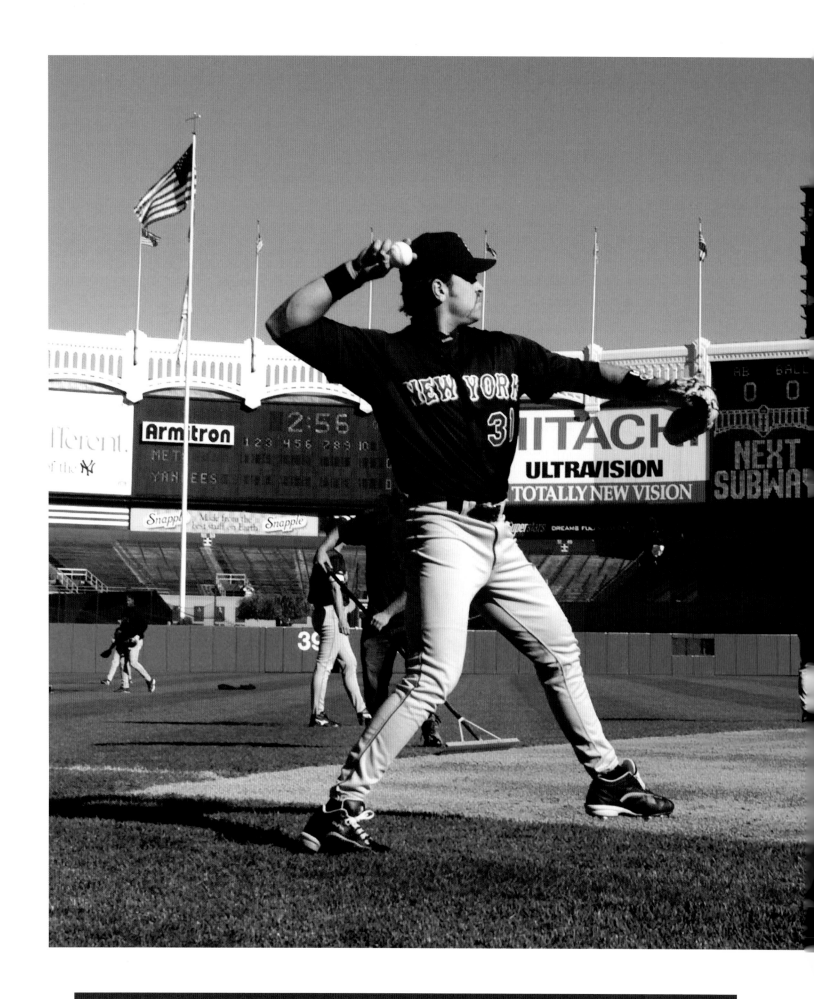

lost Game 5 with his No. 4 starter, lefthander Denny Neagle, but that still left him with righthander Orlando Hernandez (7–0 lifetime in the postseason) and Pettitte lined up on full rest for Games 6 and (if necessary) 7 at Yankee Stadium.

Surreally, the Mets, minutes before they were to play their own Game 4 on Sunday night, watched on televisions in their clubhouse as the Yankees attempted a vain comeback in Game 5. Third baseman Robin Ventura followed the action without a rooting interest, though he preferred to play the Yankees in the World Series "because there'd be no travel." Backup catcher Todd Pratt was hoping the Yankees would lose the game (even though he, too, wanted to see them in the World Series) "because I want them to see us win [the pennant] first." Franco wasn't sure what to think.

"There would be a lot of pressure," admitted the Brooklyn native as he contemplated a Subway Series. "Listen, I'd like us to get to the World Series any way we can. But for the past few years the focus in the city has been on them. If we played them, we'd have to share the focus. I'd love to see the focus on us. Just us."

Clubhouses, families, politicians, comedians and your friendly neighborhood bomb squad were divided on the matter of a Subway Series. This much, however, would be as true for all parties during an all–New York World Series as it was when Clemens—the one without the splitter—wrote it in 1867: "There is one thing very sure—I can't keep my temper in New York." ●

Piazza and the Mets warm up before Game 1 at Yankee Stadium in the Bronx.

The Subway Series saw two New York teams—as well as their fans—meeting in the Fall Classic for the first time in 44 years.

Excerpted from SPORTS ILLUSTRATED, March 8, 2010

THE TRIALS OF MR. MET

Last year was hell for David Wright and his team. But the face of New York's Other Franchise has a back-to-the-future plan for 2010

by LEE JENKINS

The pickup came to a stop in downtown Newark at 5 a.m. on Jan. 13, and Dave Racaniello hopped out of the passenger's seat, into the morning frost. He walked around to the back of the truck and pulled his Trek mountain bike from the bed, along with a small trailer packed snug with sweaters, sandwiches and a tent, survival tools for the odyssey ahead. Racaniello climbed aboard the bike, made sure the trailer was attached, pumped his legs and headed south on Route 9—bound for baseball season.

Racaniello is the Mets' 31-year-old bullpen catcher, known to friends as Rac. He spends most of his professional life hidden behind chest protectors, face masks and outfield fences, the last person on a team from whom you would expect a grand gesture. But over the winter Racaniello mentioned to his New York roommate and Mets third baseman David Wright that he someday wanted to ride a bicycle cross-country. Wright urged him to shorten the trip and the timetable: Bike to spring training.

Wright laid out terms of the challenge and started taking wagers. Racaniello, with only $20 in his pocket and nowhere to sleep but that tent, would have three weeks to reach the Mets' spring home in Port St. Lucie, Fla. Ten Mets placed their bets. Wright was the only one who banked on Racaniello to beat the elements and the clock.

Rac faced hills that wouldn't quit in New Jersey, Labradors on the loose in North Carolina and a four-lane freeway without a shoulder in Florida. He pitched his tent on high school campuses and golf courses. In Jacksonville, first baseman Daniel Murphy was generous enough to let Racaniello stay in his yard, but the sprinklers went off at 1 a.m. Every night Racaniello checked in with Wright, who reminded him what baseball players always tell themselves: "Take it day by day."

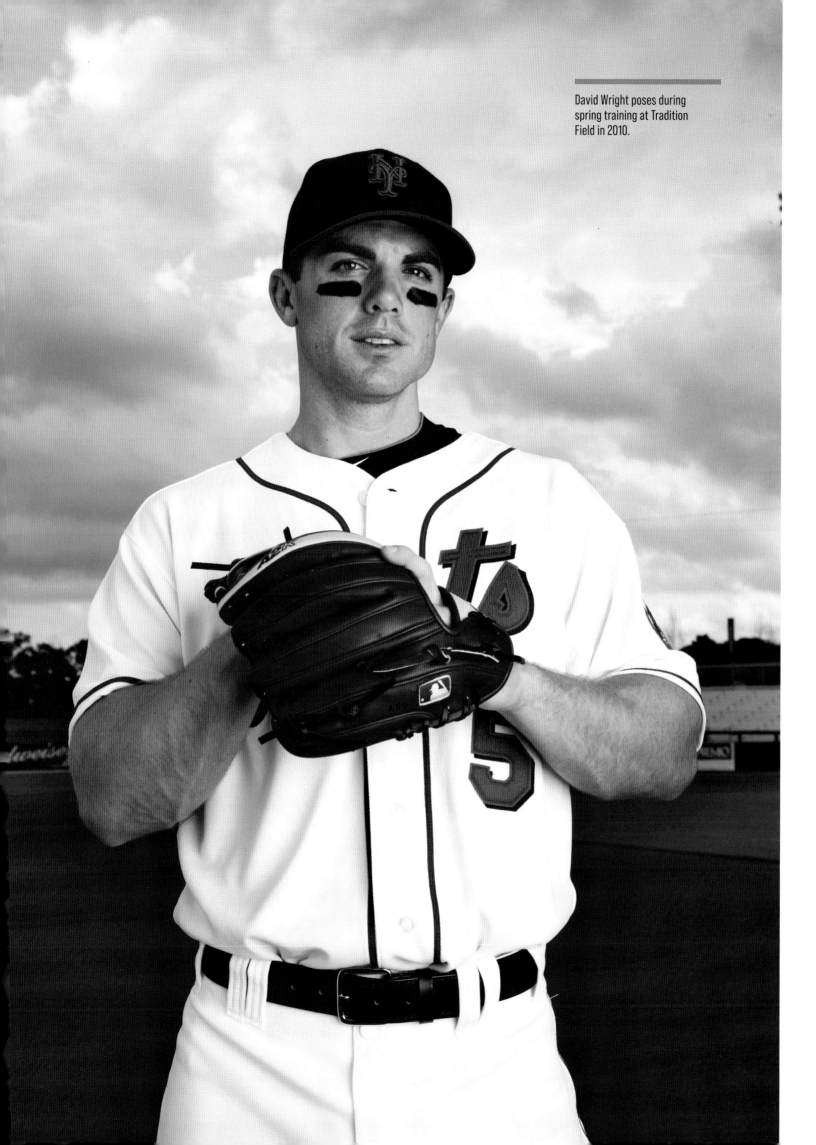

David Wright poses during spring training at Tradition Field in 2010.

On Jan. 26 Racaniello rolled into Fort Pierce, Fla., and sirens sounded. He thought he was under arrest. Turned out the Mets had sent a police escort to lead him the last few miles to the finish line. At 10 p.m. Racaniello churned into the parking lot at Tradition Field, eight days ahead of deadline. As Rac rushed to the clubhouse to take his first shower in two weeks, Wright rejoiced from afar.

Racaniello was not trying to set a tone for the 2010 season, though Mets players say that's exactly what he did. After enduring ugly September melt-downs that cost them playoff spots in 2007 and '08 and a disastrous 70-win season last year, the Mets are facing a long road back to respectability. And for the first time in an otherwise sterling six-year career, Wright, who is coming off his worst season, has ground to make up as well.

Wright is only 27, but this is the second time that he must lead New York out of a dark age. Five years ago, with the Mets coming off three straight losing seasons, he was a young star sifting through marriage proposals in the clubhouse, writing greeting cards on the bus, downing glasses of milk before games, providing an aimless organization with a quality in short supply—"hope," says then general manager Jim Duquette. Wright earned MVP votes every year from 2005 to '08 and won two Gold Gloves. He started a foundation at 22, wore a hard hat to the groundbreaking of Citi Field and for a few minutes back in 2006, when the Mets came within a game of the World Series, made the franchise cooler in New York than the Yankees. When his team lost 12 of its last 17 games to blow the National League East title in '07, Wright was exempt from blame because he hit .352 in September. When the Mets lost 10 of their last 17 to blow the wild-card berth in '08, Wright was absolved again because he hit .340 over the final month. "He had never really failed," says hitting coach Howard Johnson.

But last summer, as New York decomposed into 92-game losers, Wright finally went down. The one player who always seemed to transcend the Mets' mis-fortune suddenly looked just like them. His home run total sank from 33 to 10. His RBI total fell from 124 to 72. His slugging percentage dropped 87 points. His average rose to .307, which seemed to indicate that he was sacrificing power for contact, but he piled up a career-high 140 strikeouts. "I was never comfortable," Wright says. "I was always searching."

He was booed at home for the first time, went on the disabled list for the first time and finished with a losing record for the first time since his rookie season, 2004. As he sat stone-faced through one misera-ble week after another—"I love his smile," general manager Omar Minaya says, "and I didn't see it much"—'06 felt like a whole era ago. "I tell him, 'Hey, it's not the end of the world,'" said his father, Rhon. "But to him I think it does sometimes seem that important."

Like most megamarket teams, the Mets are stacked with mercenaries who come from other places, rent houses in the suburbs and skip town the day after the final pitch. But Wright grew up cheering for Mets farmhands at Triple A Norfolk. He played for a New York showcase team in high school. He lives year-round in Manhattan's Flatiron District, where the back pages slap him in the face. Besides the Wilpons, the family that owns the franchise, few have invested more in the team than Wright. So when the Yankees are celebrating and the Mets are suffering and the punch lines are flying—David Letterman reported last month that the Mets signed the Iraqi journalist who "threw the shoes at President Bush"—he feels them like shots to the midsection.

"He takes it personally," says manager Jerry Manuel, and the team admires that quality. But they worry about him too. "Sometimes," said assistant general manager John Ricco, "the organization has to protect him from himself." That means limiting the public appearances and interviews he has a hard time turning down, giving him days off despite his protests. The Mets have always looked out for his interests—except perhaps when they conceived the stadium he now calls home.

The first time Wright tried to hit a ball out of Citi Field, tractors were still parked in center. It was September 2008 and not a blade of grass had been laid, but Wright wanted to check out his new digs. So he and a few teammates crossed the street from

Shea Stadium and one by one dug into the batter's box. Wright went first. "It looked big," says outfielder Nick Evans. "But it was cold and windy that day, so you couldn't tell how big. I just remember that David wouldn't get out of the box until he hit the first home run."

It didn't come easily. Theories abound as to why Wright's power numbers were so diminished in 2009—"It's not like you just forget how to hit after five years," says rightfielder Jeff Francoeur—and the most popular one has to do with the Mets' new home. They wanted to build a pitcher's park in the tradition of Shea Stadium, and in most areas Citi Field is comparable to Shea. But in right center the designers put in a gap that ranges from 378 to 415 feet—ideal for leadoff man José Reyes's triples but not so conducive to Wright's opposite-field homers. According to hittrackeronline.com, Wright hit nine balls last season that would have been out at Shea but did not clear the high fences at Citi, including seven drives to center and right.

Then again, Wright mustered just five home runs on the road, proof that the ballpark was not the only factor at play. In spring training last year Manuel and Johnson implemented a subtle but significant change to the team's offensive philosophy. They urged hitters to stay inside the ball longer and catch the ball deeper in the strike zone, which would lead to more opposite-field hits. Manuel maintains that the Mets were trying to build complete hitters; it was a coincidence that they were moving into a ballpark with a massive rightfield.

In one sense the strategy worked, as New York led the NL with a .270 batting average. But it hit just 95 home runs, the fewest in the majors. "It's like we went to the golf course," Johnson says, "and never pulled out our driver." The mistake, Manuel admits, was asking everybody to conform to the new philosophy. Wright, for instance, has always naturally hit to the opposite field with power. If he were a certain breed of superstar, he might have told his coaches to shove it and kept the same approach that had served him so well. Instead he did exactly what they asked.

"He steered the ball to right," says one NL scout. "Even in hitter's counts, it's like he was trying to flip it over the second baseman's head." From 2006 to '08, 34% of the balls Wright hit to the outfield went to right, according to HitTracker. In '09, 41% went to right. "At times I did settle for punching the ball the other way," Wright said, "rather than really trying to drive it."

Still, on July 2 the Mets were only one game out of first place, even though Wright did not have Reyes in front of him or slugger Carlos Beltrán behind him in the lineup. (The two players missed a combined 207 games with injuries.) Wright was, for most of the season, the only hitter in the lineup anybody had to pitch around, but the Mets needed runs, not walks, so he started to swing at pitches he would otherwise have taken. "He was out there by himself," Johnson says. "The burden was totally on him." Francoeur arrived in mid-July from Atlanta, where he had grown up a Braves fan before becoming a Braves phenomenon and finally a Braves bust. "I knew what he was feeling," Francoeur says. "He had to get back to having fun."

Then, on Aug. 15, Wright took a 94-mph fastball off his helmet's ear hole from San Francisco's Matt Cain and left Citi Field in an ambulance. By September the Mets had 13 players on the disabled list, accounting for $88 million of the payroll. Wright, who suffered a concussion, returned from the disabled list on Sept. 1 but batted .239 the rest of the way, understandably gun-shy on pitches high and tight. A stadium with an endless right centerfield alley, a mandate to aim at that alley, a lack of protection in the lineup, a responsibility to carry that lineup and finally a horrifying head injury. It was a perfect storm for a power outage.

Because this is baseball in the 21st century, home run drop-offs always prompt suspicion of something sinister. But Wright's image is as squeaky clean as it gets in professional sports. His father is the Norfolk assistant police chief and used to be the vice and narcotics captain. "Drugs have never been an option," the younger Wright says.

Wright showed up for spring training noticeably thicker through the arms and chest, the result, he said, of a winter of strenuous workouts and smarter eating. His 2010 season essentially began the week after

Thanksgiving. He flew to Johnson's house in Hobe Sound, Fla., and together they scrapped the plan that had doomed '09. "It's going to be different this year," Johnson says. "We are focusing on catching the ball out in front and driving it more to leftfield."

Per tradition, Wright drove to spring training with three friends from Virginia, and they asked whether he was worth drafting for their fantasy teams. "I believe I am," he said. There is pressure on Manuel and Minaya to keep their jobs this season but also on Wright to return his team to the pennant race and himself to the MVP conversation. He will have Reyes back ahead of him in the order and newly signed leftfielder Jason Bay in the middle. (Beltrán will miss at least the first month because he is still rehabbing from knee surgery.)

Twelve days before pitchers and catchers were due to report, Wright pulled into the Mets' spring complex. After more than a week of workouts, Wright ran into Manuel on a golf course, and the manager asked how he was feeling. "Ready," Wright said. The next day Wright took batting practice on Field 7, which has the same dimensions as Citi Field. Manuel stood on one side of the cage. Chief operating officer Jeff Wilpon stood on the other. Wright hit a line drive off the centerfield fence, which is still 16 feet high even though the wall at Citi was cut down to eight this winter. "That's a homer this year, right, Jeff?" Wright said with a smile. Then, as if to remove any doubt, he turned his hips, threw his hands and yanked a deep fly over the leftfield fence. "Get him ready for Josh Johnson," Manuel howled.

Opening Day against the Marlins, with Johnson on the mound, is still five weeks away. That's five more weeks to make fun of the Mets before they offer their rebuttal. "There's only one thing we can do to make it stop," Wright said. "Win." •

Wright spent his entire 14-year career with the Mets, and was named captain in 2013.

(Above) One of the most popular Mets in team history, Wright signs autographs for fans before a game in 2006. (Opposite) Wright makes a catch against the Mets' crosstown rivals in 2005.

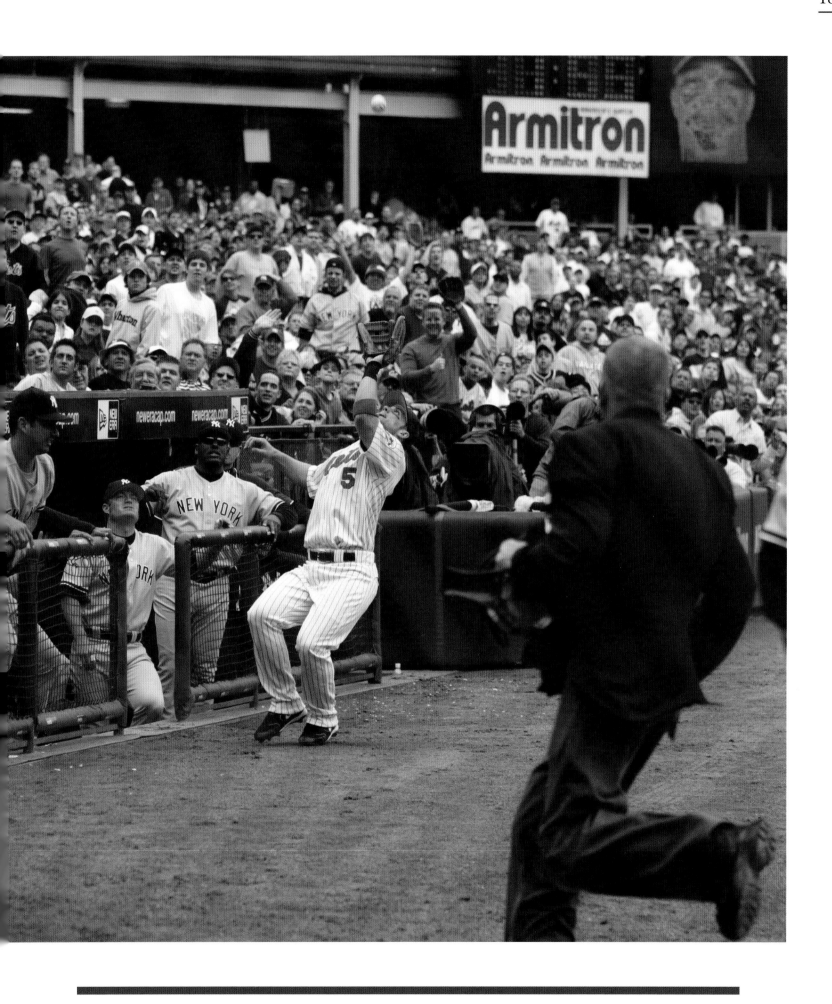

OCTOBER 8, 2018

THE SWEET AND PAINFUL FAREWELL

The Mets' David Wright was a baseball star you could believe in

BY LEE JENKINS

He arrived on a prop plane that was so small the pilot made him switch seats during the flight to balance the weight on board. He had only slept two hours, in that fitful sliver of subconscious where dream and reality blur. Growing up in Norfolk, David Wright pestered Mets farmhands for autographs at Tides games. In high school he played for a showcase team called the Mets that traveled along the Eastern Seaboard. And at 21 he circled LaGuardia Airport and gazed down on Shea Stadium, all those empty blue and orange seats waiting for their Jeter.

The Mets are famous for overhyping prospects, and Wright was accompanied by his own breathless backstory. Did you hear about the home run he hit when he was 16, 400 feet over the centerfield fence, smacking so hard into an old oak tree that a six-foot branch flew into a neighbor's yard? "Just like Roy Hobbs," said his travel-team coach, Ron Smith.

But Wright was different from Gregg Jefferies and Generation K. He delivered, changing the outlook of a punch-line organization from the moment he touched it. Wright debuted for the Mets in July 2004. Pedro Martínez signed that December, Carlos Beltrán a month later. In '06 the Mets came within a game of the World Series, and Wright really was their Jeter.

He wrote greeting cards in the clubhouse, drank milk before games and used Met3Bagger as his email address. He received a standing ovation on the road, at Petco Park in San Diego, after a diving barehanded catch on the outfield grass. Former Mets outfielder Cliff Floyd once joked, "I read his fan mail sometimes—girls are asking to marry him—and it makes me sick. One of these days, I swear I'm going to smack him." Lathered in sweat after weight-lifting sessions, Floyd would slip into Wright's form-fitting pastel Polo shirts, stretching L's into XL's.

But Wright, impossible to offend, still hauled around Floyd's Louis Vuitton luggage on the road as a rookie.

In the wake of the steroid era, Wright seemed accessible and certain not to disappoint, the son of an assistant police chief and former narcotics captain who scolded him over the price of his Flatiron District apartment and did not let him buy a new car when he reached the big leagues. His best friend on the team might have been the bullpen catcher, Dave Racaniello.

In Wright's first two seasons I was the Mets beat writer for *The New York Times*, a job that required regular profiles of the young star. Before a game at Oakland, I was in the elevator outside the visitors' clubhouse, about to ride up to the press box. As the doors closed, Wright stopped them. "Hey," he started, "I wanted to thank you for the story you wrote about me the other day."

"No problem," I replied, and let the doors close. He stopped them again.

"There's just one thing," he continued. "I saw you quoted my dad in the story and he said he never talked to you."

My stomach turned. I did quote his father, and I remembered talking to him. Could I have called the wrong person? Could someone have pretended to be Rhon Wright from the Norfolk police department?

"I know this is serious," Wright went on, "so we'll obviously have to tell your bosses." *The Times* was two years removed from a plagiarism scandal. I'd be fired for sure. Wright must have noticed the panic on my face because he doubled over laughing. "Just messing with you," he said and let the doors close. Floyd had clearly rubbed off on him.

The Mets led the National League East by seven games with 17 to play in '07 and by 3½ games with 17

Wright tips his cap to the crowd during the final game of his career in 2018.

183

to play in '08. They collapsed both times, but Wright was not to blame, racking up Silver Sluggers and Gold Gloves both seasons. He was so young. He'd have more chances.

"Right now, everything is perfect," former Mets first baseman Doug Mientkiewicz said in 2005. "He's young, he's single and he's good-looking. Everybody loves him and the world is at his feet. But one day you feel this switch and everything changes and it's never the same again."

For all, except maybe Jeter, there aren't as many chances as you think. In '09, Wright, then struggling at the plate, was booed at home for the first time, went on the disabled list for the first time and finished with a losing record for the first time since he was a rookie. He still made the All-Star team that year, and three more years afterward, but then the injuries visited in succession: shoulder, back, neck, the worst kind of Triple Crown. Diagnosed with spinal stenosis, a chronic condition, he required more than four hours of physical therapy just to

take the field. The last time I wrote about Wright, for SI in 2010, the story was titled "The Trials of Mr. Met," and still he called afterward to say thanks. I kept the message for a long time, to remember what grace sounds like.

Since May 2016, Wright has undergone three surgeries, had two daughters and played zero games, visible only on rehab assignments before sparse crowds at the Mets' spring home in Port St. Lucie. "I'm hopefully out of tears," he said on Sept. 13 at Citi Field, during the press conference announcing his retirement, though of course he wasn't.

Wright is 35, and if you stop at his face, you'd swear he hasn't aged since that night sprawled across the grass in San Diego. But his body was broken long ago. He started at third base on the final Saturday of the regular season, not because he was remotely qualified, but because he wanted Olivia Shea and Madison to see their dad the way baseball will see him forever: Met3Bagger.

Excerpted from Sports Illustrated, September 5, 2019

THE HAPPIEST MAN IN BASEBALL IS A NEW YORK MET

Pete Alonso, the Amazins' rookie first baseman with a league-leading 43 homers and a grin to match, has filled Flushing with joy in an otherwise so-so season. Are his good cheer and big bat strong enough to give the Mets a new mojo?

by STEPHANIE APSTEIN

Pete Alonso has lived in the city only since April, but he's already driving like a New Yorker. He easily merges his Lexus SUV into traffic on the FDR Drive and navigates the narrow lanes. He swings calmly off the RFK Bridge onto the Grand Central Parkway. When a teenager threatens to dart in front of the car near Citi Field, Alonso shakes his head and laughs. "Don't do it, man! Don't do it!" (The kid does not.) Alonso is 24. He seems older as he asks three preteen autograph hounds why they're not in school, but younger as he begins enumerating the things he likes about his life in 2019.

He likes that he has driven this route to Citi Field so many times that he knows the way without GPS. He likes that in a few days he will climb onto a team plane bound for yet another major league city. He liked hauling boxes into the Upper East Side one-bedroom he shares with his fiancée, Haley Walsh, because it meant he was home. He likes pitching changes, because he can practice taking a secondary lead off first base (which still amuses his teammates). He likes social media, unlike most in the public eye, because of all the encouragement he gets. He cannot immediately think of a curse he can't turn into a blessing.

Occasionally this drives his teammates crazy. Alonso related a scene from an August game against the Indians during which the Mets endured two rain

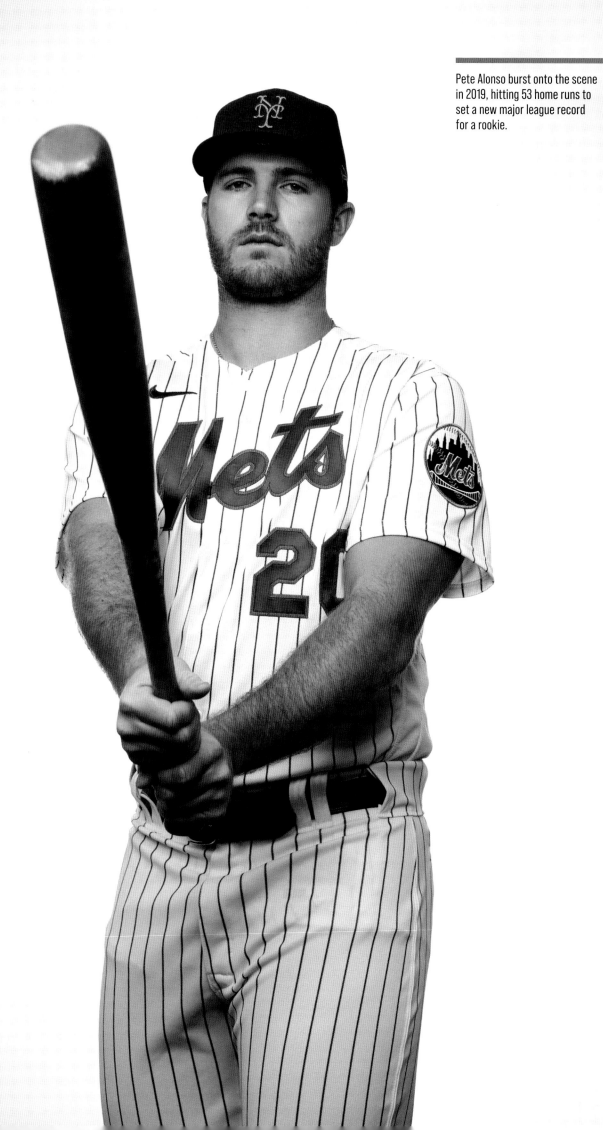

Pete Alonso burst onto the scene in 2019, hitting 53 home runs to set a new major league record for a rookie.

delays. The first, at two hours and 28 minutes, clocked in at a minute shorter than that afternoon's Cubs-Giants tilt. The second began at a quarter to midnight. As his teammates sat at their lockers, calculating the hours of lost sleep, Alonso delivered a call to arms. "First and third, bottom of the eighth!" he roared. "We're going to step on their neck when that tarp comes off at 3 a.m.!" (As it turned out, the game was called, with the Mets ahead 2–0, at 12:23.)

The averageness of New York's record (71–68 as of Sept. 5; four and a half games out of a wild-card spot) may mask the season's extreme highs (a 15–1 run, a batting-title bid from utilityman Jeff McNeil) and lows (six straight home losses in August with a playoff spot in the balance; starter Jason Vargas, now in Philly, threatening a reporter to a fight). Whatever, though, comes of the season, it is likely to be remembered as the year the Polar Bear planted his size 13 feet firmly in Flushing.

The rookie first baseman has smacked so many dingers (45), with such prodigiousness, that he has already become one of the team's most fearsome hitters and unquestioned leaders. He outslugged Ronald Acuña and Vladimir Guerrero Jr. in the Home Run Derby, broke the NL rookie and Mets franchise records for home runs in a season (39 and 41, respectively), and will almost certainly claim NL rookie of the year in November. In the process, the righthander has also proven himself a more enthusiastic cheerleader than Mr. Met. He is a repository of choreographed dugout handshakes and is often the first to chase a teammate down after a walk-off. Twice this year he tore off teammates' jerseys in postgame celebrations.

Alonso's fellow Mets consider him the most optimistic man in baseball. Whether he's really Dr. Pangloss, or whether he's just a wide-eyed rookie whose heart the game has yet to break, the dissonance between Alonso's sunny manner and the nearly annual gloom in Queens presents a polar bear–sized question: Can their prized young first baseman stay this happy, and this good, when everything isn't quite so novel?

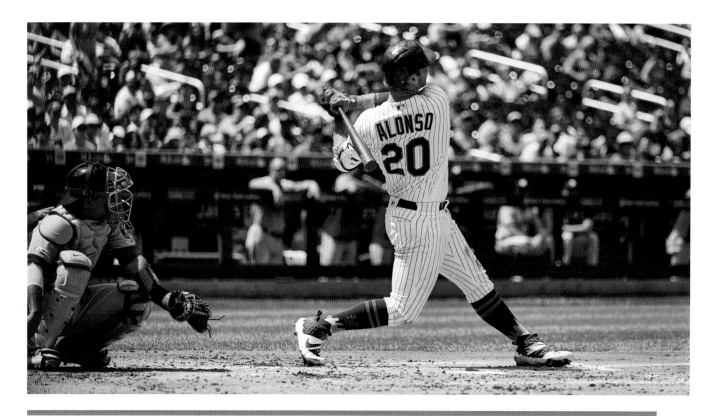

Alonso bats at Citi Field against the Nationals in August. A few days later, he would tie the NL record for home runs by a rookie with his 39th.

"I've been told I look at life through rose-colored glasses," Alonso says. But he's quick to point out that so far he's been right. "I'm not going to say I got everything figured out, because I don't," he says. "But it's like, man, maybe I know some things."

Many would-be saviors have graduated from the farm system to Flushing, and most have failed. The lineage stretches back to catcher Steve Chilcott, whom the team took No. 1, ahead of Reggie Jackson in the 1966 draft. Jackson became a Hall of Famer. Chilcott never played a major league game. Former teammates cheered when Gregg Jefferies, a two-time Minor League Player of the Year as a slugging shortstop, was run out of town after parts of five seasons with the big club. Defensive wizard shortstop Rey Ordoñez, a three-time Gold Glover in the '90s, never developed as a hitter. The team's three bally-hooed pitching prospects in '95—Bill Pulsipher, Jason Isringhausen and Paul Wilson, known as Generation K—had all suffered major injuries by '98. None won even 25 games for the Mets. Outfielder Lastings Milledge, the No. 9 prospect in all of baseball in 2006, was swapped for role players a season later after, among other calamities, the Mets denounced a rap song he appeared on.

Even when the organization creates a star, he tends to implode. Righty Dwight Gooden and outfielder Darryl Strawberry had productive careers, and helped the Mets win the 1986 World Series, but found their Hall of Fame potential derailed by drugs, alcohol and mismanagement. Righty Matt Harvey became a phenomenon—"Happy Harvey Day," fans would greet one another—but he has a 5.65 ERA since his ill-fated assurance that he could finish out Game 5 of the 2015 World Series, which the Royals won in 12 innings to clinch the Series.

Allows Alonso, "It's a little bit easier to be a Yankees fan."

These days the Mets have one of baseball's better homegrown cores, with Alonso, McNeil, outfielder Michael Conforto, emerging shortstop Amed Rosario and pitchers Jacob deGrom, Noah Syndergaard, Zack Wheeler and Steven Matz. But management has struggled to surround them with much. In December new general manager Brodie Van Wagenen traded two top prospects for second baseman Robinson Canó and closer Edwin Díaz. Canó had a career-low .710 OPS before he tore his left hamstring in August. Díaz's 5.29 ERA is worst among pitchers with at least 20 save opportunities. Setup man Jeurys Familia, on a three-year deal, has been even less effective than Díaz. Infielder Jed Lowrie, signed in January, has yet to make his Mets debut, owing to a mysterious series of injuries.

Given such mismanagement, it's hard to imagine the team would be playing games of any relevance in September without the surprising contributions of its big bopper. No one has had a better knack for the moment: Alonso leads the major leagues in game-tying and go-ahead home runs (20).

Alonso says he is a student of the "see ball, hit ball" school. He controls the strike zone well, and when he gets a pitch he likes, he demolishes it. If that seems simple, that's because, he says, it is. In college, "I had to worry about turning in a paper on the French Revolution the day we are playing No. 1–ranked Texas A&M. We've gotta face a first-rounder on the mound, and I've gotta crush a paper. Now …" he laughs, "I've just gotta face [Max] Scherzer." (Alonso is 2 for 12 against him.)

When he played in the Cape Cod League before his junior year at the University of Florida, opponents would come by the field to watch his batting practices. Big leaguers are similarly impressed. During a June series at Wrigley Field, Cubs third baseman Kris Bryant asked Alonso if he could spare an extra Dove Tail PA20 bat. Bryant used it for about a week before exhaustion set in. He was having trouble dragging the 34-inch, 32-ounce lumber through the zone.

Mets fans may have been let down before, but all that past disappointment did nothing to deter their desire to see the big first baseman in Queens. Last year, with Pete tearing up minor league pitching and the Mets' hitters struggling, the West Bank Gourmet Deli in Manhattan added a sandwich to its board: the We Need Alonso.

Early in her son's first major league spring training, in 2018, Michelle Alonso and a cousin made their

way through the stands before a game. They jumped up and down to get Pete's attention. He replied with an exuberant wave. An older teammate barked the old ballplayer's command: "Act like you've been there before." Michelle could see her son's shoulders slump.

"You haven't been here before," she told him later, "and you need to act like you haven't. Allow yourself to enjoy it, or else someday you'll look back on these highlights and regret that in the moment you felt like you had to numb yourself to it."

The message didn't take immediately. ("Mom, you don't get it.") But gradually she saw him return to himself. He never sulked after what he considered to be unfair treatment at the hands of the team last year. He led the minors with 36 home runs, which he hit at Double A Binghamton and Triple A Las Vegas, but the team didn't call him up, to delay his eventual free agency. Alonso decided to suppress his frustration and enjoy his time in Nevada. He hit a walk-off home run in his last game. He does not set out to prove the doubters wrong, he says. He wants to prove the believers right.

When manager Mickey Callaway informed Alonso, on the eve of this season, that the team would no longer be suppressing his service time—that he had made the major league roster—he cried. But while many rookies live in a hotel, just in case they get sent back down, he says he never considered it. "I kind of knew, if I'm going to be up there, I'm going to stay," he says. "I wasn't scared." So in mid-April, after the Mets returned from the second road trip of the season, he and Walsh signed a one-year lease.

After each game, he scrawls the details of his performance in a composition notebook he keeps in his locker. He records opportunities for improvement, but he also tries to see progress even in failure. *0 for 4 … well, I took some really good swings. I fouled a few back.*

Some of this he comes by naturally. When Dennis Braun, Alonso's coach at Plant High in Tampa, met the kid's parents, he was skeptical. Could these people possibly be that positive? Pete's father, a staffing consultant who is also named Pete, never complained about his son's playing time. Michelle, who used to work in a crime lab, brought pom-poms to games. Then Braun got to know them well enough

that they now travel to Pete's games together. They're for real, he says.

So is Pete. In high school he'd jump in to break up fights. In the minors, without saying anything, he once placed a pair of new cleats in the locker of a teammate whose were held together with duct tape. And this year, in a July tweet, when the Mets were at their lowest, he exhorted fans to come to the ballpark, ending his missive with #LFGM—let's f------ go Mets—thus coining this season's catchphrase. "He could make anybody believe," says third baseman Todd Frazier, who gave Alonso the Polar Bear nickname in spring training.

Alonso has been surprised by how much he loves New York. A self-proclaimed country boy, he thought he might find the city overwhelming. (His younger brother, Alex, scoffs. "He didn't grow up country," he says. "Tampa is a city. He's culturally country.") But Alonso loves the peace Manhattan's pace provides. No one has much time to bother him. Once a doctor—or at least a man wearing a white coat near a hospital—caught his eye while rushing down the street. "Hey Pete, I love what you're doing! I gotta get to work! Stop swinging at sliders in the dirt!"

But he doesn't spend much time out and about—when he's in the city, he's at Citi. The Mets laud his work ethic, especially when it comes to his weakest area, his defense. It was Alonso's glove that dropped him to pick No. 64 in the 2016 draft. In high school he would miss balls rolled at him casually between innings. Braun can't count how many college coaches told him they had no room for such a stiff defender.

Before this season, though, Alonso informed Van Wagenen that he intended to mold himself into a Gold Glove first baseman. Weeks earlier the GM had surreptitiously watched Alonso before last year's Arizona Fall League All-Star Game. As the other prospects chatted and took selfies, Alonso sweated through ground balls at first. Every day this offseason he texted Van Wagenen a photo of the scale. He eventually lost 12 pounds, which brought the 6'3" Alonso down to a still-*Ursus maritimus*-like 245. Callaway insists the groundskeepers complain about Alonso's destroying the field with all his extra

In addition to his power at the plate, Alonso has developed into a defensively capable first baseman.

practice. Today, according to FanGraphs, he is almost a league-average defender at first.

None of this surprises Braun. "He would tweet, 'I'm gonna play in Citi Field. I'm gonna make it,'" says the coach. "People called me and were laughing. Just last year people from the Mets told me they didn't think he was ever gonna field in the big leagues." (Braun wouldn't say who.)

This is the sort of environment in which new Mets are expected to thrive. "It will be hard to knock the smile off my face," Bobby Bonilla said in December 1992, when he signed with the Mets. By June he was wearing earplugs to drown out the boos. deGrom recently snapped, "I'm not talking about that" at a reporter. The proposed topic of discussion? The clubhouse Ping-Pong table.

Alonso, whose family calls him Peter, asked the Mets this spring to list him as Pete so he would seem more approachable. "I don't want him to lose that enthusiasm," says director of media relations Harold Kaufman.

So far, he has not. He stands patiently at his locker before and after games, accepting questions from all comers. He becomes practically giddy when the team informs him that various celebrities have requested an introduction: Jerry Seinfeld, Judd Apatow. *They want to meet me? I want to meet them!*

It is easy to be so positive when everything is new, when you are a rookie breaking records for a team that, for all its flaws, put up a surprising fight in the second half. What will test Alonso's temperament, though, are the penny-pinching offseasons and season-long slogs to which the Mets and their fans have grown accustomed. Will Alonso change their outlook, or will the Mets change his?

Alonso's optimism is not reflexive, he says. He chooses every day to see the glass as half full—or at least as refillable. "I just think that if you're thinking negatively it is very, very rare for positive results to come out," he says. He sees the 0 for 4s. He just chooses to focus on the good swings.

He likes that Mets fans choose to be Mets fans, even when the team brings them pain. He likes that sometimes he can turn that pain into joy. His high-rise overlooks the East River, but he likes that his apartment does not have a coveted water view, because he likes to see the city. ●

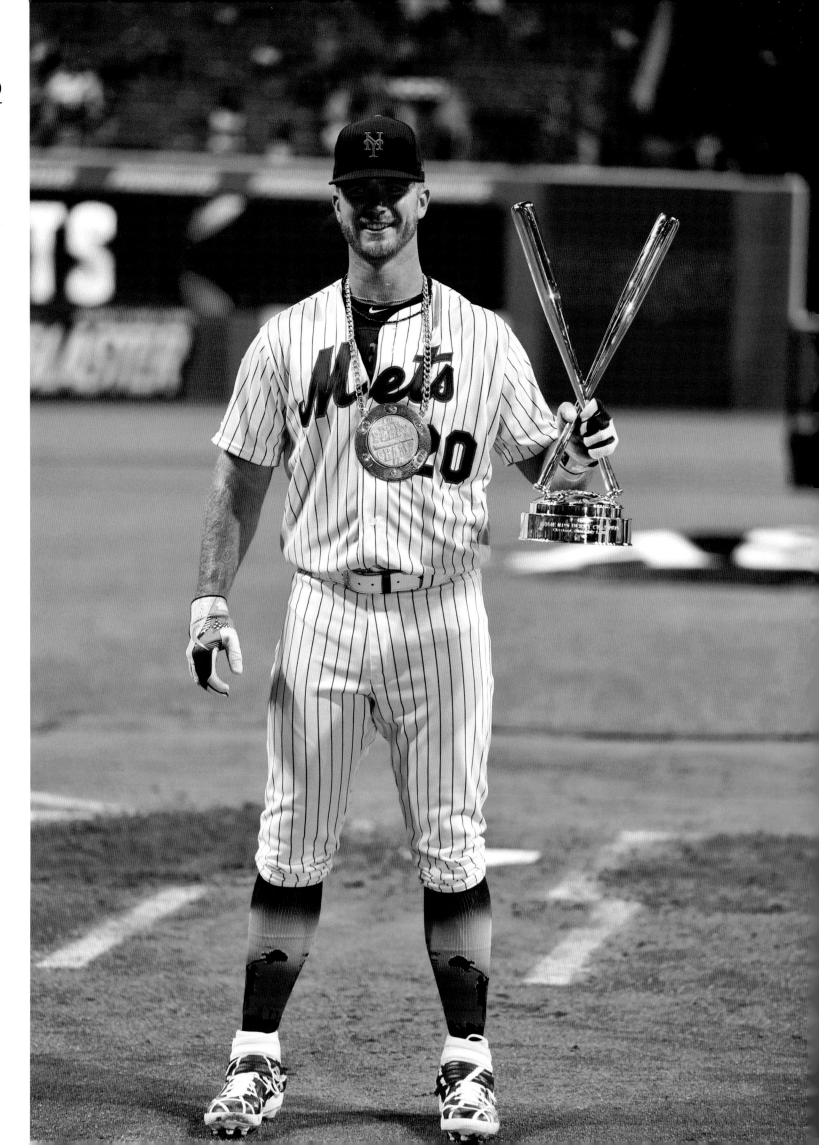

(Above) Mets fans don Polar Bear hats in support of Alonso at Citi Field. (Opposite) Alonso celebrates after winning the 2019 MLB Home Run Derby in Cleveland.

Excerpted from SPORTS ILLUSTRATED, April 2021

FRANCISCO LINDOR, SMILING SUPERSTAR

The Mets' new shortstop worries about where the game is heading and wants to save it, one smile at a time

by TOM VERDUCCI

Glorious sunshine, 80° heat and a sleek Porsche 911 GT3 RS in fashion gray with a cinnamon-red leather interior greets Francisco Lindor as he strolls from lunch at the Bella Collina Club in Montverde, Fla., where the hilltop clubhouse was built, stone by stone, as an exact replica of a castle in Tuscany. Lindor is on his way to see a school building named for him—just 10 years after he was a student there. Only an orchestra in the parking lot playing Debussy, the painter of dreams, could have completed the serenity of the tableau.

Until the damn car will not start.

Lindor turns the key. Nothing. Not a click, a groan, a grind or the even the smallest hint of operational hope. Only mocking silence.

What happens next opens a window into why Lindor is the best hope not only to end the Mets' 35-year championship drought but also to rescue baseball from its technocratic reductionism that promotes probabilities over athleticism, efficiency over entertainment and data over humanism.

Lindor laughs. The man they call Mr. Smile lights up with the wattage of joy that Lewis Carroll had in mind when he invented the word *frabjous*.

"It's because of the sun!" Lindor says. "It gets hot when I park it in the sun and just decides, *I don't want to go.* Can you believe it? You spend 300 grand on a car, and it doesn't want to go when it's hot. That's kind of a problem when you live in Florida!"

Lindor meets misfortune with a smile. He doesn't do petty anger. Nor does he do those paint-by-number,

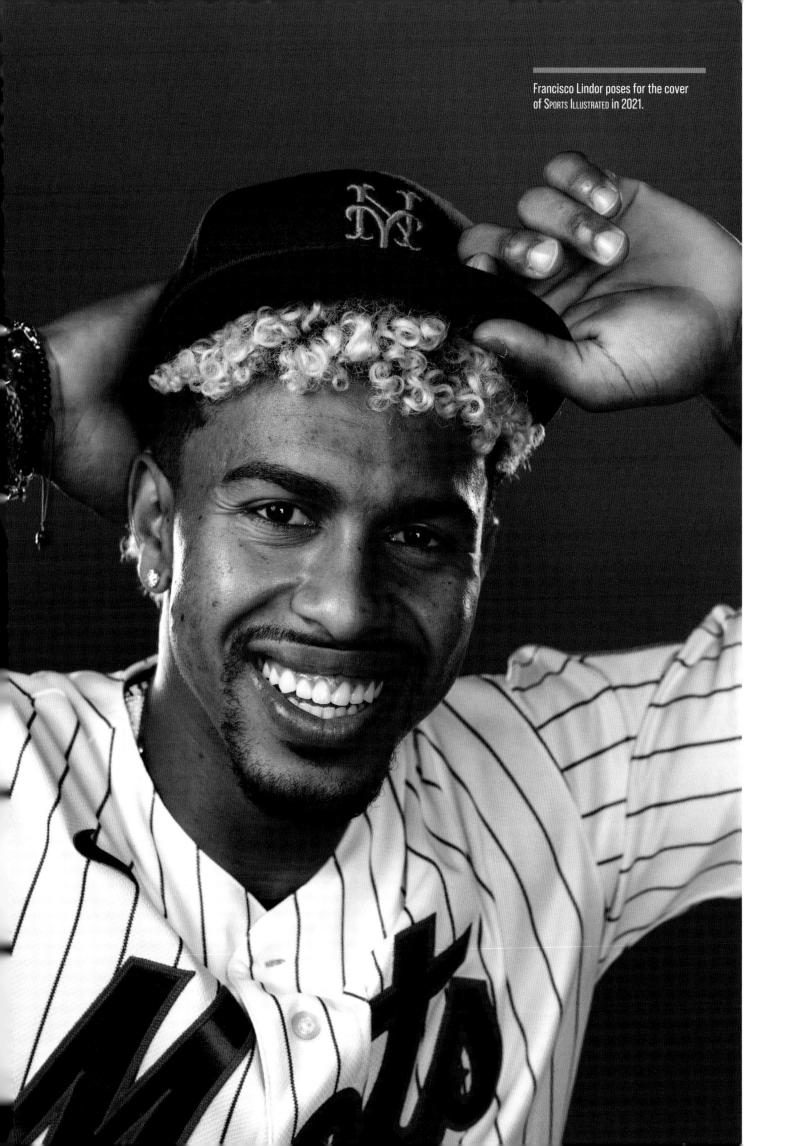

Francisco Lindor poses for the cover of Sports Illustrated in 2021.

laminated defensive positioning cards teams stuff in players' back pockets, or endorsements of defensive shifts, or cookie-cutter methods to field a ground ball or anything else that stifles the creativity of ballplayers. He laughs at convention even more than at a temperamental $300,000 sports car that refuses to start.

Under new management from owner Steve Cohen and president Sandy Alderson, the Mets signaled their elevated intentions by swinging a blockbuster offseason trade with Cleveland for Lindor, a singular talent and personality. The Mets also obtained righthander Carlos Carrasco in the Lindor deal and off the free-agent market signed pitchers Taijuan Walker, Trevor May and Aaron Loup, catcher James McCann and outfielders Kevin Pillar and Albert Almora Jr.

Lindor provides New York an enormous upgrade over erstwhile shortstops Amed Rosario and Andrés Giménez, who were sent to Cleveland in the deal. New York shortstops ranked 21st in OPS and 26th in defensive runs saved last season. Defense has been the club's most corrosive problem while falling 33 wins short of Atlanta during the Braves' three-year hold on the National League East. Since 2017, New York has ranked 30th, 27th, 28th and 28th in defensive runs saved.

The Braves, Dodgers and Padres also bulked up this winter to make for an intense pennant race, but no move was more jaw-dropping than Mr. Smile's coming to Broadway. Lindor relishes the pressure that comes with parachuting into a championship-starved New York.

"To know I'm going to an organization that can put team after team after team together, that's exciting," he says. "It's also exciting to play in New York. It's New York. Every player who goes to New York gets excited to play, whether you're home or away. I love it. I love the fans screaming whether they are against you or for you."

New York is getting the only American League shortstop to win a Platinum Glove since 2011, when the award for the best fielder in each league was first handed out. Though just 5'11" and 185 pounds, the switch-hitter also belted more homers before his 27th

birthday (last November) than every shortstop in history except Cal Ripken Jr. and Álex Rodríguez.

The home runs, though, do not come to mind when he is asked what he loves most about baseball. Lindor thinks for about five seconds, then says, "I love making great plays. I love that. But also, the ups and downs. Finding that balance of being humble but confident in your craft.

"If a person sees me wrong because I have a $3 million home, that's their fault. I'm still the same person. And it's the same thing in the game. I'm smiling. I'm having fun. Because that person plays the game mad or serious or has no emotions or controls his emotions better than I do, it doesn't make me a bad baseball player or a bad person.

"The life lessons within the game are huge. I try to live my life on being consistent and staying positive. If I do that in the game and in life every single day? I'm a great human being. I'm a great baseball player."

The smile hides the adversity he has endured. The frightened 12-year-old who spoke no English when he left Puerto Rico to attend school in Florida, where his family of five crammed into a small pay-by-the-week motel room with only a microwave to prepare meals. The strict father who depended on government assistance after he had to quit work because of panic attacks brought on by PTSD. The developmentally disabled younger stepsister, Jezabel, who can neither walk nor talk with cerebral palsy. The older sister, Legna, who was diagnosed at age 32 with cervical cancer. The mother, Maria Serrano, who suffered an aneurysm last September.

Yet none of those hardships have soured Mr. Smile. One does, though. Ask him about the direction of the game, and you understand why Lindor joined the executive board of the MLB Players Association.

"I do worry," he says. "I worry that we won't have the freedom to play the game the way we want to play the game…. I was worried that the game was going to go to so much analytics that it was going to take over it. Well, it took over. You saw it in the World Series.

"Now it's like I have to look in the dugout to know where to play. They take starting pitchers out in the third inning. They do matchups according to computers. The front office is managing. You see GMs

making more money than managers. That should tell you who is running the team. I just want the freedom to play the game."

Francisco Lindor wants to save the game, one smile at a time.

If analytics call for the removal after only 73 pitches of the first pitcher in World Series history with nine strikeouts while allowing only two base runners, what more governors will be placed on ballplayers? The irony is that just as restrictions tighten in the name of efficiency, the majors are enriched with the most dynamic, deepest class of freewheelingly great shortstops ever.

Shortstop traditionally has been a glove-first occupation, with occasional outliers who could hit for power. Until 2018, only once, in 1947, did shortstops collectively bat better than the major league average, as measured by adjusted OPS. Now, for three years running, shortstops have outhit the league average. In just a 60-game season last year shortstops launched more home runs than they did in every year through 1986.

Today's group features six shortstops with a career slugging percentage better than .470 through age 27 (minimum of 300 games, at least half at the position): Trevor Story of the Rockies, Corey Seager of the Dodgers, Lindor, Carlos Correa of the Astros, Trea Turner of the Nationals and Javier Báez of the Cubs.

That is as many such slugging young shortstops as there had been in the history of the game before they arrived.

Moreover, Gleyber Torres of the Yankees (still with more games at second base), Fernando Tatis Jr. of the Padres (143 games) and Bo Bichette of the Blue Jays (75 games) are on track to join them, while Paul DeJong of the Cardinals, Xander Bogaerts of the Red Sox and Tim Anderson of the White Sox fall just below the .470 threshold.

The two highest collective OPS seasons by shortstops have occurred in the past two years (.772 and .748), displacing the 2006 group (.740), which included Derek Jeter, Hanley Ramírez, José Reyes, Jimmy Rollins and Miguel Tejada.

Today's shortstops are changing the game by being so good so young.

"There is a more recent trend to move guys [through the minors] more quickly and trust that their athleticism will allow them to make adjustments," says Blue Jays president Mark Shapiro, who drafted Lindor for Cleveland in 2011. "When I started, it was more formulaic. It was 2,000 plate appearances [in the minors] and making sure guys didn't skip a level. Now it's more about one, the mental approach—and that's elite with Frankie—and second is athleticism.

"There is something in Francisco Lindor that is different than most players: He wants to be among the greatest. You combine that with intelligence and elite athleticism, and that's why he's going to impact the game for years."

The Padres recently signed Tatis, just 22, to a 14-year, $340 million contract. Only outfielders Mike Trout ($426.5 million) and Mookie Betts ($365 million) have deals of greater value. Story, Seager, Correa, Lindor and Báez all entered spring training as potential free agents after this season. (Lindor indicated he was open to negotiating an extension with New York until Opening Day.)

"Given my choice of all of them, I'd take Lindor," says one National League executive. "Because of his age and his body, his chances of being a high-level defender at that position for the next five, six, seven years is pretty high. His floor is pretty high. And if he can still be a 30-home run hitter, he's annually in the discussion of the top five players in baseball."

As a rookie in 2015, Lindor hit .313 with 12 home runs. He followed that by hitting .301 with 15 home runs in '16.

"The next year [2017] I was like, 'F--- that. Turn on the ball,'" he says. "I hit my .273, 33 home runs, Silver Slugger. All of a sudden it's, 'Wow, he's a great shortstop.' I sacrificed my batting average for home runs."

Ask Lindor who is the best shortstop and you get honesty, not diplomacy.

"Overall? Me," he says. "Because I will do it every single day. I count on myself every single day. Every single day. Trevor Story? I love watching him.

We talk hitting and defense. The best hands at the shortstop position right now are Freddy Galvis and Andrelton Simmons. Best hitter? When Seager is at his level I think he's the best hitter.

"If we go tool by tool, plenty of them are better than me. Tatis? He's incredible. And Báez? I've been playing against Báez since I was growing up and it's like, 'Bro, how are you doing this?'

"There's that fine balance between being confident and being cocky. Sometimes for me it's hard to admit to myself who is the best shortstop. Why? Because of that fine balance. I'm confident. I think I'm the best shortstop."

Confident? Lindor kept betting on himself in terms of his value. He resisted overtures from Cleveland to sign an early contract extension. "I was never opposed to it," he says. "It just had to make sense. Three-forty makes sense. Back in the day maybe 240 makes sense." Lindor will earn $52.3 million through his six service years of club control. Tatis, because of the way his long-term contract is structured, will make $35 million in that same window.

Confident? On one of his first days in a New York uniform Lindor walked into the spring training facility at Port St. Lucie, Fla., with blue hair, his Lindor 1 New Balance sneakers (which he helped design, insisting the line include a multicolor unisex version) and a replica of the Mets varsity jacket worn by Eddie Murphy in *Coming to America*.

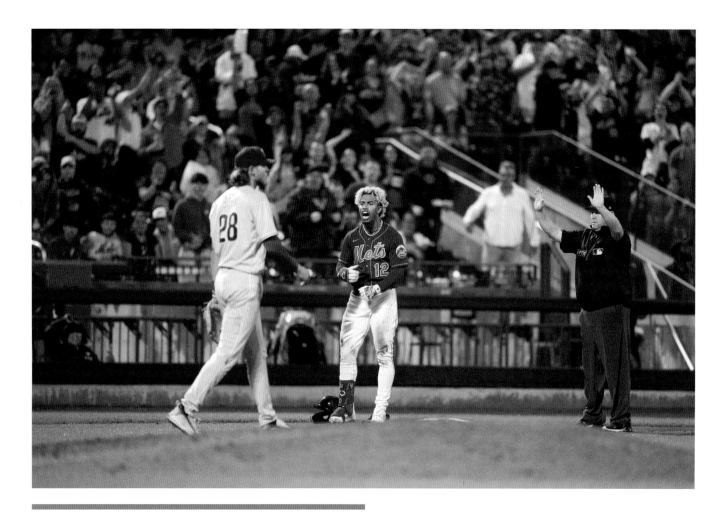

Lindor celebrates after tripling in two runs against the Phillies in 2022.

"I think he doesn't like to look bad, which is why I think he's such a good fit in New York," says Jason Kipnis, his former double-play partner in Cleveland. "He wants everybody to like him. To love him. He wants to be the big superstar. It's like the jacket he wore. He's going to play the part."

———————————

Genius bows to no boundaries. Van Gogh painted *Starry Night* while in a sanitarium. Lindor learned how to field grounders freelancing from the bottom of a hill. His father, Miguel, would stand halfway up the small incline next to their home in Gurabo, P.R., with a bat and some yellow rubber balls. Francisco and his brother, also Miguel, and cousin Christian Figueroa, both nine years older, waited at the bottom. Behind them was a thicket of bushes. Letting a ground ball get by meant having to wade into the thicket to find it.

The hill and the bounciness of the rubber balls assured tricky hops. Miguel hit grounders to their left and right more than he hit straight at them. He taught them to attack the ball, to catch it with one hand and to improvise.

"Make things happen," Lindor says. "You go get the ball. You keep the ball in front of you. You do whatever you can. And fight. Fight for it. This hand?"

Lindor raises his throwing hand. "If it was a bad hop, you either get your face out of the way or you catch it with your bare hand. I've been using that my whole life. Here in the United States, it's two hands. My dad always said one hand."

Asked whether his father was strict, Lindor nods and says, "Still is. My dad thinks I'm playing Little League."

He hears from Miguel after every game via text.

"A paragraph," Francisco says. "'You're doing this, you're swinging up, you're not catching the ball the right way…' I'm like, Pops…"

The 2017 All-Star Game was in Miami, allowing Miguel, who lives in Florida and does not travel by air, a rare opportunity to see his son play in person. Lindor faced Zack Greinke and Greg Holland. He struck out both times. His dad texted him.

"For that? I came here to Miami to see that?"

The son texted back, "Pops, it's an All-Star Game. What are you talking about? Do you know who I faced?"

Says Lindor, "I guess it's a good thing because he keeps me true to myself. His criticism hurts me more than anybody else's, because his is the one that matters. It comes from a good place, which is my pops. I love him."

When Lindor was 12 his father moved the family to Orlando so that Francisco could attend Montverde Academy and that Jezabel, who was eight at the time, could receive better medical care. An arrangement for Francisco to board at the school fell through, leaving his father; his stepmother, Mari Rivera; Francisco; his stepsister, Jezabel; and his toddler sister, Angela, to live in a $100-a-week motel room on Route 192, 45 minutes from the school. Francisco slept in a top bunk with his nose close to the ceiling.

On the drive to Francisco's first day of school, Miguel quizzed his son on the English words they had practiced in Puerto Rico. Francisco remembered almost none of them. He could not grasp the phrase, "I don't understand." Miguel stopped the car.

"Give me your hand."

Francisco opened his palm. Miguel grabbed a pen and wrote on it, "I don't understand."

"There," he said. "When you don't understand something, just show that to people."

Francisco would call his mother in Puerto Rico and cry into the telephone because the math textbooks made no sense.

"You'll be fine," she said. "You can do it. Keep on pushing."

"I was scared," Lindor says. "It's not that I *felt* I was in the middle of nowhere. I *was* in the middle of nowhere. I was like, *Where am I?* It was difficult the first three or four days. And then you start going to baseball practice."

Lindor, who became a boarder at the school after two months of commuting, was determined to be a major leaguer. The idea of being on television motivated him. "I thought I came here to play the game," Lindor says. "I didn't need English to play the game."

He flunked the introductory level of English as a Second Language. His friends moved to ESL II. Lindor repeated ESL I. He was the only one in the class.

"I looked around and thought, *I'm the dumb kid*," he says. "I didn't like school. I wasn't going to do schoolwork then—until they said, 'Well, if you don't do your schoolwork, you can't play.' I said, 'O.K. I've got to study first to be on the field. I got it. I'll do whatever it takes to be on the field. Cool.' That helped me understand there is a process to everything. I have to get that done first to be successful somewhere else."

By his senior year Lindor was one of the top prospects in the nation. So was Báez, who like Lindor had left Puerto Rico for Florida at age 12. When their two high school teams met for a game that February, 110 scouts and executives attended.

"One thing that stood out about Lindor was that right away you said, 'There's no doubt this guy can play shortstop in the big leagues,'" says Josh Byrnes, then the Padres' senior vice president of baseball operations. "He had gifted hands. And when you did the background work on him you found out he had a relationship with his special needs sister that was pretty significant. He wasn't just a high-energy player. He was a high-class person."

Says Lindor, "Seeing [Jezabel] reminds me, 'You're in a much better position. No matter what, don't complain. Don't complain. You've got your health? You're fine.' And she's a happy girl. She smiles a lot. But it's like, 'Don't complain. You're good.'"

Picking 10th in the 2011 draft, the Padres rooted for Lindor to fall to them. Cleveland selected Lindor eighth. The Cubs grabbed Báez with the next pick. The Padres took infielder Cory Spangenberg.

"Báez was getting a little more attention," Shapiro says, "but Lindor stood out from a makeup and character standpoint. Analytically, even though we didn't have a lot of analysis because he was so young, he profiled well in our model."

Lindor agreed to a $2.9 million signing bonus just one minute before a midnight deadline that would have sent him to a junior college.

"I had no fear. I trust the process," he says. "My dad is on the couch like *desperate*. 'Oh, my God. What are you doing?' I'm like, Pops, it's O.K. If God wants me to play the game, I will play the game."

Lindor was staying at a hotel in Arizona during Instructional League when the direct deposit cleared.

He saw the net amount in his online statement: $1.45 million.

"I looked outside my hotel window and I saw a Best Buy," he says. "I walk in, I see an iPad and I said, 'I want that one. That color. Just sell me that.' I bought it and went back to my room. That was the greatest thing ever."

Lindor also used the money to buy homes for both his parents. (His mom, Maria, now lives across the street from him in Clermont, Fla., and, he says, is recovering from the aneurysm.) He also bought something else for himself in addition to the iPad: braces.

"My dad always told me my teeth were fine," he says. "I was like, Dad, they're jacked up. We didn't have money to pay for them. Growing up I did smile a lot, but not in pictures. In pictures I had a half-smile. When I got back home, we had the house and I got braces. It changed my life. I was like, I'm good."

Professional baseball wanted to change Lindor, and, as a teenager eager to please, he allowed it. When he began fielding ground balls with the one-handed, attacking style his father taught him on the hill, he felt the daggers embedded in the sideways glances he got. Some coaches told him to use the standard U.S. method: throwing hand and glove forming a version of a gator's mouth closing on the baseball, followed by the hands funneling toward the belly, then throwing with an overhand motion.

"That's just how they were taught," Lindor says. "And they had success with that so that's all they know. 'Gator, funnel, throw.' If I'm running forward and I'm catching a ground ball, I ain't going to funnel. Get rid of it!

"…Here? The game is played a certain way. When I came here using one hand I was 'hotdogging the game. I'm a hot dog. I'm cocky.' Then I started using two hands because I needed to make sure people didn't see me like that.

"I went through a process where I didn't want people to see me as this cocky, arrogant Puerto Rican that is coming here to play the game. I want people to see me as someone who respects the game. Somebody that's a good person. And through that

process as I got older, if I'm flashy it doesn't mean I'm disrespecting anybody."

Says the Dodgers' Byrnes, "These shortstops have changed the expectations of what you can get out of the position. They can dominate both halves of an inning. I think it filters down to high school fields, where kids trying to get drafted now have higher expectations of what a major league shortstop can do.

"Baseball helped Patrick Mahomes with the way he throws. We preach to our infielders that you have got to be creative. It's O.K. to catch one-handed. It's O.K. to play different positions. You need athletes playing that position."

Lindor admits he may have the weakest arm of the elite shortstops, but he plays one of the deepest shortstops because he is so quick. Last year he played four to six feet deeper than Rosario, who was included in the six-player trade to get Lindor.

He also has an uncanny knack for reading pitchers' stuff and hitters' mechanics. For instance, he talked about how a tiny front-shoulder movement of Royals catcher Salvador Pérez on certain pitches gives away where he is going to hit the ball.

"That's how I go with my defense," Lindor says. "I watch mechanics and swing path and understanding my pitcher."

Those ubiquitous laminated cards teams use to tell fielders where to position themselves? Lindor has no use for them.

"Helllll no!" he says. "No. No. No. I think I'm smart enough to remember nine hitters and 10 pitchers. And nothing against the people that use it. I'm going to rely more on my instincts than a card. And they're pretty accurate."

Lindor has no use for defensive shifts, either. Since he debuted in 2015, the use of shifts has more than tripled—from 10% of pitches to 35% last year. In that same time the difference between batting average on balls in play facing a shift and facing a standard defense went from a 17-point reduction to a 28-point reduction. If it were up to Lindor, a team could not station more than two infielders on either side of second base.

"The shift has got to be cut down," he says. "Let me do me. Let me make the crazy play. Let me be

like, 'O.K., he's going to pull the ball. I can't be on that side of the base.' So as the pitch goes, I run on the other side of the base—*pow!*—and make the play."

In addition to banning the shift, Lindor wants to use his position with the MLBPA to find ways to:

• Allow teams to profit from their stars. "You're telling me you sell a jersey outside the stadium and the team only gets 3%? Because they've got to split it with everybody else? Split it with Pittsburgh? Split it with Tampa, which doesn't want to spend money? Split it with the Indians, who don't want to spend money? That's not fair to a team in New York and not fair to a team in L.A. What are they going to do with 3% of $150? Go buy some coffee?"

• Incentivize winning. "'Oh, you finished last in the league. We're going to give you money.' Because of the luxury tax, these teams that didn't want to spend money, they send them money for next year."

• Market the game—and its players—more aggressively. "We can't market the shift. We can't market strikeouts."

• Give players a voice in how the baseball plays. "It drives me crazy that the game of baseball is the only game that you can change the ball and nobody can say anything. It drives me crazy.

"…Make the ball where it spins good for pitchers and it's good for hitters. Get us all in one room. Let us talk about it. Don't be sneaky about it.

"And that's why I am part of the association. I want to be fair. I want to be in the situation where I can help others, especially the Latin players. Let's find a way."

With the Porsche deciding it was too hot to move, Lindor hitched a ride from a friend in her Dodge SUV to Montverde Academy, where for the first time he saw Lindor Hall above the main entrance to the middle school building. It is a short walk from Lindor Field. After donating money to refurbish the baseball diamond in 2013, he made an even more generous gift to help build a state-of-the-art middle school building replete with an all-purpose gymnasium, student lounges and three

Lindor stands outside a building named in his honor at Montverde Academy in Florida.

large science labs. "We had one tiny lab when I went here," he says.

An extrovert, Lindor comes by leadership naturally. Growing up everybody called him Pacquito, the diminutive of Francisco. His older brother and cousin were constantly goading him to round up other kids to play basketball and baseball. "They'd say, 'Go talk to that person,' and I'd go over there," he says. "I've always been a go-getter."

That is why Game 7 of the 2016 World Series gnaws at him. Lindor was 22 years old. It already had been a very good day. Just before the game his older sister Legna called to tell him she was cancer-free after being diagnosed earlier that year. Cleveland and the Cubs were tied after nine innings. Cleveland held the

momentum after a game-tying two-run home run by Rajai Davis in the eighth inning. Then rain stopped the game. Everything changed. The Cubs regrouped in a players-only meeting called by outfielder Jason Heyward. When play resumed, Chicago immediately rallied for two runs against Bryan Shaw, who was working his second inning, and held on for an 8–7 win.

"I went to the locker room [during the rain delay] and I saw the plastic and I said, 'Oh, s---,'" Lindor says, referring to the protective sheeting to shield players' lockers from the anticipated champagne celebration. "So I went down to the weight room and I just laid down for a nap. I was 22. If I was older, we would have won that game. It would have been different.

"Not that I would have gotten the team together, but I would have gone to [first baseman Mike] Napoli. 'Hey, Nap. What do you think?' Like, I was just happy to be in the World Series. 'Hey, Nap'—because he was our team leader—'hey, Nap, bro, we've got to find a way to do something different.' Or, 'Rajai, what you got? Let's do this. Let's do something.'"

Says Kipnis, "As riveting as any words may have been, I don't think it's that simple. It's not like we let our guard down."

Three years later, when Cleveland pitcher Trevor Bauer heaved a baseball over the center field wall upon being removed by manager Terry Francona, Lindor spoke up.

"I'm like, I can't wait to go inside, because I won't do it in front of people," Lindor says. "I told [Bauer] from A to Z. I told him everything. Every word I could find in English I told him, and probably doubled up in Spanish, too. And he took it. Like, 'You're right. My bad.'"

Life is moving fast. On Nov. 4, Lindor became a father for the first time; his girlfriend, Katia Reguero, gave birth that day to a girl, Kalina. On Dec. 27 he proposed to Reguero in their backyard. On Jan. 7 the couple announced their engagement; that same day he was traded to the Mets. On Jan. 29 he closed on a 6,502-square-foot lakefront estate in Montverde for $2.9 million. Baby, engagement, trade, new home, a school building named after you. And how was your offseason?

If there is one mantra to guide Lindor through this loud, full life of his it is found in the two letters stitched into the leather of his outlandishly colored fielding gloves: BC.

"Be consistent," he says. "It's from my dad. My dad always said, 'Be consistent. Whatever you do, be consistent.'"

Kipnis, asked what impressed him most about Lindor during their five seasons together, says, "His consistency at such a young age. You won't find many players who had such a grasp on routine and what it took to get ready to play a major league game. He is so in tune with his body and what he does on the field."

The sight of Lindor Hall brings out the famous Lindor smile. But he has done more than provide a financial gift and his name. Lindor funds a scholarship program that awards tuition grants to students. (Boarding costs at Montverde run close to $53,000.) He reads applicant essays and meets with the winners. He runs free clinics at the school and two years ago purchased uniforms and cleats for the baseball team.

"I do it because we have an opportunity to shape them into the man or woman they are going to become," he says. "Because the structure I had at this school and the life lessons I learned I apply today. I can be a better person and I can help kids. That to me is the biggest compliment in life. Because everything I learned, I learned from somebody older than me. Besides my parents, school shaped me into the person I am today."

That frightened 12-year-old who spoke no English returns to campus often (he trains there in the offseason), only now as a father who relishes leadership and the cauldron that New York can be. "I can't wait," he says. "I've talked to countless people about the city and they've said, 'Be you. Be real. Give them everything you've got, and they'll respect you.'"

As he moves about the campus in jeans and a T-shirt, Lindor seems more student than superstar. He is still Pacquito, the motormouth kid who will talk to anyone. As students move between buildings, he fist bumps a basketball player and asks him about his grades. A baseball player shows him a new bat. Lindor examines it for weight and feel as if it were gold. Then he walks by a group of students he knows, including a nephew.

"Hey, you, why aren't you in class?" he calls out to them in mock anger.

He wheels and picks up an orange traffic cone, lifting it to his mouth as a megaphone. He shouts through it in the direction of a school safety officer across the street.

"Officer! These kids are cutting class! Take them to the principal!"

As Lindor puts the traffic cone down, everyone within earshot turns to see which mischievous student is causing such commotion. Nobody is laughing harder or smiling more broadly than Pacquito. •

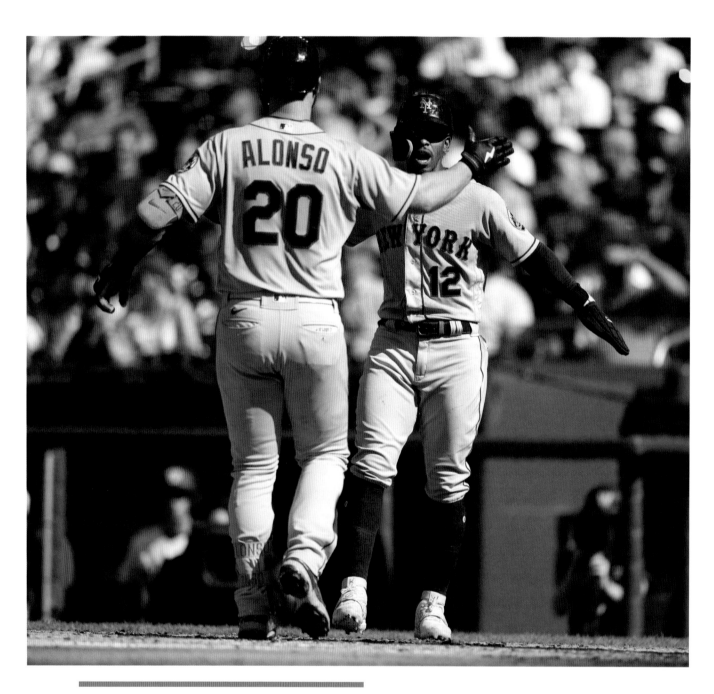

(Above) Lindor and Pete Alonso form the core of today's Mets.
(Opposite) Lindor connects with young fans at Nationals Park in
Washington, D.C.

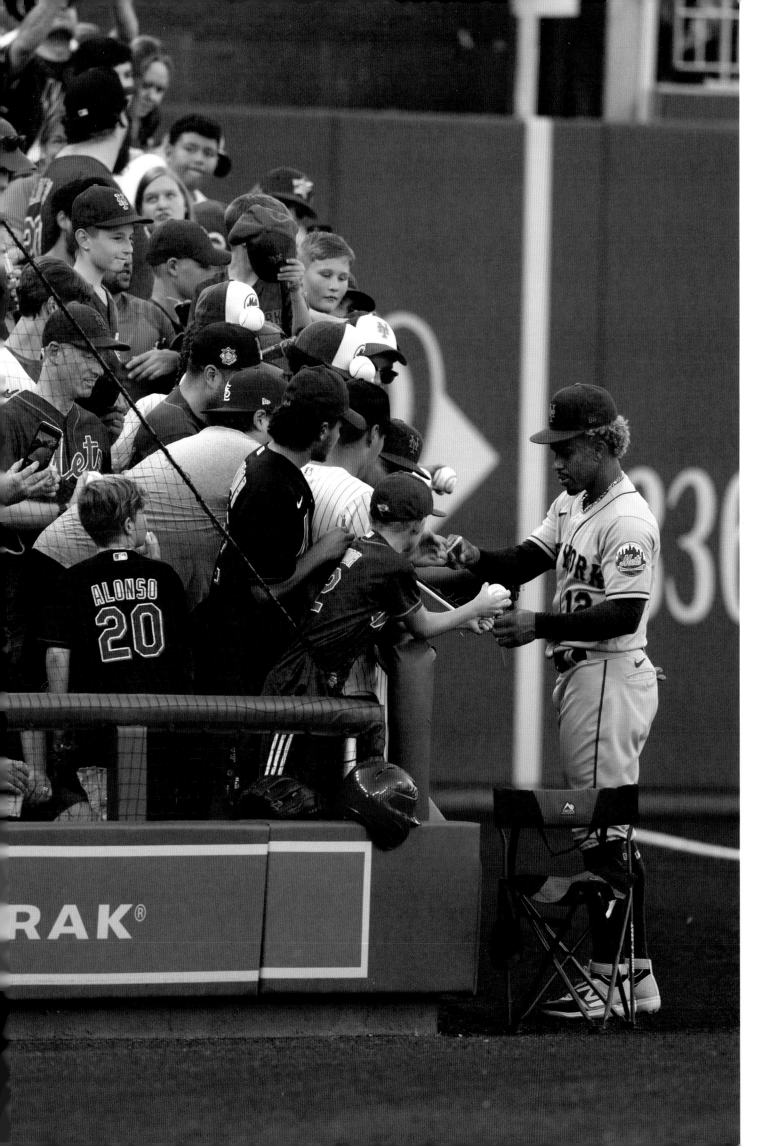

Excerpted from SPORTS ILLUSTRATED, July 29, 2022

WILL METS ACE JACOB DeGROM GET THE LAST LAUGH?

When he's not bullying opposing hitters, he's known to set his sights on his own clubhouse. As he nears a return from injury, the key question is whether he can push around his own body

by STEPHANIE APSTEIN

As the executive director of the Mets' Florida facility, Paul Taglieri works through a list of duties longer than the line at the Citi Field Shake Shack. He oversees the grounds crew. He fixes anything that breaks. He distributes hats to the janitorial staff. One thing he does not do anymore, though, is escort the major league team onto the field for spring training games.

He had to give that up a couple of years ago, because the team's ace would not stop ambushing him in the dugout and pouring a cup of water on his crotch. "So it looked like I urinated on my pants," Taglieri says. "And then I had to walk around the stands with 7,000 people."

Once, he thought he had eluded Jacob deGrom. Then Taglieri ducked into the tunnel that leads back into the clubhouse. "And he's standing there with the hose hooked up to the sink, and he just crushes me," says Taglieri. So now one of his underlings starts the game, while Taglieri hides in the stands and communicates with her by radio.

When he's not tormenting opposing hitters, deGrom likes to torment the people closest to him. "I would be like, 'Read the handbook! This is bullying! I'm gonna call HR on you,'" Taglieri says, laughing.

Catcher James McCann likes to say that deGrom doesn't just want to beat you; he wants to embarrass you. For the most part, he succeeds: He won back-to-back National League Cy Young Awards in 2018 and '19 and he has received votes four other times. Hitters

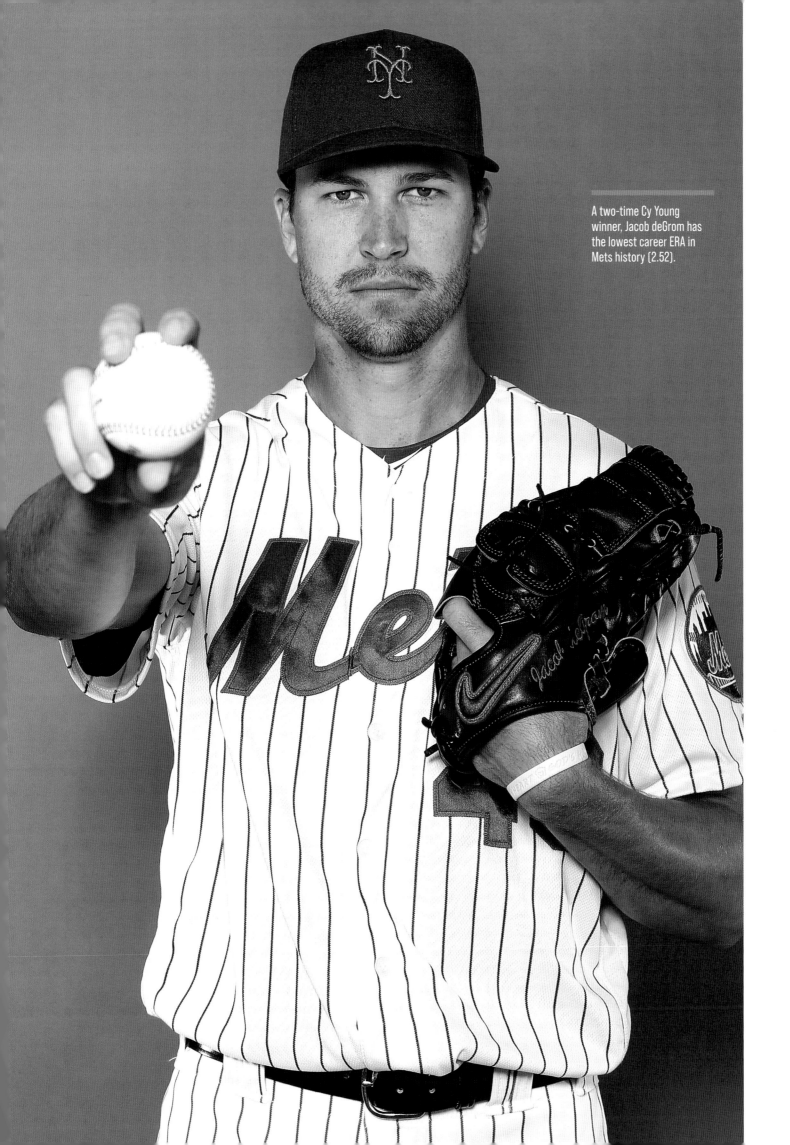

A two-time Cy Young winner, Jacob deGrom has the lowest career ERA in Mets history (2.52).

celebrate making contact against him. No other starter throws so hard so often. (He has hit 99 mph 671 times since '18. The No. 2, Gerrit Cole, has done it 126 fewer times in 205 more innings.) Remarkably, and much to the chagrin of his opponents, deGrom has added velocity with age: His four-seamer averaged 94 mph in '16 and 99 mph in '21.

"I don't know where he's getting it, but it's pretty ridiculous," says Dodgers All-Star shortstop Trea Turner, who faced deGrom 45 times as a National and amassed an OPS of .608. "It was a tough at bat at 94, and it's not fun at 100. It's a little bit annoying."

Last season was on pace to be deGrom's masterpiece: He carried a 1.08 ERA and a 0.554 WHIP into early July, and he induced a swing and miss on nearly a quarter of his pitches, more even than the most dominant relievers.

But then a forearm strain became elbow inflammation became the end of his season, a year after neck, back and lat injuries limited him to 68 innings in the COVID-19-shortened season. He insisted this spring that he was ready to make 30 starts this year, but after two spring training appearances, he was shut down with a stress reaction in his right scapula. He hit 101 mph during his first two rehab starts, in early July, then after his third the Mets announced he felt mild muscle soreness and pushed his next outing back two days. The world has staged two Olympics since deGrom last threw a major league pitch. If nothing else goes wrong, he is scheduled to make his season debut next week in Washington.

He declined to be interviewed for this story, but at a news conference this spring, he was asked whether he is confident he can continue to throw hard and stay healthy. "Yeah, I think so," he said.

He would be the first. The pitchers clustered beneath him on that list of fireballers also dot the injured list: Angels righty Noah Syndergaard, who had Tommy John surgery in 2020 and has appeared in 17 games since; Red Sox righty Nathan Eovaldi, who had Tommy John surgery for the second time in '16 and twice since then has hit the 60-day injured list with loose bodies in his elbow; Yankees righty Luis Severino, who had Tommy John surgery in '20

and has pitched in 23 games since '18. deGrom had Tommy John surgery in '10, after his first season in rookie ball, and he turned 34 in June. And during that same news conference, he said that after this season, he plans to exercise the opt-out in the five-year, $137.5 million contract extension he signed in '19. He added that he hopes to remain a Met.

Even without him, New York pitchers are embarrassing hitters. The rotation, bolstered by newcomers Max Scherzer and Chris Bassitt, is striking out more than a batter per inning, the second-best figure in the sport. Closer Edwin Díaz is whiffing 51% of the men he faces, the second-best mark in history. The Mets have the second-best record in the National League. But Atlanta sits only three games back, and the trade deadline looms. So in what could be their ace's final season in Queens, the Mets will have to answer a question: deGrom bullies friend and foe alike. Can he bully his own body?

At his lowest point, David Wright turned to his friend. Thirteen months after being diagnosed with the spinal stenosis that would eventually end his career, the Mets' captain underwent a procedure to repair a herniated disc in his neck and fuse two of his vertebrae. His 2016 season was over. His career was in doubt. He was confined to a neck brace and forbidden to drive. Still, he wanted to show up at Citi Field and cheer on his teammates.

So he asked deGrom, then New York's lanky 28-year-old No. 3 starter and Wright's neighbor in a Lenox Hill high-rise, to ferry him to the ballpark. Typically when they carpooled, Wright drove, because, he says now, deGrom exhibits "zero" regard for the speed limit. "You're just nauseous," Wright adds. "I did everything I could to not get into a car with him."

So he gave the kid a talking-to. "Jake, in all seriousness, I need you to drive carefully," Wright said. "I can't take your driving thing."

deGrom agreed. Then he swung onto the FDR Drive, turned on his hazard lights and made the trip at 10 mph. Other drivers honked and flipped them off as they blew by. Wright just rolled his eyes.

"He's getting the biggest kick out of it, because he's making fun of me," he says.

deGrom's eyes light up when a teammate enters the clubhouse wearing unfashionable shoes. He once watched Syndergaard struggle to balance on a bosu ball; the next day, players walked into the training room to see deGrom standing serenely—and pointedly—atop it. Another time, after a string of interviews during Pete Alonso's Rookie of the Year season, deGrom turned to the kid. "It's the New York Mets," he said. "Not the New York Petes."

He intimidates younger players and peers alike. "When I first showed up, for probably the first two years, three years, it was like, I don't know if you're my friend or if I should be deathly scared of you," says center fielder Brandon Nimmo, who has played with deGrom since 2016. "It's kind of both."

deGrom enjoys keeping people off balance, both at the plate and in the clubhouse. Sometimes he will ask new members of the organization startlingly personal questions, just to see how they react. "He's testing you," veterans explain.

And it's hard to be sure of his mood. "You walk up to him, and he looks like he wants to choke-slam somebody," says Ricky Meinhold, who was a pitching coach in the Mets' organization from 2019 through '21. "And then he'll change that thought and say, 'Hey, Ricky, how ya doing?'"

Some of this behavior may seem mean. People close to him insist they cherish it. "He's not a bad guy," Nimmo says. "He's a really good guy. He will throw some pranks out there, he can throw some one-liners at you, but it's all in good fun."

Indeed, sometimes the hassling feels more like an honor. Meinhold can't quite decide how to feel about the fact that he eluded deGrom's pranks.

"I'm lucky, I guess," he says. "Well, I guess not, at the same time, because the people that he does do those things to he absolutely adores, whether he'll say it or not."

deGrom learned from the best: Wright was the team prankster for most of his career. He, too, targeted Taglieri, once having his car set on cinder blocks and the tires distributed throughout the stadium—one on Taglieri's couch, one among fans on the berm in the outfield, one in a pitching machine in the batting cage, one on a backfield.

At first, deGrom was the victim of Wright's sense of humor. For the first three years of his career, any time deGrom piped up, Wright and bullpen catcher Dave Racaniello would round on him. "Weren't you in Triple A, like, six months ago?" they'd ask him. Wright would challenge deGrom to games of pluck and then beat him so badly deGrom would throw his cards in the air.

As a rookie, deGrom once made the mistake of laughing when a teammate made a joke at the captain's expense. So Wright grabbed a pair of scissors and turned his jeans into jorts. "You could almost see a little bit of buttcheek," says Wright, clearly still delighted with himself. "We paraded him around the hotel." (Wright adds that he paid for a replacement pair.)

But soon they realized they were better as a team. One day Taglieri walked into the facility to find that the lock on his office door had been changed. Wright and deGrom finally gave him the key … and watched, cackling, as he realized they had paid someone to come in overnight and erect drywall inside so that the office was now two feet wide by two feet long. The walls were painted; Taglieri's family photos hung on hooks.

"I can't get to them, because they tell me, 'We have a lot of money, and we have a lot of time. You'll never get even,'" Taglieri says.

The Mets still speak with awe of one of the few people to pay deGrom back. Former assistant hitting coach Pat Roessler, quite reasonably, "wasn't crazy about rats," says Nimmo. So during a series at Fenway Park when the team spotted a rodent in the dugout, deGrom spent the night touching Roessler lightly on the shoulder with a wrapper and rolling small objects by his feet.

Later, deGrom returned to the clubhouse to find his street shoes nailed to the floor of his locker.

"That was pretty good," says Red Sox catcher Kevin Plawecki, who played with deGrom from 2015 through '18. Plawecki has his own victory story: He once sprinkled Hi-C drink powder in deGrom's cleats before a workout. When deGrom took off his socks, he realized his sweat had combined with the powder to stain the soles of his feet beet red.

"But you gotta be careful," says Nimmo, "because Jake doesn't stop."

Often, during spring training, deGrom throws an early bullpen session and finds himself at the complex with nothing to do. He waits for Taglieri to leave his office, then gets to work. Some days deGrom turns everything upside down: desk, desk chair, end tables, golf clubs. Sometimes he swipes Taglieri's car keys and moves his car across the parking lot.

In 2019, on the last day before the team began renovating the Port St. Lucie facility, deGrom wandered casually into Taglieri's office and picked up a golf club.

"What are you doing?" Taglieri asked warily.

"I think I'm going to start the construction now," deGrom said, and slammed the club through the wall.

"He does not apologize," says Taglieri, laughing. "I'm not afraid of David [Wright]. I'm afraid of Jake."

deGrom fears no one. He is the best athlete most of his teammates have ever seen, and he likes to remind them of that. He can dunk a basketball while wearing dress shoes. Racaniello believes he could have been a high-level wide receiver. ("I gotta bring him down," he says. "I always give him a hard time, 'We don't know if you can take a hit!' He's like, 'I can take a hit.'") Wright once watched deGrom walk across a gym on his hands.

Second baseman Jeff McNeil, when asked what opponents say about deGrom's stuff when they reach second base, identifies a problem: They don't reach second base.

And deGrom is competitive to the point of absurdity. He stages one-man races off the field after shagging fly balls. When teammates' elementary schoolers want to toss around a Nerf football, he pegs them with it. He insists on taking grounders at shortstop, and he keeps track of how many errors everyone makes. "After he beat you in sprints," Wright says, "he'd give you a head start and beat you again." Coaches say they breathed a sigh of relief when the new collective bargaining agreement introduced the universal designated hitter; deGrom kept hurting himself swinging too hard. Teammates say they rarely see deGrom happier than when he has humiliated an opposing hitter. "That brings him a lot of pleasure, knowing that guy's got no chance," says McCann.

Even as a child growing up in De Leon Springs, Fla. (population: 2,840), deGrom was something of a thrill seeker. He likes to tell teammates about the days when he and his friends got hold of an excavator, drove it to the shores of a lake, tied a rope to the arm and swung the joystick back and forth, flinging themselves into the water. When he and Cardinals lefty Steven Matz played together in the minor leagues, they would make an annual pilgrimage to deGrom's DeLand, Fla., ranch before the season began and race four-wheelers through the property. "Reckless activities, we used to call it," Matz says, laughing. "Not anymore," he adds. Even now, deGrom wakeboards whenever he gets the chance, recording videos of himself flipping over waves. Racaniello says deGrom credits the extracurriculars with helping him increase his velocity as he ages.

"I'm not trying to get him in trouble, based on contract stuff," says retired utilityman Kelly Johnson, who played with him in 2015 and '16 and remains one of his close friends. "But if he was not playing baseball, it would be crazy to know what he would be doing to his body."

Until the Mets allow him to take up skydiving or fight Jake Paul, deGrom finds other ways to indulge his inner child. "Every time I talk to him," says Johnson, "he's buying some old, beat-up truck. It's like, how many of these do you need?" Many athletes treat their body like a temple. deGrom treats his like a Taco Bell. "I've never seen somebody so in shape drink so many Mountain Dews," says Wright. When the team nutritionists banned the junk food he prefers to wolf down before his starts, deGrom sent a clubhouse attendant to the concourse to fetch him a burger and fries.

All this might seem an uncomfortable fit for a professional athlete. But no one much cared what deGrom did to his body as long as it was producing 200 innings of sub-2 ERA. Indeed, this spring, before deGrom went down, pitching coach Jeremy Hefner insisted the team trusted its ace to do what made sense for him.

"I don't pay too much [attention]—like, I'm very concerned about what they do on the field, and obviously what they do off the field translates over

to that," Hefner said. "But if a guy wants to have a burger, he can have a burger. If a guy wants to not have a burger, then don't have a burger." He added, "I'm not any more concerned about him than I would be about anyone else."

Four months—and one injury—later, Hefner says his opinion has not changed. "Pitchers do an unnatural thing by throwing overhand, and we can try to fix mechanics and all those types of things, and sometimes guys just break," he says. He adds that the length of deGrom's ramp-up—his first rehab start came on July 3, so he will have spent just about a month in the minors—is an indication that the Mets are trying to give him every possible chance to stay healthy going forward.

A common refrain about deGrom is that he knows his body. "He's one of the best I've seen at making adjustments on the fly," says McCann. "A lot of guys

deGrom and David Wright were neighbors and fellow pranksters during their years together in New York.

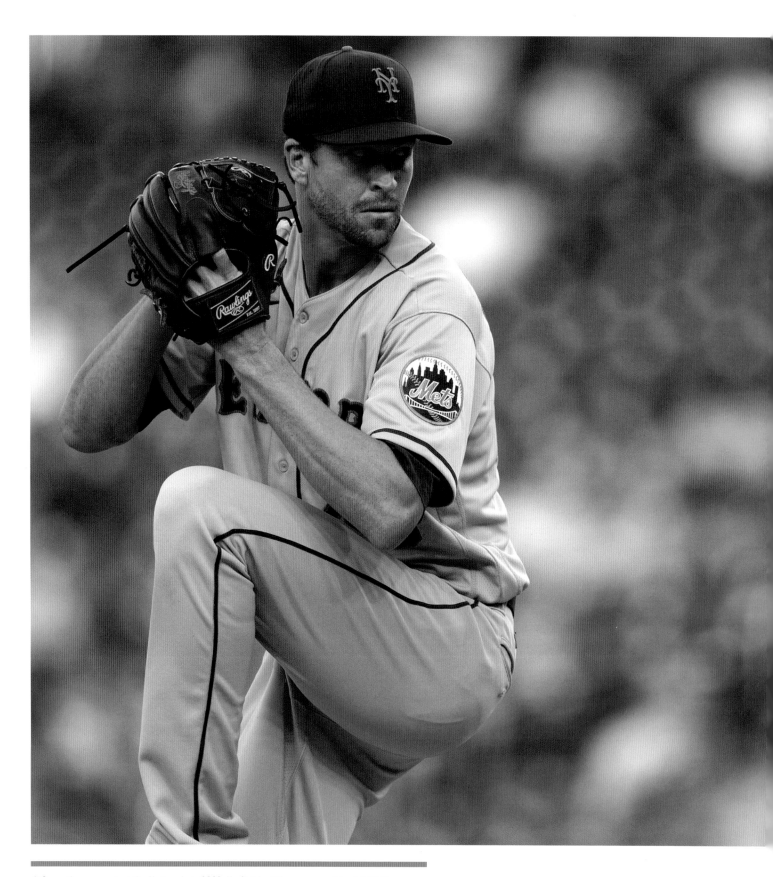

deGrom throws against the Nationals in 2022. He finished the season with a 3.08 ERA.

have to go watch video. He watches video, but he'll tell you in the moment, 'My release point's lower,' or 'My release point's a little higher,' or whatever. He can feel that. And usually he makes the adjustment."

Hefner says, "I think Jake's just naturally gifted with how he understands where his body is in space really well. So whether it's playing Ping-Pong or he's taking ground balls or he's throwing a pitch or whatever, he has a really good understanding of where his body is in space, and that helps him, and then he's also blessed with height and flexibility and the ability and rhythm." Hefner adds that deGrom's background—he came up as a shortstop and did not pitch regularly until his junior year at Stetson—means he has less mileage on his arm than most of his peers. If anyone is to defy the aging curve, Hefner says, he would bet on deGrom, "100%."

And he puts in the work. The weight room at the Mets' spring facility overlooks the 10 bullpen mounds; when deGrom throws, his teammates gather at the window to watch. "He cares so much about his craft," Wright says. "I think he picks up a baseball almost every day in the offseason and throws with his dad. For all the goofiness and all the pranks, you'll see him in the mirror in the gym, repeating his delivery. You'll see him in the video room, trying to pick up things he's doing right and wrong. He's a master of his craft, and I think other people see that, and they can learn a lot from it."

Racaniello marvels at the care deGrom dedicates to his bullpen sessions. Each delivery is the most important thing he will do that day. He might take half a minute between pitches, so engrossed is he in every one. "I don't know if there's anyone that focuses more in a bullpen," says Racaniello. "He's always been that way."

Meinhold says he will never forget his first impression of deGrom, which came when he silently watched one of the ace's bullpens. "When he got on the mound to get his work in, it was locked in," he says. "Like *locked in*, like the ultimate locked in. You could just see it from his mannerisms, from his attention to detail in how he comes set, how he focuses with his eyes, how he takes his breath, how he delivers the pitch. Everything was so under control

and with a purpose. And I say these things and somebody reading it would be like, 'Yeah, he's a major league pitcher, obviously,' but that's not the same with everybody. And if you're in the game, and you're around those types of athletes, you know, there's a handful that are very, very good at it and then there's the guys that are even better at it or are more crisp with it. It's not so common. I know that every time he does his touch-and-feel sessions during the week, it's a certain amount of pitches every single time, no matter what. When he [throws] his bullpen, it's the same amount of pitches every single time, no matter what. And when he plays catch in the outfield, it's roughly around the same range every single time. That's not normal."

Little about deGrom is. His career to this point is unprecedented. So is his career moving forward. His future in New York is uncertain. As his teammates have forged this unifying season, he has followed along from his home in Florida. For much of the spring he did not have a locker at Citi Field; when he did, it was empty. He is around little enough that new manager Buck Showalter, when asked about what to expect from him when he returns, recently remarked to reporters, "Y'all know him better [than I do]." How well Showalter will get to know him is an open question. At least one Met has begun to wonder whether deGrom will return this season at all.

Despite deGrom's inactivity in 2022, his market figures to be robust this coming winter if he maintains his promise to opt out. Syndergaard received $21 million from the Angels after making two starts in '21. Justin Verlander fetched $25 million from the Astros after making zero. deGrom should top them both—and could top Scherzer's record $43.3 million average annual value.

When he takes the mound, no one bullies hitters like deGrom. After this season, maybe he will bully an owner or three into bidding for his services. It's not usually wise to bet against him.

"He doesn't want to get beat by anybody in baseball," says Plawecki. "[Or] in life in general— going back to messing around in the locker room, he always wants to have the last laugh. And most of the time he does." •

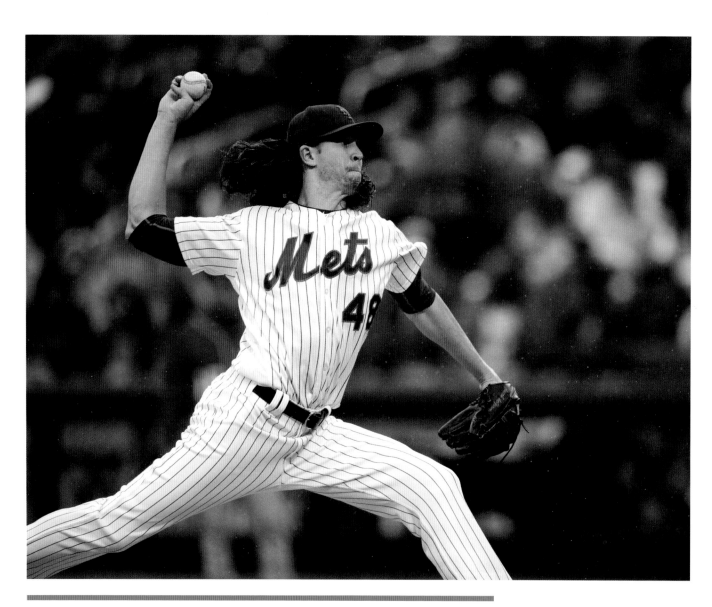

(Above) Once known for his long hair, deGrom finally had it cut in 2017. (Opposite) It had little negative effect on his performance; in 2021, he set a major league record by striking out 50 batters over his first four starts of the season.

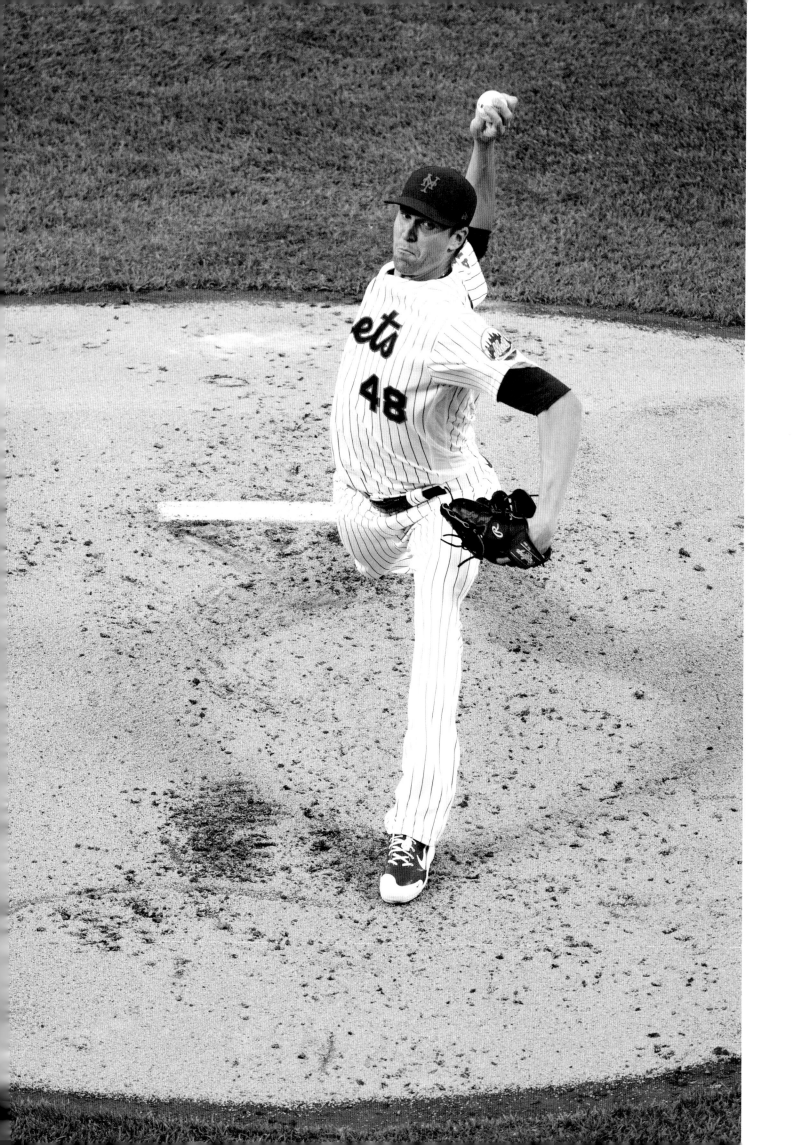

METS BY THE NUMBERS

HEAD-TO-HEAD RECORD

Rk	Team	Years	Games	Wins	Losses	Ties	W/L%
1	Philadelphia Phillies	61	1,055	513	541	1	.487
2	Atlanta Braves	57	835	390	444	1	.468
3	Pittsburgh Pirates	60	766	369	395	2	.483
4	St. Louis Cardinals	60	766	361	405	0	.471
5	Chicago Cubs	60	761	368	391	2	.485
6	Los Angeles Dodgers	60	633	277	355	1	.438
7	San Francisco Giants	60	631	292	339	0	.463
8	Cincinnati Reds	60	626	299	327	0	.478
9	Montreal Expos	36	597	299	298	0	.501
10	Houston Astros	54	577	260	316	1	.451

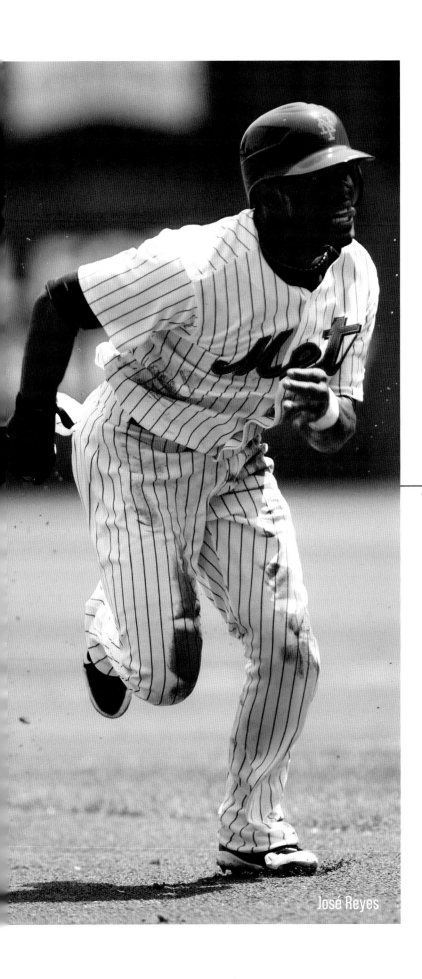

José Reyes

GAMES PLAYED

1. Ed Kranepool **1,853**
2. David Wright **1,585**
3. José Reyes **1,365**
4. Bud Harrelson **1,322**
5. Jerry Grote **1,235**
6. Cleon Jones **1,201**
7. Howard Johnson **1,154**
8. Mookie Wilson **1,116**
9. Darryl Strawberry **1,109**
10. Edgardo Alfonzo **1,086**

PLATE APPEARANCES

1. David Wright **6,872**
2. Ed Kranepool **5,997**
3. José Reyes **5,931**
4. Bud Harrelson **5,083**
5. Cleon Jones **4,683**
6. Howard Johnson **4,591**
7. Darryl Strawberry **4,549**
8. Edgardo Alfonzo **4,449**
9. Jerry Grote **4,335**
10. Mookie Wilson **4,308**

HITS

1. David Wright **1,777**
2. José Reyes **1,534**
3. Ed Kranepool **1,418**
4. Cleon Jones **1,188**
5. Edgardo Alfonzo **1,136**
6. Mookie Wilson **1,112**
7. Bud Harrelson **1,029**
8. Mike Piazza **1,028**
9. Darryl Strawberry **1,025**
10. Howard Johnson **997**

BATTING AVERAGE

1. John Olerud **.315**
2. Jeff McNeil **.307**
3. Keith Hernandez **.297**
4. Mike Piazza **.296**
 David Wright **.296**
6. Edgardo Alfonzo **.292**
 Dave Magadan **.292**
8. Daniel Murphy **.288**
9. Steve Henderson **.287**
10. Ángel Pagán **.284**

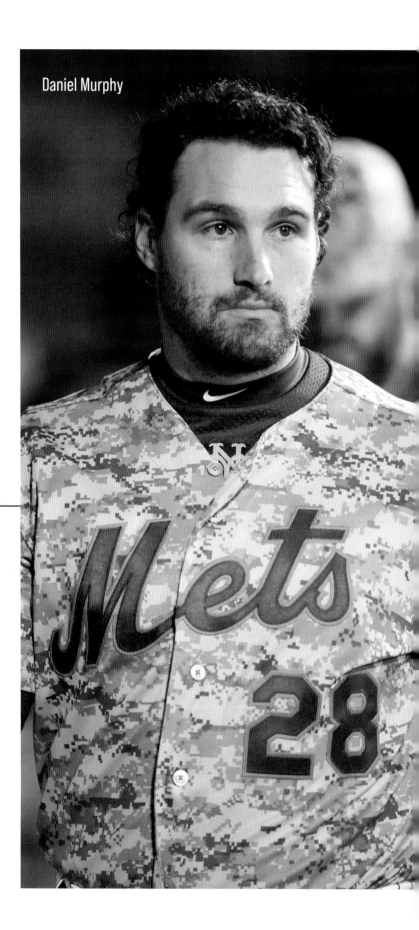

Daniel Murphy

ON-BASE PLUS SLUGGING (OPS)

1. John Olerud **.926**
2. Mike Piazza **.915**
3. Pete Alonso **.884**
4. Darryl Strawberry **.878**
5. Carlos Beltrán **.869**
6. David Wright **.867**
7. Carlos Delgado **.857**
8. Bobby Bonilla **.851**
9. Cliff Floyd **.832**
10. Robin Ventura **.828**

HOME RUNS

1. Darryl Strawberry **252**
2. David Wright **242**
3. Mike Piazza **220**
4. Howard Johnson **192**
5. Dave Kingman **154**
6. Carlos Beltrán **149**
7. Pete Alonso **146**
8. Michael Conforto **132**
9. Lucas Duda **125**
10. Todd Hundley **124**

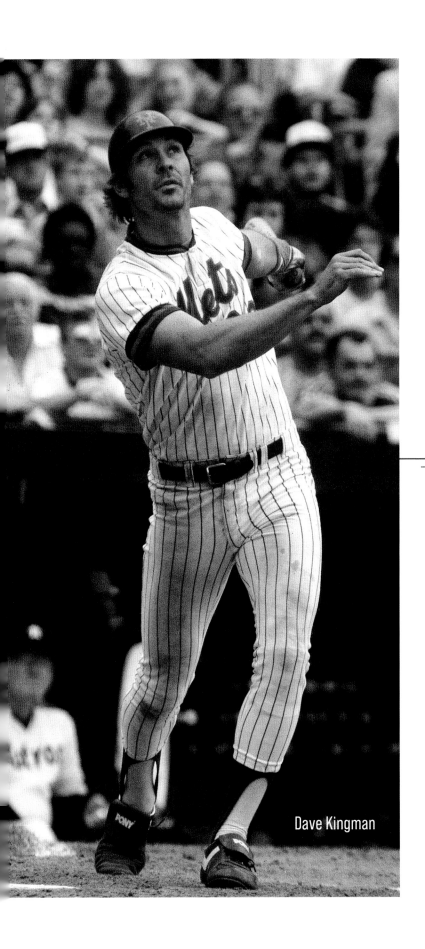

Dave Kingman

RUNS BATTED IN

1. David Wright **970**
2. Darryl Strawberry **733**
3. Mike Piazza **655**
4. Howard Johnson **629**
5. Ed Kranepool **614**
6. Carlos Beltrán **559**
7. Edgardo Alfonzo **538**
8. Cleon Jones **521**

 José Reyes **521**
10. Keith Hernandez **468**

WALKS

1. David Wright **762**
2. Darryl Strawberry **580**
3. Bud Harrelson **573**
4. Howard Johnson **556**
5. Wayne Garrett **482**
6. Keith Hernandez **471**
7. Edgardo Alfonzo **458**
8. Ed Kranepool **454**
9. Carlos Beltrán **449**
10. Lee Mazzilli **438**

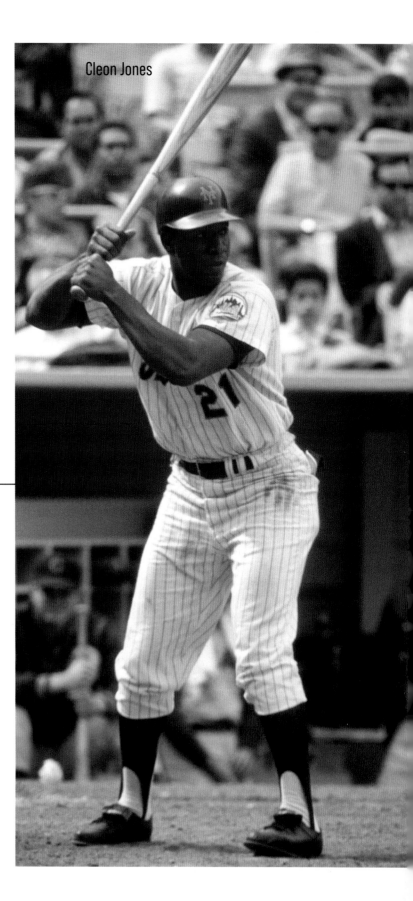
Cleon Jones

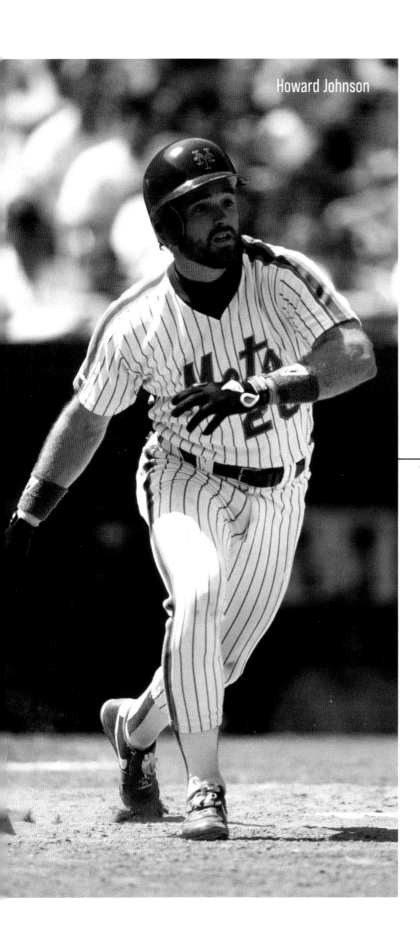

Howard Johnson

RUNS SCORED

1. David Wright **949**
2. José Reyes **885**
3. Darryl Strawberry **662**
4. Howard Johnson **627**
5. Edgardo Alfonzo **614**
6. Mookie Wilson **592**
7. Cleon Jones **563**
8. Carlos Beltrán **551**
9. Ed Kranepool **536**
10. Mike Piazza **532**

STOLEN BASES

1. José Reyes **408**
2. Mookie Wilson **281**
3. Howard Johnson **202**
4. David Wright **196**
5. Darryl Strawberry **191**
6. Lee Mazzilli **152**
7. Lenny Dykstra **116**
8. Bud Harrelson **115**
9. Wally Backman **106**
10. Roger Cedeño **105**

EARNED RUN AVERAGE

1. Jacob deGrom **2.52**
2. Tom Seaver **2.57**
3. Jesse Orosco **2.73**
4. R.A. Dickey **2.95**
5. Jon Matlack **3.03**
6. Jerry Koosman **3.09**
7. John Franco **3.10**

 Dwight Gooden **3.10**
9. Bob Ojeda **3.12**
10. David Cone **3.13**

INNINGS PITCHED

1. Tom Seaver **3,045.2**
2. Jerry Koosman **2,544.2**
3. Dwight Gooden **2,169.2**
4. Ron Darling **1,620**
5. Sid Fernandez **1,584.2**
6. Jon Matlack **1,448**
7. Al Leiter **1,360**
8. Jacob deGrom **1,326**
9. Craig Swan **1,230.2**
10. Bobby Jones **1,215.2**

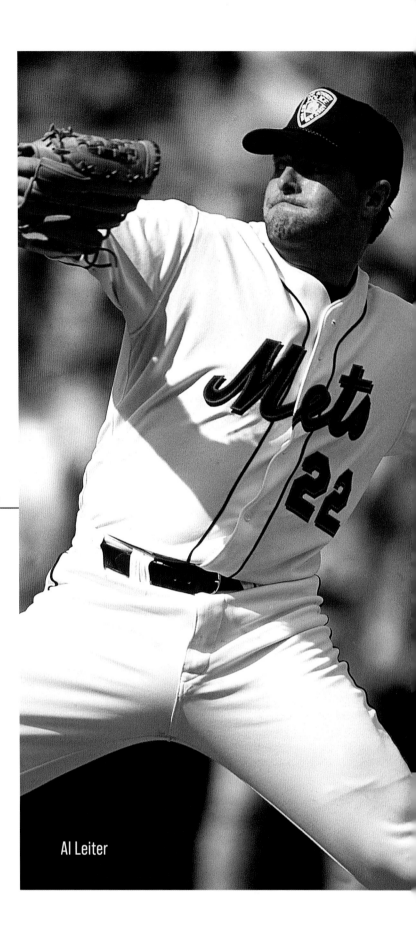

Al Leiter

MOST WINS BY
A METS PITCHER

1 **TOM SEAVER** 198

2 **DWIGHT GOODEN** 157

3 **JERRY KOOSMAN** 140

4 **RON DARLING** 99

5 **SID FERNANDEZ** 98

6 **AL LEITER** 95

7 **JON MATLACK** 82

8 **DAVID CONE** 81

9 **JACOB deGROM** 77

10 **BOBBY JONES** 74

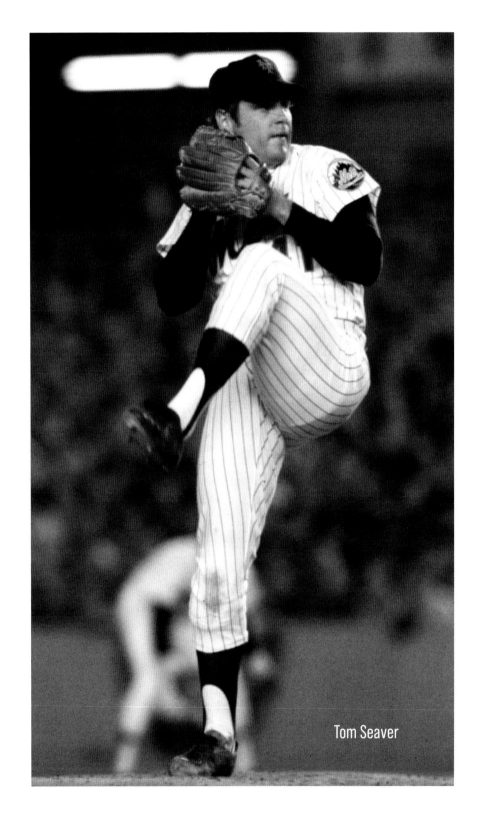
Tom Seaver

STRIKEOUTS

1. Tom Seaver **2,541**
2. Dwight Gooden **1,875**
3. Jerry Koosman **1,799**
4. Jacob deGrom **1,607**
5. Sid Fernandez **1,449**
6. David Cone **1,172**
7. Ron Darling **1,148**
8. Al Leiter **1,106**
9. Jon Matlack **1,023**
10. Jon Niese **838**

COMPLETE GAMES

1. Tom Seaver **171**
2. Jerry Koosman **108**
3. Dwight Gooden **67**
4. Jon Matlack **65**
5. Al Jackson **41**
6. Jack Fisher **35**
7. David Cone **34**
8. Roger Craig **27**
9. Ron Darling **25**
 Craig Swan **25**

David Cone

Noah Syndergaard

SHUTOUTS

1. Tom Seaver **44**
2. Jerry Koosman **26**
 Jon Matlack **26**
4. Dwight Gooden **23**
5. David Cone **15**
6. Ron Darling **10**
 Al Jackson **10**
8. Sid Fernandez **9**
 Bob Ojeda **9**
10. Gary Gentry **8**

WIN-LOSS %

1. Dwight Gooden **.649**
2. Rick Reed **.621**
3. Tom Seaver **.615**
4. David Cone **.614**
5. Noah Syndergaard **.603**
6. Jacob deGrom **.590**
7. Ron Darling **.586**
 Al Leiter **.586**
9. R.A. Dickey **.582**
 Pedro Martínez **.582**

MOST SAVES BY A METS PITCHER

1 JOHN **FRANCO** — 276

2 ARMANDO **BENÍTEZ** — 160

3 JEURYS **FAMILIA** — 124

4 JESSE **OROSCO** — 107

5 BILLY **WAGNER** — 101

6 EDWIN **DÍAZ** — 96

7 TUG **McGRAW** — 86

8 ROGER **McDOWELL** — 84

9 FRANCISCO **RODRÍGUEZ** — 83

10 NEIL **ALLEN** — 69

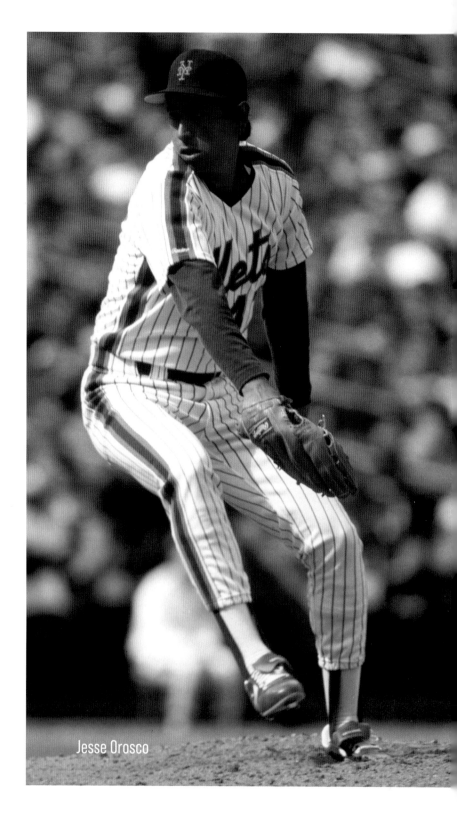

Jesse Orosco

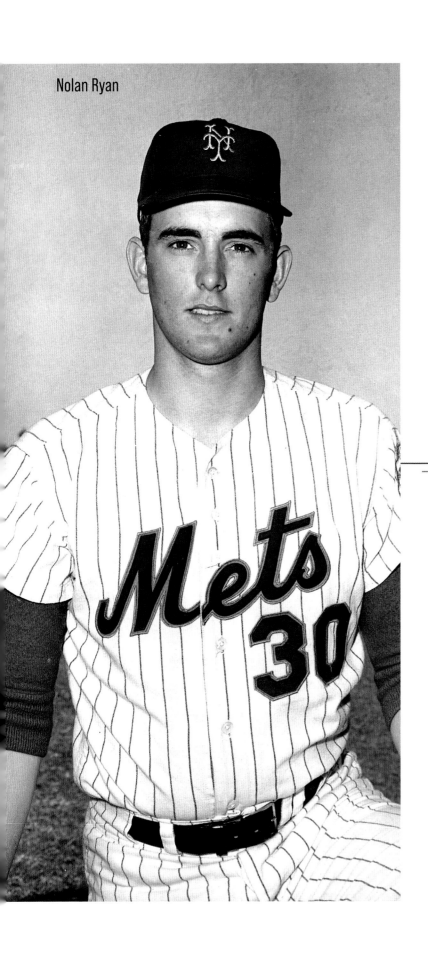

Nolan Ryan

HITS/9 IP

1. Nolan Ryan **6.512**
2. Sid Fernandez **6.628**
3. Jacob deGrom **6.930**
4. Tom Seaver **7.184**
5. Jesse Orosco **7.252**
6. David Cone **7.524**
7. Gary Gentry **7.605**
8. Tug McGraw **7.778**
9. John Maine **7.854**
10. Dwight Gooden **7.873**

STRIKEOUTS/9 IP

1. Jacob deGrom **10.907**
2. Noah Syndergaard **9.740**
3. David Cone **8.722**
4. Zack Wheeler **8.720**
5. Nolan Ryan **8.700**
6. Matt Harvey **8.615**
7. Steven Matz **8.570**
8. Óliver Pérez **8.550**
9. Sid Fernandez **8.229**
10. Dwight Gooden **7.778**

THE COVERS

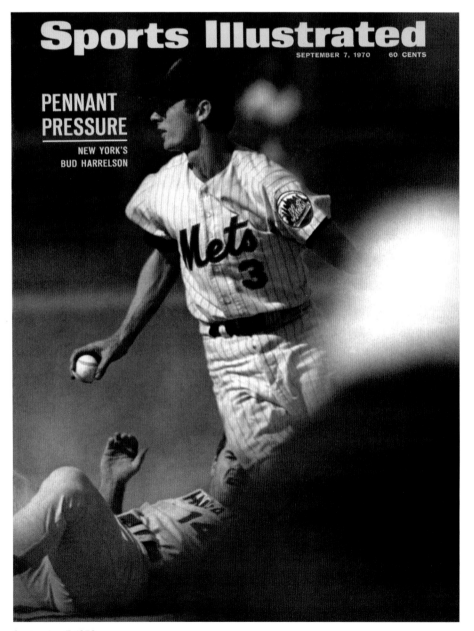

September 7, 1970

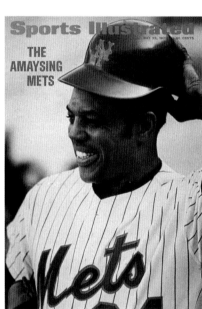

May 22, 1972

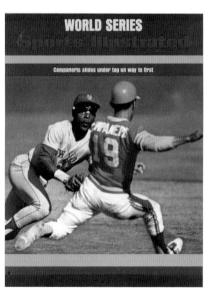

October 22, 1973

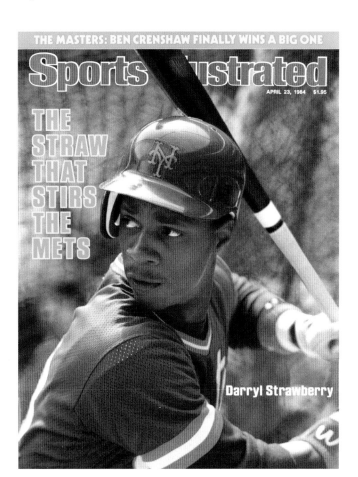

July 21, 1975

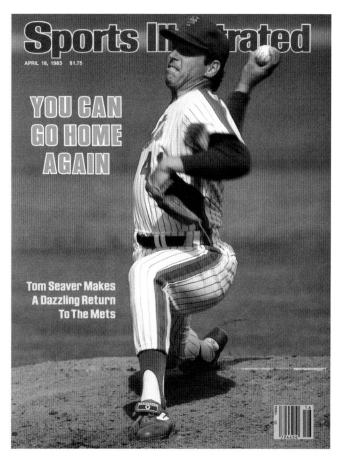

April 18, 1983

April 23, 1984

April 15, 1985

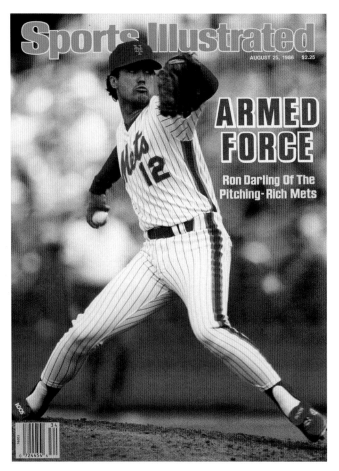

August 25, 1986

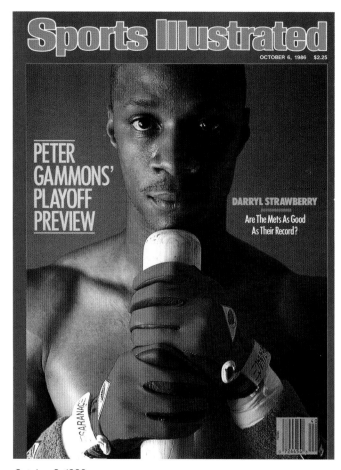

October 6, 1986

October 27, 1986

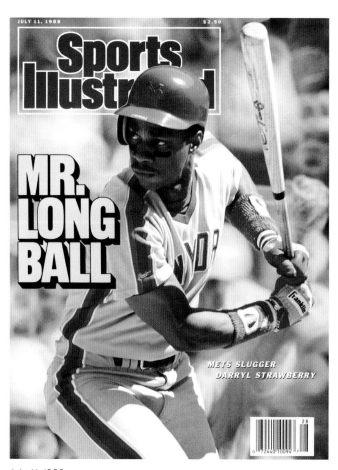

July 11, 1988

July 24, 1989

July 9, 1990

March 22, 1993

May 23, 1994

229

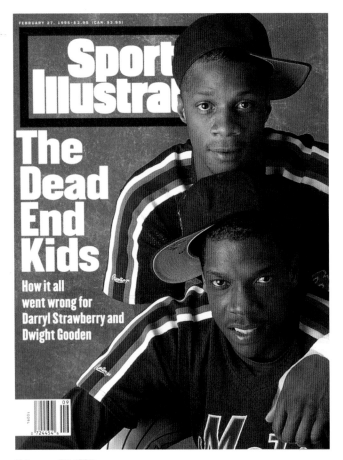

February 27, 1995

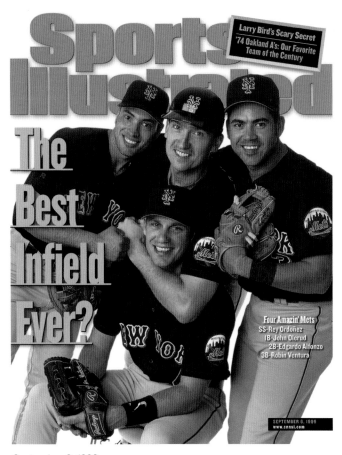

September 6, 1999

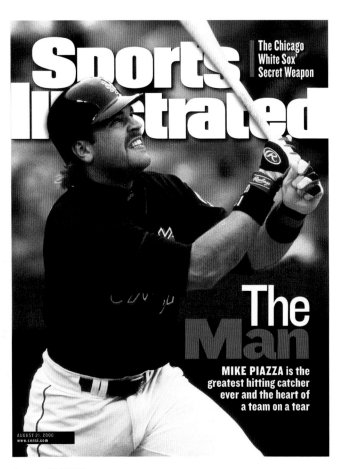

August 21, 2000

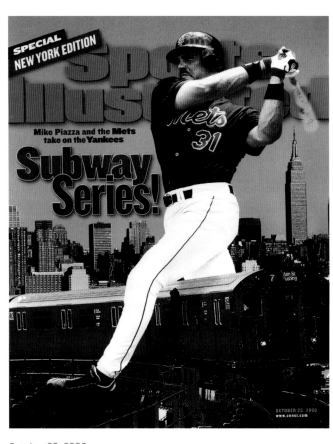

October 23, 2000

July 17, 2006

June 18, 2007

February 25, 2008

May 20, 2013

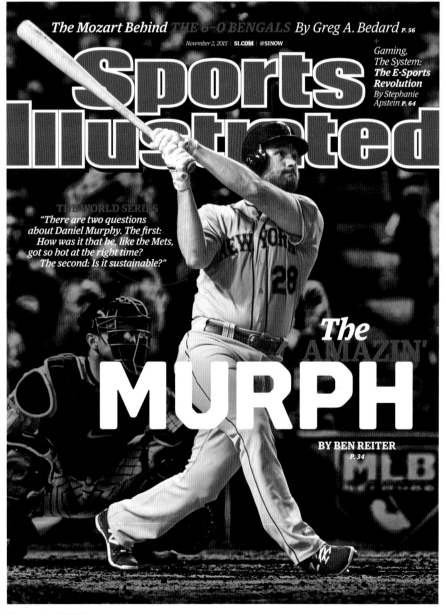

November 2, 2015

March 28, 2016

Spring 2020

April 2021

Photo Credits

Al Tieleman: Page 69; Ben Van Hook: Page 185; Brad Mangin: Page 190; Carlos M. Saavedra: Page 189; Chuck Solomon: Pages 53, 65, 163, 172, 181, 215, 220; Damian Strohmeyer: Page 180; Erick W. Rasco: Pages 186, 196, 212, 213, 216, 223; Heinz Kluetmeier: Page 120; Jeffery A. Salter: Pages 193, 200; John D. Hanlon: Page 33; John Iacono: Pages 66, 131, 135, 138, 140, 143, 152, 164, 165; Manny Millan: Pages 56, 62, 113, 128, 132, 205; Neil Leifer: Pages 2, 18, 20, 34, 37, 38, 41, 59, 74-75, 89, 91, 95, 96, 97, 99, 103, 104, 106, 156, 157, 221; Rob Tringali: Page 183; Simon Bruty: Pages 202, 203, 210, 214; Tony Triolo: Pages 154, 217; Walter Iooss Jr.: Pages 10, 100, 107, 175, 178.

Additional photography: Focus on Sport: Pages 5, 8, 13, 46, 72, 129, 145, 218, 219, 224; Jim McIsaac: Pages 7, 149; T.G. Higgins: Page 17; AP Photos: Pages 17, 22, 25, 26, 29, 44, 84, 86, 87, 141, 225; Bettmann: Pages 30-31, 42, 55, 70, 79, 82, 92, 94, 97; Rich Pilling: Page 49; Stephen Dunn: Pages 51, 148; Andrew D. Bernstein: Pages 61, 118; Robert Riger: Page 77; MLB: Page 109; George Gojkovich: Page 115; Ronald C. Modra: Page 117; Owen C. Shaw: Page 125; Doug Kanter: Page 167; Jed Jacobsohn: Page 170; Spencer Platt: Page 173; Paul Bereswill: Pages 191, 209; Michael Reaves: Page 205; Bernstein Associates: Page 222.

Library of Congress Cataloging-in-Publication Data available upon request.

This book is available in quantity at special discounts for your group or organization.
For further information, contact:
Triumph Books LLC
814 North Franklin Street, Chicago, Illinois 60610
(312) 337-0747
www.triumphbooks.com

Printed in China
ISBN: 978-1-63727-297-8